Romantik

02

JOURNAL FOR THE STUDY OF ROMANTICISMS

Editors

Robert W. Rix (University of Copenhagen), Lis Møller (Aarhus University), Karina Lykke Grand (Aarhus University), Anna Lena Sandberg (University of Copenhagen)

Editorial Board

Elisabeth Oxfeldt (University of Oslo), Gunilla Hermansson (University of Gothenburg), Tomas Björk (Stockholm University), Lauri Suurpää (Sibelius Academy, Helsinki), Leena Eilittä (University of Helsinki)

Advisory Board

Charles Armstrong (University of Bergen), Paula Henrikson (Uppsala University), Jacob Bøggild (University of Southern Denmark), David Fairer (University of Leeds), Karin Hoff (Georg-August-Universität Göttingen), David Jackson (University of Leeds), Stephan Michael Schröder (University of Cologne), Roland Lysell (Stockholm University)

Nordic Co-Editor (second issue)

Gunilla Hermansson (University of Gothenburg)

Editorial Consultant

Cian Duffy (St. Mary's University College, Twickenham, London)

Main editorial contact

Robert W. Rix [rjrix@hum.ku.dk]

Editorial Secretary

Kasper Rueskov Guldberg (Aalborg University)

Visit www.romantikstudier.dk or www.unipress.dk

Subscription services

Aarhus University Press [unipress@au.dk] or [+45 87 15 39 65]

Subscription price

Annual subscription price is DKK 150.00

Price per issue

DKK 199.95 per issue plus postage

Contents

02

The themes outlined in the articles of the present edition of *Romantik* are truly transnational. Two of these articles were first heard as papers at a one-day conference entitled 'Disseminating Romanticism: European Connections and Regional Disconnections', kindly sponsored by the Department of Culture and Global Studies, Aalborg University, Denmark. The theme of the conference was timely. It is ironic that in our globalized world, the discipline of Romantic Studies is often disconnected from the cosmopolitan milieu in which the Romantics moved. The standard myth of the Romantic genius isolates the artist as both singular and solitary. But the writers and painters of the period were part of various communities and networks; they corresponded across national borders, and their productions were influenced by international currents. We need a greater focus on the channels of dissemination in terms of the import/export of books, the exchange of letters and personal contacts. What was the effect of technological advances (transport, printing, postal service, etc.) on the development of connections and the dissemination of Romanticism? To what extent were particular regional Romanticisms shaped by their emulation of and competition with national and international currents?

When training the lens on how ideas and aesthetic models were transmitted, it may be rewarding to gauge what barriers were in place to prevent the spread of Romanticism – censorship (as was the case in Spain and Portugal), *national* antagonism, publishers' commercial considerations, etc. Factors like these had an enormous impact on how Romanticism morphed into different shapes and forms in various countries. The lack of dedicated focus on such issues is partly a problem with academic institutions in various countries, which tend to emphasise a national tradition and thereby place limits on the scope of investigation. However, it makes sense to look at different yet similar Romanticisms and bring these into productive dialogue with one another. In this way, we hope to begin a possible remapping of the Romantic topography in Europe and beyond.

If we on one level are interested in international developments – its linkages – perhaps we have also reached the stage where we need to re-calibrate our ideas of Romanticism in order to more accurately register *regional* developments. Sometimes the nation state is not the most meaningful category to use. Rather, we may investigate the internal fissures of *domestic* oppositions, antipathies, and competi-

FOREWORD

tion. For Britain, the 'four nations' approach has been one way forward. But here, as well as for Europe in general, more could and perhaps needs to be done. This issue offers articles that zero in on important questions that will guide us in our future investigations. This issue also contains articles which challenge other ways of drawing boundaries, such as those that are traditionally seen to exist between art and science and between Enlightenment and Romanticism. In this way, we hope the thematic range is wide enough to interest many researchers, teachers, and students, and yet narrow enough to show the consistency of the journal's innovative approach.

Welcome to *Romantik*!
The editors

Romantic
National

NOTES TOWARDS A DEFINITION OF ROMANTIC NATIONALISM

JOEP LEERSSEN

[ABSTRACT]

While the concept 'Romantic nationalism' is becoming widespread, its current usage tends to compound the vagueness inherent in its two constituent terms, Romanticism and nationalism. In order to come to a more focused understanding of the concept, this article surveys a wide sample of Romantically inflected nationalist activities and practices, and nationalistically inflected cultural productions and reflections of Romantic vintage, drawn from various media (literature, music, the arts, critical and historical writing) and from different countries. On that basis, it is argued that something which can legitimately be called 'Romantic nationalism' indeed took shape Europe-wide between 1800 and 1850. A dense and intricately connected node of concerns and exchanges, it affected different countries, cultural fields, and media, and as such it takes up a distinct position alongside political and post-Enlightenment nationalism on the one hand, and the less politically-charged manifestations of Romanticism on the other. A possible definition is suggested by way of the conclusion: Romantic nationalism is the celebration of the nation (defined by its language, history, and cultural character) as an inspiring ideal for artistic expression; and the instrumentalization of that expression in ways of raising the political consciousness.

.

KEYWORDS *European Romanticism, Nationalism, Volksgeist, Friedrich Carl von Savigny, Organicism.*

Introduction

The conceptual splicing of Romanticism and nationalism, either as 'Romantic nationalism' or as 'national Romanticism', is becoming increasingly widespread.[1] 'Romantic nationalism' now has a sizeable Wikipedia entry, and established usage of these terms is found in the fields of nineteenth-century history-writing, music, the arts, and architecture. To some extent this is wholly unsurprising: the two movements arose jointly in the decades around 1800, shared the turbulent political and social circumstances of that period, and have many important actors in common. Composers like Liszt and Rimsky-Korsakov, poets like Petőfi and Wergeland, novelists like Hendrik Conscience and Felix Dahn, historians like

Joep Leerssen, Academy Professor and Chair of Modern European Literature, University of Amsterdam
Aarhus University Press, *Romantik*, 02, 2013, pages 9-35

Michelet and Palacký, folklorists like Grimm, Asbjørnsen and Moe, are important names in the history both of the Romantic and of the national movements of Europe. Since scholars like Isaiah Berlin and Hans Kohn began to address the intellectual history of nationalism, the interaction and overlap with Romanticism has been habitually noted, especially, of course, in the case of Germany,[2] where the interactions between the intellectuals of the Romantic generation and the anti-Napoleonic *Befreiungskriege* were too obvious to be ignored – too obvious even to be scrutinized as anything other than wholly and unproblematically self-evident. The connection between Romanticism and nationalism was usually seen as a situational one: the two arose simultaneously, concurrently, in one specific part of the world at one particular historical moment, and therefore unavoidably shared common features, interactions, and cross-currents.

The activities of intellectuals in both spheres was noted, but without much attention to the question of how precisely the poetics of Romanticism could chime, intellectually, with the ideological doctrine of nationalism. In the 1980s and 1990s, the 'Romantic-nationalist-nexus' became an analytical lens or conceptual framework for research, mainly on Central European intellectuals of the early-to-mid-nineteenth century. Since then, the concept has begun to move beyond the status of a mere container term, indicating a loosely-observed synchronicity,[3] towards that of a specific nodal point in the history of ideas.[4]

By now, we may have reached the stage where the 'Romantic-nationalist-nexus' deserves typological specification, for it is not entirely as unproblematic as its widespread usage might lead us to believe. In the various individual cultural sciences, the term is applied to fields as diverse as literature, architecture, painting, music, or folklore,[5] without much meta-theoretical reflection, let alone with due attention to its usage in adjacent fields. This imposes the need for interdisciplinary cross-calibration. Furthermore, the field of nationalism studies has tended to move away from the intellectual history approach of mid-century scholars like Berlin and Kohn; the emphasis now being, on the whole, more politological and sociological – fields of study for which the finesse of Romantic poetics, and the intermedial and transnational complexities of the European spread of that movement, is of subordinate importance.

What is more, in this scheme of things the causal relationship between culture and the sociopolitical or institutional infrastructure is regrettably one-directional: culture (and, by implication, Romanticism) is usually seen as a by-product or context, never as an agency, as the sort of thing which stands in need of explanation by relating it to its sociopolitical or institutional parameters. Even studies of nineteenth-century nation-formation which, in the wake of Benedict Anderson, profess an awareness of cultural processes, are prone to such socio-economic reductionism. They tend to reduce 'literature' and 'theatre' to the sociology of 'print capitalism' and 'public playhouses'; to address the public involvement or impact of writers rather than the actual substance of their writings; and when they cite writers, composers or artists, it is as 'celebrity witnesses' of historical events rather than as active participants in their shaping. In elaborating a cor-

rective to that infrastructural reductionism, and in seeing culture as something more than a mere social ambience or ingrained collective *habitus*, one must take care not to slip into the opposite, but equally anachronistic error: to reify culture into an anthropological category (as a putative, underlying ethnic identity). Instead, culture, in its agency, should be understood as a historically situated and historically variable praxis of communicated ideas.[6]

Nationalism and Romanticism are both notoriously complex, protean terms, each carrying a huge semantic bandwidth. The splicing of two terms so contested and fuzzy might confuse, rather than focus on precisely what it is that we are discussing. At worst, the notion might mean little more than that the 1848 revolutionaries tended to get carried away by pathos and enthusiasm (yes, they were very Romantic, those nationalists), or that Romantic artists abandoned elite classicism or cosmopolitanism in favour of the vernacular (yes, they were nationalists, those Romantics). Since both nationalism and Romanticism were all-pervasive attitudes in these decades, the notion that many people might be affected by a mixture of both might become a toothless truism. Hence what is needed is a conceptual improvement, identifying which elements in nationalism were particularly congenial to the poetics of Romanticism, and which elements in Romanticism were particularly congenial to nationalism.

In what follows, I want to align some features of Romanticism, as a paradigm in poetics, and nationalism, as a paradigm in political thought, and, with reference to some of the artists/intellectuals involved, outline some elements that render the notion of 'Romantic nationalism' both concrete and discrete. Discrete, in that it specifies the Romantic-nationalism-nexus in terms of a specific intellectual profile that is recognizably and uniquely its own; concrete, in that we can see this profile, not as a theoretical verbal construct of 'the sort of attitudes which we know formed part of that type of -ism', but on the basis of facts: real actions and utterances, undertaken and made by real people at specific moments and in specific places.

To be sure, the historical time-frame (the *Sattelzeit* with its continuities and discontinuities) is highly meaningful. There are social, political, and institutional events, some of them of a drastically revolutionary nature, which affected both Romanticism and nationalism. Both movements owe as much to Napoleon and to technological innovation as they do to Herder and Rousseau. Without the wars and constitutional upheavals of the period 1792–1815; without the invention of cheap wood-pulp paper and of new high-speed, mass-volume printing techniques; without the institution of state-controlled libraries, archives, museums, education, and university systems, neither Romanticism nor nationalism could have arisen as they did. That does not mean, of course, that the time-frame starts with an instantaneously incisive 'Big Bang'. Romanticism has its pre-1789 run-up (think *Ossian*, *Werther*) in what has been called pre-Romanticism, sentimentalism, and/or the Counter-Enlightenment.

So, too, nationalism has its run-up in Enlightenment patriotism,[7] the civic-democratic, anti-aristocratic set of political virtues that motivated Pascale Paoli

in Corsica, the *Marseillaise* in France, and George Washington and Simon Bolívar in the Americas. Much as the aesthetics of the Sublime, themselves of eighteenth-century vintage, are still at the heart of Romanticism, so too the ethics of patriotism, itself a Ciceronian-Enlightenment political virtue, are still at the heart of nationalism. Both movements emerge from revolutionary disruptions and discontinuities and try to change and innovate the world; yet both carry within their bosom the older ancestry of Herder and Rousseau. This moral inheritance includes sentimental primitivism, anti-elitism, and anti-classicism, as well as the enduring Enlightenment ideals of anti-absolutism and social improvement by means of reasonable and responsible civic-mindedness.

That enumeration may create the impression that the incisive discontinuities were all political and institutional, while the continuities were all cultural and intellectual. This is not wholly true. In the realm of cultural reflection, some transformations take place which set off the early nineteenth century from the preceding period, and these cultural/intellectual ruptures provide a good point of access to discuss the family resemblance between Romanticism and nationalism. More or less in this order, but with some interweaving, I shall address: [1] the linguistic revolution, [2] the spread of idealism, and [3] the rise of historicist dialectics. In each case, I shall try and indicate both the intermedial and transnational spread of these Romantic principles (across various nationalities and media), and their impact in the field of political thought and emerging nationalism.

The Linguistic Revolution and the Vernacular Turn

To begin with, there is the elaboration of the Indo-European model of language relations. The story is a familiar one, moving from Sir William Jones's discovery of Sanskrit to Friedrich Schlegel's consolidation and Europe-wide broadcasting of that model in his *Über die Sprache und Weisheit der Inder*.[8] In literature, this reinforces an already emerging taste for Oriental tales and provides Romantic authors and painters with a powerful imaginative alternative to the over-used classicist reservoir of cultural imagery.

In intellectual life the implications of this 'vernacular turn' rippled far and wide.[9] The Indo-European linguistic family tree, a triumph of scientific systematization, lent interest to languages and dialects which until then had been dismissed as uncouth vernaculars spoken by uneducated rustics; and that in turn had an emancipatory effect on the many speakers of those idioms, often in the peripheries of the great empires, which were now gaining serious scholarly attention. Ultimately, this process was to furnish a new criterion of nationality.

Nations were now defined as groups of people identified by a common, separate language. To have one's idiom classified as 'a language' meant that the speakers formed 'a nation'; and that realization either transformed or formed many national movements in the nineteenth century. Groups which until 1800 had primarily identified themselves by means of their legal constitution (current or

remembered), religion, or historical inheritance, now re-defined their identity, indeed their 'nationality' by the criterion of language (examples range from the Basque country to Hungary and Croatia). Others freshly articulated a newly emerging national identity by using the novel criterion (Estonians, Latvians, Albanians, and Bulgarians). The case of Ireland is especially telling.[10] After 1830, a pre-existing antiquarian, scholarly interest in Irish-Gaelic began to change into an altogether different discourse: that of the language as a marker of nationality, and indeed the core argument why Ireland could never be fully integrated under English ('Anglo-Saxon') rule. The tipping point is exemplified in the generational shift from Daniel O'Connell to Thomas Davis's Young Ireland movement around 1840. O'Connell (who had a native knowledge of the language) attached little or no symbolical importance to it, and he saw no need to ensure its survival or cultivation into the future. His nationalism was wholly based on the reasoning of constitutional and religious rights and wholly carried through social agitation and parliamentary activism. Davis and the Young Irelanders (gathered around the periodical tellingly called *The Nation)* based their calls wholly on arguments of cultural descent and specificity, celebrating Irishness and propagating their ideology by means of rousing verse and nativist songs such as 'A Nation Once Again'.

The floating and informal three-tier distinction between dialect variant, language and language family also had a three-tiered impact on cultural stances taken, where, below the level of the national movements proper, there were the manifestations of regionalism among dialect speakers (Walloon, *Plattdeutsch*) while at the higher level of aggregation there were the pan-movements encompassing entire language families, such as Pan-Slavism.[11] The demarcations between these levels were, to be sure, floating, impressionistic, and contested; but Slavicism was a poetical reality for the Slovak poet Jan Kollár, erstwhile student at Jena. His sonnet cycle *Slava's Daughter* (1824) fused his yearning for an unattainable beloved into his equally wistful and idealistic aspiration for the solidarity and emancipation of all Slavs everywhere, from Poland to the Balkans. The cycle became a huge consciousness-raiser among like-minded Slavic readers all over Europe. Kollár followed his poetic Romanticism with an agenda of cultural activism (for instance, his tract on the mutual interrelations between the Slavic nations) and was one of the figureheads of the 1848 Slavic Congress in Prague, masterminded by the Czech historian František Palacký.

Examples could easily be multiplied, from Estonia's Lydia Koidula to Spanish-Galician Rosalía de Castro: poets deploying a subaltern vernacular in order to demonstrate and celebrate its literary capabilities, reach out in cultural solidarity to a native reading constituency, and assert the fully 'national' status of their cultural community. This gesture feeds both into the politics of nationalism and the poetics of Romanticism. Politically, it meshes with the ethno-linguistic origins of many national movements in Europe: almost no cultural or national emancipation movement of the nineteenth century fails to use the argument of linguistic identity as the main trump card among their claims for a place on the European

map.[12] Poetically, the gesture meshes with the Romantics' new penchant for the literary registers of lyricism and balladry as expressions of authentic simplicity. From the German discovery of the *Lied* to Wordsworth's celebration of artless spontaneity and emotional authenticity in the Preface to the *Lyrical Ballads*, the valorisation of 'language really used by men', the rejection of the established high style with its artificial conventions, constitutes one of those revolutionary shifts which sets the poetics of Romanticism apart from the preceding literary generations.

The Poetics of Inspiration, the Politics of Idealism

'Humanity is surrounded by infinity, by the mystery of divinity and of the world' – that is how Uhland begins his 1807 essay 'On the Romantic'.[13] This tension-filled juxtaposition of the down-to-earth and the transcendent is one of the most salient and all-pervasive characteristics of the Romantic generation of lyrical poets. Novalis had metaphorically phrased the Romantic oscillation between the banal and the sublime as a mathematical operation, analogous to raising a figure's exponent to a higher power by squaring it (in German: *potenzieren*, so that 4 becomes 16) or logarithmically bringing it down to its root integer (in German: *logarithmisieren*, so that 25 becomes 5).

Romantisieren ist nichts als eine qualitative Potenzierung. Das niedre Selbst wird mit einem bessern Selbst in dieser Operation identifiziert. So wie wir selbst eine solche qualit[ative] Potenzenreihe sind. Diese Operation ist noch ganz unbekannt. Indem ich dem Gemeinen einen hohen Sinn, dem Gewöhnlichen ein geheimnisvolles Ansehn, dem Bekannten die Würde des Unbekannten, dem Endlichen einen unendlichen Schein gebe, so romantisiere ich es – Umgekehrt ist die Operation für das Höhere, Unbekannte, Mystische, Unendliche – dies wird durch diese Verknüpfung logarithmisiert – Es bekommt einen geläufigen Ausdruck.[14]

The poetics of 'inspiration', both in Wordsworth's Preface to the *Lyrical Ballads* and among the contemporary German Romantics, resides uniquely in negotiating the tension between straightforward, simple forms and complex metaphysical meaning. The appeal of simple song lies not simply (as it would have for the Rousseauesque Sentimentalists of the previous generation) in its touching artlessness, but in its capacity of intuiting the transcendent through its humdrum manifestations and expressing it in a small formal compass. Wordsworth's childlike natural piety triggers intimations of immortality, his youthful nut-beating gives way to a sense of spirits in the wood, his solitary highland lass sings songs that not only make the valley overflow with their sound, but unwittingly echo across the world and the centuries – much as Keats's immortal nightingale was heard in ancient days by emperor and clown, or Shelley's skylark ('bird thou never wert') is not just a feathered animal but something trans-historical.

The 'unpremeditated ecstasy' of Shelley's skylark (so close to Wordsworth's 'spontaneous overflow of powerful feeling') is the type of cantatory response to

creation which the Romantic poets themselves emulate. The energies feeding literary production lie outside the realm of cerebral cogitation, intellectual control or mastery of form. The poet has, rather, the passively responsive capacity to become (to invoke Coleridge's poem and M. H. Abrams' classic essay)[15] an Aeolian harp, humming as the invisibly-fingered agitation of a divine afflatus or breeze wafts through its finely-tuned strings and sets them vibrating in their 'sympathetic harmony'. The imagery of breezes, harp-strings and 'tuned' or 'highly-strung' temperaments is, as Abrams already suggested, one of the unobtrusive but all-pervasive tropes of Romantic lyricism. From the 'blessing in this gentle breeze' (which opens *The Prelude*) to the wind that sets treetops or cornfields waving at nightfall (in Goethe's *Wanderers Nachtlied* or Eichendorff's '*Es war als hätt' der Himmel ...*'), the formula is all-pervasive, invoking both the power, unknown origin, and invisibility of the poet's inspiration, and the non-cerebral responsiveness of the poet's sensibility. Whatever the particular, specific complexities of these various poets' views on the relation between art and artist, they all celebrate the combination of artlessness in form and responsiveness to the intuited, transcendent meaning of things (a point already made in Maurice Bowra's classic *The Heritage of Symbolism*, 1951).

Poetry (and art in general) can, in this Romantic view, electrify; much as it results from rapturous inspiration, so too it, in turn, can inspire and enrapture its audience (a point already made by Plato in the *Ion* dialogue). Romantic art, as a result, can become profoundly rhetorical and propagandistic. The inspirational effect of the *Marseillaise* was already noted around the battle of Valmy, celebrated as a quasi-magic spell in Jules Michelet's historical description of that episode and echoed in numerous *Marseillaise* spin-offs – from the painting by Isidore Pils, '*Rouget de Lisle chantant la Marseillaise*' (1849)[16] to the *Marseillaise* scene in the movie *Casablanca*. Michelet's rhetoric is worth quoting:

Rouget de Lisle, c'était lui, se précipita de la salle, et il écrivit tout, musique et paroles. Il rentra en chantant la strophe : « Allons enfants de la patrie !» Ce fut comme un éclair du ciel. Tout le monde fut saisi, ravi, tous reconnurent ce chant, entendu pour la première fois. Tous le savaient, tous le chantèrent, tout Strasbourg, toute la France. Le monde, tant qu'il y aura un monde, le chantera à jamais.[17]

And to that immortality (once again corresponding to those death-and-time-transcending lyrical figures of the English Romantics), Michelet adds an explanation of this magic power: the song, in its combination of battle-fury and magnanimity, is more than a mere rhetorical contrivance; it is a direct manifestation of the very soul of the French nation.

Telle était bien alors l'âme de la France, émue de l'imminent combat, violente contre l'obstacle, mais toute magnanime encore, d'une jeune et naïve grandeur; dans l'accès de la colère même, au-dessus de la colère.[18]

To be sure, that is just vintage Michelet – his habitual flourish of seeing in the glories of the revolutionary events the glory of France itself;[19] but precisely in that oft-repeated flourish, Michelet proves himself a Romantic of the Wordsworth, Shelley, and Eichendorff stamp, extrapolating from the actual to the metaphysical, from the evenemential to the transcendent.

That translation of the actual into the ideal also fed into political and constitutional thought. From behind the bloody welter of revolutions and violent regime changes, Michelet sought to discern and salvage an ideal, the spiritual essence of a trans-political France – and with that eminently Romantic programme, he influenced the discourse and rhetoric of French statesmen ever since. It was not just Charles De Gaulle who was mystically inspired by his *certaine idée de la France* – even in 1842, when the corpse of Napoleon was transported from St Helena to Paris, a political transsubstantiation was operative. When the funeral cortège, after a triumphant, religiously-fervent progress through France, finally arrived at the *Invalides*, the officer in charge saluted the waiting monarch, Louis-Philippe, and presented a dead emperor to a living king with the words 'Sire, I have brought, as you ordered, the corpse of the emperor'. The confrontation between two regimes (potentially awkward in highlighting the country's constitutional instability and frequent regime-changes) was then defused and taken to an uncontentious level beyond conflict by Louis-Philippe's reply *Je le reçois au nom de la France*.[20] The present king and the erstwhile emperor can coexist and cohabit because both represent, each in his reign, something transhistorical and ideal, 'La France'. The situation is, in Novalis's terms, *potenziert*, the actual selves raised to their higher power. In the process, the figure of Napoleon is also definitively redeemed from party-political contention and, almost literally, *canonized* as a titanic, world-historical figure – precisely the view which a good few Romantics had always had of him.

Thus, the most abstruse poetical metaphysics of Romantic idealism turns out to have a very real, political application. That had already been recognized by the Prussian general Gneisenau, who, during the years 1810–1813, sought to convince his King to make common cause with popular opinion and turn against the hegemony of Napoleon. The King – dour, pragmatic, and mistrustful of populism – was reluctant to arm his subjects, and dismissed Gneisenau's schemes for a popular insurrection as 'mere poetry'; only to be told by his general that

Religion, Gebet, Liebe zum Regenten, zum Vaterland, zur Tugend, sind nichts anderes als Poesie, keine Herzenserhebung ohne poetische Stimmung. Wer nur nach kalter Berechnung handelt, wird ein starrer Egoist. Auf Poesie ist die Sicherheit der Throne gegründet.[21]

'The security of the throne is founded on poetry'. It certainly was founded on little else in those years after the defeats of Jena and Austerlitz, and Gneisenau had judged the mobilizing power of poetic fervour correctly.

The poetry that Gneisenau referred to was probably the verse of Ernst Moritz Arndt, who was a genius at the 'hostile imitation' of French state-building strate-

gies. Against the *Marseillaise*, Arndt composed battle verse for the militias of the 1812–1814 anti-Napoleonic wars, most importantly the evergreen *Des Deutschen Vaterland*. This song put together in a nutshell Arndt's main ideological concerns, which he had spread before in his *Geist der Zeit* pamphlets: the need for German unity, derived from the twin pillars of a common language and a common morality. The German's fatherland, so the song goes, is more than a mere region, but the entire moral-geographical footprint of the German language area:

> Was ist des Deutschen Vaterland ?
> So nenne mir das große Land !
> So weit die deutsche Zunge klingt
> Und Gott im Himmel Lieder singt,
> Das soll es sein !
> Das, wackrer Deutscher, nenne Dein !

> Das ist das Deutsche Vaterland,
> Wo Zorn vertilgt den welschen Tand,
> Wo jeder Franzmann heißet Feind,
> Wo jeder Deutsche heisset Freund –
> Das soll es sein !
> Das ganze Deutschland soll es sein ! [22]

The link between language as the informing essence of a nation's identity and its territorial footprint – one of the central tenets of ethno-linguistic nationalism – found its first and most influential expression in this battle song. I shall return to it at the conclusion of this article. As regards the nationalist passion-building role of poetry, one name beside Arndt's needs to be pointed out: that of Theodor Körner. He had sat at the feet of Friedrich Schlegel in Vienna, joined a volunteer militia in the anti-Napoleonic wars, and fell in battle in 1813. His posthumous collection of poems alternatingly addressing tender feelings and the joys of the soldier's life, *Leyer und Schwert* ('The Lyre and the Sword'), has fallen out of the canon of German Romantic poetry nowadays, as has the poetry of other patriotic versifiers like Massmann, Rückert, and Geibel, or even Uhland (who is remembered for other things than his patriotic verse); but Körner's impact in the first half of the nineteenth century was enormous. He became the very prototype of the poet-martyr, doing battle and writing verse from one and the same inspiring passion. The impact of Körner reverberates from Mangan and Davis in Ireland to Petőfi in Hungary[23] to Christo Botev in Bulgaria, and Patrick Pearse in (again) Ireland. The underlying role model of the poet capable of articulating and marshalling his nation's very identity was raised to semi-divine heights in Carlyle's *Of Heroes and Hero-Worship*, which saw figures like Shakespeare and Dante as indispensable national demigods. Many Romantic poets developed the ambition to become their nation's poetic protagonist by creating its foundational epic: Jan Fredrik Helmers with *De Hollandsche Natie* ('The Dutch Nation', 1812), France

Prešeren in Slovenia with his *Krst pri Savici* ('Baptism on the Savica', 1836), Eduardo Pondal in Galicia with *Os Eoas*, ('Children of the Sun', unfinished), Runeberg in Finland with *Elgskyttarne* ('The Elk hunters', 1832) and of course Adam Mickiewicz with his various Polish-themed epic poems. Even later, Frédéric Mistral's Occitan *Mireio* (1859) and Jacint Verdaguer's Catalan *L'Atlàntida* (1877) can be considered a poet's attempt to forge (as James Joyce ironically phrased it) 'in the smithy of his soul the uncreated conscience of his race'. That urge also expressed itself in the more modern genres of the historical drama and novel, and the 'instrumentalized text edition', of which some more will be said later.

This idea that verse tapped the soul of the nation and brought its transcendent, soul-stirring glory closer to society carried over into the field of music, which was considered to have a uniquely 'inspiring' potential. The *Leyer und Schwert* lyrics, set to choral music by the young Carl Maria von Weber in 1814, marked the start of that composer's 'national' prestige and helped to mark out his debut opera *Der Freischütz* (1821), with its folk-vernacular topic, as a 'national German' work. Thenceforth, Romantic music has such close interconnections with nationalism that the point need hardly be laboured; Glinka and his Russian successors, Chopin, Liszt, Smetana, and Wagner may suffice as indices. Like the Romantic poets, the Romantic composers increasingly cultivated an artistic stance of inspiration and disregard for established formal conventions, exploring new harmonies and new musical forms such as the rhapsody or the symphonic poem. Like the poets, they turn to the vernacular, adopting musical genres, modes and stylistic features from outside the established classical repertoire: mazurka, hornpipe, csardas or jota; Gypsy music with its augmented seconds, folk melodies with their Doric or Mixolydian modes, drone bass lines and parallel fifths. And as in the case of the poets, the combination of vernacular expressions and sublime inspiration turn composers from mere *virtuosi* into the inspired mouthpieces and champions of their nation.[24]

Here, too, what started out as an artistic programme became an accepted nation-building instrument. By the 1880s the nationalistic fervour that music could inspire was invoked as a matter of received wisdom – Albert, Prince of Wales (the future Edward VII), mentioned in a speech 'those emotions of patriotism which national music is calculated so powerfully to evoke'[25]. He is still proved right, year after year, at the Last Night of the Proms, with its flag-waving performances of 'Land of Hope and Glory', 'I Vow to Thee, my Country', and 'Jerusalem' – all of them (slightly belated) answers to the *Marseillaise*.

Volksgeist, Historicism, Medievalism

The transcendental essence which poets and historians tried to extrapolate from the transient incidents of material reality had, in a national context, been given a name by 1805: it was called *Volksgeist*. The term originated in the legal arguments of scholars like Hegel and, especially, Friedrich Carl von Savigny, who resisted the imposition of a Napoleonic code on German states. In Savigny's view, it was

a travesty to have a millennial heritage replaced by a merely instrumental set of regulations devised by an ad-hoc assembly of bickering politicians. Savigny became the foremost proponent of an *organicist* notion of law (which also took in the older views as put forward by Montesquieu) that each nation engendered its own proper legal system – as much as it had its own language. In due course, Savigny (who lived from 1779 until 1861) was to become one of the great legal statesmen of post-Napoleonic Prussia. But in pre-1813 Marburg, part of the new-fangled Kingdom of Westphalia ruled by a minor Bonaparte, he was as yet a re-served academic, muttering through clenched teeth in the privacy of his study. In claiming that a law system was the direct expression of a nation's specific mentality, Savigny was the first in the German language to give currency to the notion of *Volksgeist*.[26]

Interestingly, this reliance on a national psyche to identify cultural traditions and specificities also meant that Savigny was a true historicist – in fact, the very founder of the 'historical school' in jurisprudence. Law, to Savigny, was an evolv-ing moral corpus as much as it was an organically collective one – it developed as the nation developed across the centuries, and it should therefore be seen as an historical accumulation rather than as a mere set of rules and guidelines.

In formulating this link between national essentialism, organicism, and his-toricism, Savigny's ideas summarized the fundamental European refusal of the Napoleonic, technocratic view of the state. Edmund Burke had similarly rejected the French Revolution's reliance on society as a set of interactive obligations (the Rousseauesque 'social contract'), and, like Savigny, had pointed out that nations cannot be adequately defined in purely synchronic terms, necessitating also a diachronic perspective. In his *Reflections on the Revolution in France*, Burke had writ-ten, famously:

Society is indeed a contract. Subordinate contracts for objects of mere occasional interest may be dissolved at pleasure; but the state ought not to be considered as nothing better than a partnership agreement in a trade of pepper and coffee, calico or tobacco, or some other such low concern, to be taken up for a little temporary interest, and to be dissolved by the fancy of the parties. It is to be looked on with other reverence; because it is . . . a partnership in every virtue and in all perfection. As the end of such a partnership cannot be obtained in many generations, it becomes a partnership not only between those who are living, but between those who are living, those who are dead, and those who are to be born. Each contract of each particular state is but a clause in the great primeval contract of eternal society, linking the lower with the higher natures connecting the visible and invisible world, according to a fixed compact sanctioned by the invisible oath which holds all physical and all moral natures each in their appointed place.[27]

A trans-generational contract, 'not only between those who are living, but be-tween those who are living, those who are dead, and those who are to be born': this very argument is what Fichte unfolded in his *Reden an die deutsche Nation* of 1808. Germany cannot be reformed on a French model because that would break

the diachronic continuity and indeed the transcendent essence of what constitutes the nation.

As the here-and-now was being disrupted to its very foundations by the Napoleonic avalanche of revolutionary changes, innovations and abolitions, intellectuals sought stability in the diachronic continuities and traditions: historicism, the anchoring of the present in the past.[28]

The impact of Savigny's particular brand of national-organicist historicism, which sees all things as the end-products of a growth process, is best illustrated with reference to his most famous pupil. As law professor in Marburg, Savigny served, for a while, as mentor to a bright young law student, whom he trained in the jurisprudential craft of paleography – the study of ancient documents and their provenance, of old types of handwriting and of obsolete forms of the language. At this time, the study and source-criticism of medieval documents was almost the exclusive preserve of legal historians such as Savigny; medieval *literature* was as yet merely an entertaining fancy for antiquaries and amateurs. This young scholar thus trained by Savigny was bookishly inclined and even followed his master as an assistant, when Savigny went to Paris to consult sources in the Parisian libraries and archives. The young man was none other than Jacob Grimm.[29]

Himself the son of a lawyer (who had died early, leaving him an impoverished semi-orphan), Grimm had enrolled at Marburg in order to prepare for a career as a public official through the traditional means of a law degree. Later on he was to choose differently, having meanwhile discovered, among the old documents Savigny introduced him to, the literary riches of the *Minnesänger* and *Reinhart Fuchs*. Even so, he was to remain close to Savigny for the rest of his life and applied to his study of cultural material precisely that historicist organicism that he had learned from his legal mentor and from the craft of jurisprudential source criticism.[30]

Savigny introduced Jacob Grimm, and also Jacob's shy brother Wilhelm, to a set of literary amateurs whose social gatherings he frequented. This was the so-called 'Bökendorf Circle', so named after the country seat of the baronial family Von Haxthausen. The young Haxthausens, August and Werner, had cultural, literary and national interests and received like-minded people (such as their cousin Annette von Droste-Hülshoff) in what became a regular network. The central node in this network was occupied by Clemens Brentano, who since the beginnings of his Göttingen student days had struck up a close friendship with Achim von Arnim, who married Brentano's sister Bettina in 1811. Brentano's other sister Kunigunde became the wife of, again, Savigny.

It was through these associations that the Grimm brothers, as Savigny's protégés, came to attend gatherings at Bökendorf. They were also involved in the collection of folksongs that formed the Bökendorf Circle's chief literary pleasure that was to culminate in the collection *Des Knaben Wunderhorn* in 1806–1807. Edited by Arnim and Brentano, this prototype of all Romantic folksong collections was really the collective effort of the entire Bökendorf Circle. Indeed the Grimms' own collection of fairy tales (the epoch-making *Kinder- und Hausmärchen*, which

appeared in 1812 and included material contributed by the Arnims, Brentanos, Haxthausens and Droste-Hülshoffs) may be seen as a prose spin-off of the *Wunderhorn*.[31] But there was a difference. Whereas the folk material collected in the *Wunderhorn* was meant to appeal to sentimentally inclined readers, who wanted to dip into the naïve, but charming verses of simple country folk, the interest of Grimm's folk- and fairy tales was different. The Grimms sensed that such tales constituted the oral remains of an older, now-vanished system of supernatural beliefs and sagas of the German nation. For the Grimms, pupils of Savigny, the interest of these tales was historicist and anthropological, a window on the primitive mentality of the German nation in its infancy. And so we can trace, from the *Wunderhorn* (1806) to the *Märchen* (1812), and thence to the Grimms' *Deutsche Sagen* (1816) and Jacob Grimm's *Deutsche Mythologie* (1835) a progress from sentimentalism to philological historicism, and from a dilettante literary interest to hard-nosed academic scholarship.

At the same time, Grimm developed his linguistic skills, coming to the formulation of 'Grimm's Laws' in his *Deutsche Grammatik* around 1820. Again, we can see this as the application of Savigny's legal historicism to cultural topics: Grimm looked at language, not as a fixed, closed system, but as a process in a continual state of development, where each phenomenon was to be understood as the product of an evolutionary dynamics. *Das Sein aus dem Werden begreifen* – to understand *what is* in terms of *how it came to be* – was a methodological historicism for which Grimm always acknowledged the mentorship of Savigny.[32]

For Grimm and the generations of *Germanisten* whom he inspired, all the various specialisms they deployed (folklore studies, linguistics, history, literature, and jurisprudence) came together in the overriding agenda to understand the nature of the German nation, its origins and national psyche. Much as astrophysicists nowadays seek to understand the universe by taking their observations back to conditions as close as possible to the Big Bang, so too the historicism of the Grimms led them back towards the most ancient, heroic, epic-collective moments in the nation's history. There, in the tribal beliefs, cults, dialects, and lays, before native authenticity was addled by Roman, Christian, and foreign influences, lay the moment when the German nation enjoyed a pristine cultural authenticity, when priests, bards, and judges were essentially serving one and the same purpose: to articulate what it meant to be properly German. That is what the *logos* in *philology* stands for: culture, in the philological view, was an act of national self-creation by self-articulation. Not for nothing does the Grimms' massive *Deutsches Wörterbuch* carry, as an epigraph, the opening line of the Gospel according to John: *Im Anfang war das Wort* – in the beginning was the Word.[33]

The nationalistic applicability of this type of philology was enormous – and, in the German case, notorious.[34] To understand the nation's cultural and literary track record was a national enterprise, witness this appeal of the great French medievalist Gaston Paris for a text society in the year 1875 (overshadowed by the recent defeat of 1870–1871):

We appeal to all those who love the eternal France, to all those who feel that a people which repudiates its past is ill prepared for its future, and to all those who know that a national consciousness is only fully alive when it links together, in a profound solidarity, the present and the bygone generations.

And two years later, he came back to the idea of a philological historicism as a national imperative, calling on the support of those who felt that

[L]a piété envers les aïeux est le plus fort ciment d'une nation, de tous ceux qui sont jaloux du rang intellectuel et scientifique de notre pays entre les autres peuples, de tous ceux qui aiment dans tous les siècles de son histoire cette "France douce" pour laquelle on savait déjà si bien mourir à Roncevaux.[35]

The National Past and the Contemporary State

The reference to Roncesvalles at the end of Paris's quote is more than just a phi-lologist's invocation of the *Chanson de Roland*, with its heroic-chivalric celebra-tion of a noble defeat on behalf of *la douce France*. It also alerts us to the fact that Romantic historicism had, in the century after *Ossian* and the first modern edi-tion of the *Edda*, furnished all self-styled nations of Europe with something that was now called a 'national epic', and that this constituted the philologists' main claim to social recognition. The first edition of the *Chanson de Roland* had come out in 1836, and it was in the post-1871 context that the text became a symbolic classic for a revanchist France. A similar nation-building function in times of defeat had propelled the canonicity of the *Nibelungenlied* in Germany, first given a modern edition in 1806. It was in a review of this edition in 1807 that Wilhelm Grimm called it a 'National-Epos', probably the first time that term was used. (Previously, the genre epic referred exclusively to texts in the classically transna-tional canon, like the *Iliad* or the *Aeneid*).

Indeed, most of these national classics which are now habitually placed in the opening chapters of literary histories, as the originary starting point of literary traditions, were published in the Romantic decades: Besides the *Nibelungenlied* and the *Chanson de Roland*, there were the Russian *Lay of Prince Igor* (1800), the Dutch *Caerle ende Elegast* (1832), *Beowulf* (1815) and the tale of Deirdre (1808, the first published fragment of the Gaelic *Táin Bó Cuailgne*).[36]

Here, as in the case of *Volksgeist* historicism, such literary re-launchings in-volve at the same time a sense of a reconnection with ancient roots and (the national literature as an enduring and informing continuity), and a new sense of historical dynamics (literature as a continual growth process). The latter as-pect was explored most influentially in the lecture series on literature held by the Schlegel brothers, especially Friedrich's Vienna lectures of 1810, published in 1813. What Schlegel delivers is in fact an application of Savigny's organicism to literature: literature is defined as the collective imagination and memory of a national community, through which it articulates itself into higher states of historical awareness and powers of cultural self-reflection. As such, it grows from

primitive origins in a continuous development, along with the nation's histori-
cal experiences and moral track record. Much as, for Grimm, the nation is the
categorical unit of language and culture, so for Schlegel the nation with its own
national language becomes the categorical unit for literature – a sharp departure
from earlier literary-historical approaches, for whom language of expression or
the nationality of the author had been incidental qualities rather than categori-
cal determinants, and for whom 'development' did not have the overtones of
organic growth-processes that it had after Schlegel. The idea that literature is a
dynamic process rather than a condition or a corpus echoes perhaps, that first
gnomic usage of the qualification 'progressive' in Schlegel's famous earlier, 1798
definition of Romantic poetry as 'progressive-universal'.

The sense that literature also forms a mental continuum between the nation's
present and its past is no less important. For Grimm, reading ancient epic works
was a form of mental time-travel, in which the reader had to transport himself
back into 'wholly vanished conditions'; the very definition, perhaps, of literary
historicism.

*Unter den drei dichtungsarten fällt zu beurtheilen keine schwerer als das epos, denn die lyrische poesie
aus dem menschlichen herzen selbst aufsteigend wendet sich unmittelbar an unser gemüt und wird
aus allen zeiten zu allen verstanden; die dramatische strebt das vergangne in die empfindungsweise,
gleichsam sprache der gegenwart umzusetzen und ist, wo ihr das gelingt, in ihrer wirkung unfehlbar.
. . . um die epische poesie aber steht es weit anders, in der vergangenheit geboren reicht sie aus dieser
bis zu uns herüber, ohne ihre eigne natur fahren zu lassen, wir haben, wenn wir sie genieszen wollen,
uns in ganz geschwundene umstände zu versetzen.* (Missing capitalization *sic.*)[37]

By the same token, ancient texts were points of ancestral reconnection, living
manifestations of that trans-generational contract which, in the historicist view,
constitutes the nation's enduring identity. This is why the reprinting of ancient
texts, salvaging them from the unread limbos of neglected archives and bringing
them into the light of the public sphere by means of printed publication, was
such a core concern for Romantic philologists.

That philological recycling reached out into adjacent fields. Where ancient
manuscript were unavailable, scholars turned to orally transmitted epic works in-
stead – most famously, in the edition of the oral epic from the Balkans – *Hasanagi-
nica* and the collections of Vuk Karadžić – but also in the Grimm-inspired collec-
tions of tales and verse in the Baltic, in Scandinavia, In Russia and the Ukraine.[38]
In many cases, the materials thus collected were given 'epic' (that is to say: heroic
and national-foundational) status, and in many cases such 'instrumentalized edi-
tions' tread a thin line between authenticity and forgery. The prototype of this
type of endeavour, Macpherson's *Ossian*, is already a notorious case in point, and
severe authenticity doubts have surrounded similar editions such as Lönnrots
Kalevala or La Villemarqué's *Barzaz Breiz*. Vaclav Hanka's edition of a medieval
Bohemian manuscript heroically extolling the Czechs' resistance against the Ger-
mans was based on a forgery which he himself had fabricated; and debates sur-

round, to this very day, the actual provenance and authenticity of the *Lay of Prince Igor*.[39] Doubtful as the underlying methodology may have been, the nationalist cultural impact of these texts has been none the smaller, either in La Villemarqué's Brittany, in Lönnrots's Finland, or in the Russia that saw *Prince Igor* turned into Borodin's national opera.

A hugely important genre that may to some extent be considered a spin-off of philological historicism was the historical novel in the Walter Scott mode.[40] Scott was himself, of course, a textual editor of note (e.g. his *Minstrelsy of the Scottish Border* and the *Sir Tristram* romance by Thomas the Rhymer) and in some of his novels (for example, *Quentin Durward*) presents the fictional tale itself as a quasi-edition of a manuscript found in an attic. That frame-narrative conceit of the 'found manuscript', a favourite of the genre of the Gothic romance and, subsequently, of the historical novel down to Umberto Eco's *The Name of the Rose*, rises to prominence in these decades, when in fact a lot of manuscripts were being found in attics and in secularized monastic libraries all over Europe. Certainly the one overwhelming reason for Scott's huge success was the historicist appeal of his novels: the way they could transport their readers back 'into wholly vanished conditions' (to recall Grimm's phrase), the way they brought the past back to life (as the telling phrase was with many readers, not least among envious historians). Bringing the past back to life: that was not merely a private reading sensation, but the very definition of what romantic historicists were aiming to do.

As is widely attested, Scott's powers of evoking the past through the literary imagination caused great envy among the historians of his generation (Macaulay, Thierry, Michelet, and all their nation-building followers in Central and Eastern Europe);[41] that envy is, in fact, what marks these historians out as 'Romantic historians' – that, and their transcendental idealism noted earlier on, as well as their tendency to cast the nation-at-large as the protagonist of their historical narratives.[42]

Bringing the past back to life also spread from Scott to other fields besides history-writing: most importantly, the visual arts. History painting, an established and prestigious pictorial genre ever since the establishment of the classical art academies, underwent a vernacular turn and 'went national' in these decades. Originally, the themes for academic history paintings were restricted to the canon of biblical and classical antiquity; and this had begun to change in the second half of the eighteenth century, first in the art that glorified the dynastic roots of monarchs and then in the art that celebrated the hero figures of medieval chivalric and early-modern Europe, such as Joan of Arc. Initially, the non-classical repertoire of romantic history painting was not particularly nationalized – the 'troubadour' paintings of France could as easily take themes from English, Italian or Spanish medievalism as from French.[43] However, after the 1820s we can see a definite *penchant* among Romantic history painters for topics from the nation's own history (although the themes from biblical and classical antiquity remain strongly present).[44]

The aim to 'transport the audience into the past' may be responsible for the tendency for history painting to use increasingly large canvases and to cover entire walls with huge shock-and-awe scenes into which onlookers can immerse themselves.[45] The art of the historicizing mural is linked to the newly established Düsseldorf Art Academy and was used to render a more complete illusion of age and authenticity to new, or newly restored, building in the nineteenth century. Many of those buildings, whose interiors were covered in historicist murals (by artists like Rethel, von Schwind, Wislicenus), were themselves built in a Puginesque neo-gothic style or historicist style: the Amsterdam Rijksmuseum, the Neuschwanstein castle in Bavaria, the city hall of Antwerp; among the restorations which involved extensive mural decoration were Hohenschwangau, the Goslar Imperial Manor in Prussia-annexed Hanover, the city hall of Aachen, and the Wartburg. The fashion persisted (like Romanticism itself) until the turn of the century: witness Akseli Gallen-Kallela's murals, on themes from the *Kalevala*, for the Helsinki National Museum, and Carl Larsson's fresco '*Midvinterblod*' for the Stockholm National Museum – both, again, places dedicated to 'bringing the past to life' and 'encapsulating the nation's identity'. The huge series of historical paintings by Alphonse Mucha, *The Slavic Epos*, is perhaps the last flourish of the genre, and also a good example of the merger between the 'epic' mode of romantic historicism which the visual arts borrowed from romantic philologists and novelists. (The tradition survived, in the twentieth century, in the new genre of the historical spectacle movie, which often involved screen adaptations of nineteenth-century post-Walter Scott historical novels.)

We see how Romantic historicism can freely move between media and cultural fields: from philological antiquarianism to fictional narrative and the visual arts.[46] Its prime point of overlap, Wagner's notion of the operatic *Gesamtkunstwerk*, indicates that it is anything but mere escapism or consumerism, but profoundly informed by the politics of celebrating the nation. The 'monumental' size of history paintings and their public display locations also indicates their 'monumental' function in rendering the nation's past a collective point of reference for the modern-day state. Academic art flourished most egregiously in the many commemorative monuments that were thickly scattered among the public places of the European city-spaces, amounting to what has been variously described as *statuomanie* or *Denkmalwut*.[47]

What is equally striking is how these national motivations were applied in highly transnational fashions and vogues. Scott's novels had an incalculable inspiring effect on national movements everywhere. For the Scottish readership, they affirmed that Scotland was not merely a subjugated periphery of the British state, but something which – from having a past of its own – derived a legitimate identity of its own.[48] While Scott placed his historicism in the service of a Scottish-accommodated Great Britain (as the notorious management of George IV's Edinburgh visit shows),[49] the impact of his novelistic formula elsewhere in Europe was to galvanize historicist nationalism among all subaltern nationalities – Flemish, Polish, Hungarian, Baltic, etcetera. In the course of the century,

'having a history of one's own' came to rank alongside 'having a language of one's own' as the main entitlement to a properly national (as opposed to regional) identity.[50] (Conversely, the idea of regionalism was predicated on the very absence of historicity, on the idea of timelessness, static traditionalism and rustic idyll.)

Dialectics, Restoration, and Cultural Geopolitics

Ironically, Scott's novels are in fact the very opposite of epic. The message of an epic is to glorify hard-won victory or heroism-in-defeat. Such epic endings, in the mode of the *Nibelungenlied*, *Beowulf* and the *Chanson de Roland*, were in fact used by Scott's followers elsewhere in Europe, like Hendrik Conscience in Flanders and Henryk Sienkiewicz in Poland;[51] but Scott himself rarely opted for that type of narrative resolution. His plotline typically places powerless protagonists in a national crisis between opposing forces, and resolves the narrative by letting the protagonists survive into a future in which ancient hatreds will be laid to rest. Whereas Conscience's novels *De leeuw van Vlaanderen* and *De Kerels van Vlaanderen*, and Sieniewcz's 'Trilogy' or *Krzyzaci* , exhort the reader to follow the inspiring ancestral example of resisting and defeating the foreigner, Scott's novels suggest that it is wiser to let bygones be bygones.

The resolution that Scott holds out in his novels is remarkably close to the Hegelian notion of *Aufhebung*, with its threefold meaning of abolishing the past, raising it to a higher level and storing it away in a safe place. *Aufheben* is exactly what Scott does with the past: the Jacobite Rebellion of 1745 (in *Waverley*), the Norman-Saxon divide *(Ivanhoe)*, or the Covenanting wars (*Old Mortality*), are laid down *ad perpetuam rei memoriam*, salvaged from oblivion, and at the same time shown to have been surmounted, to have become a matter of history, without partisan-antagonizing power in the present – something to be respected, but neither to be repressed nor to be revived.

What Scott and Hegel share is a new sense of historical development: a dialectical one, where history moves through the alternation of conflict and resolution. That movement was also instinctively grasped by Goethe, who repeatedly compared it to the opposing, alternating movement of contraction and expansion, diastolics and systolics, which between them form a heartbeat. Goethe based the entire dialectics of his *Faust* on it: the play's forward impulse is generated by Faust's insatiable thirst for knowledge and Mephistopheles's 'everlasting nay'. If Romantic poetry is 'progressive' (in Schlegel's usage of the term *progressive Universalpoesie* i.e. ongoing, unceasingly proliferating), then its impulse lies in this desire to explore the unaccustomed rather than to acquiesce in applying the norm. This, of course is fundamentally different from the poetics of classicism, and of the Enlightenment's view of historical development as causal, linear, and progressive.

Both Romanticism and nationalism are characterized by a combination of dynamic progressivism and nostalgia for permanence. The dialectic idea that historical progress is never linear but a conflict-driven process of constantly re-

negotiating one's relationship with, and continuation of, the past, appears to be a common denominator, evinced by historians, philosophers, artists, and writers. What is more, the 'past' which in these Romantic decades becomes a rear-view mirror for the dynamism of progress is almost invariably seen as, specifically, a *national* one.

Nationalism is, of all the great political doctrines of the nineteenth century, perhaps the most idealistic one in that it derives its political agenda, not from social or practical considerations of state interest, power, or wealth, but from the ideal-typical abstraction of the 'nation' and its essential character or *Volksgeist*. This national essence can be understood or intuited from its expressions in the collective history, the subsisting vernacular culture (always seen as a remnant from the primordial past), or its language. And from those abstractions, a very specific, concrete agenda is derived concerning the empowerment of the 'nation' in the state's constitution and, more importantly, the geographical outlines of that state. Nationalism typically will try to align the borders of the state with the cultural footprint of the nation.

To be sure, there had been earlier, isolated attempts to rationalize cultural differences in administrative divisions; but this is almost negligible compared to the all-dominant tendency to define the nation by its language and history, and to define the state's geography by its constituent nationality. Given the fact that in the Romantic decades most states were multi-ethnic monarchies, this necessarily engendered an enormous discourse of cultural geopolitics. The principles were laid down by intellectuals like Arndt, whose song 'What is the German's Fatherland' answers the question raised in its opening line with recourse to the spread of the German language. That line of reasoning was implicitly also proclaimed in Hoffmann von Fallersleben's '*Deutschland, Deutschland über alles*', which celebrates an ideal, yet-to-be-realized Germany stretching beyond political frontiers from the Meuse to the Niemen and from the Belt to the Adige. The conflicts and wars that this linguistic geopolitics triggered in all German borderlands (indeed, from the Meuse to the Niemen and from the Belt to the Adige!) are notorious, as is the application of linguistic geopolitics in other culturally mixed areas of Europe, from the Basque country to the Balkans and from Ulster to the Baltic. Carried by the transnational spread of Romanticism at large, Romantic nationalism allowed all vernacular cultures in Europe to raise claims to recognition in one form or another – and while these claims were in the first instance raised in the academic centres of learning and the metropolitan centres of power, they were soon mapped onto the provincial borderlands, which accordingly became an *enfer des autres*. Romantic nationalism challenged the elite universalism of the Enlightenment, but in the process forgot Herder's cultural relativism and instead established a shooting gallery of essentialist, introspectively self-celebrating, mutually intolerant vernaculars.

In the preceding pages, I have attempted to weave a skein of connections in three dimensions: between the politics of nationalism and the poetics of Romanticism; between intermedially related cultural fields and media of artistic and

intellectual expression; and between different countries and societies communicatively linked by manifold cultural transfers. In the process I have also shuttled back and forth between my three thematic strands: linguistic essentialism and the vernacular turn; romantic historicism; and the poetics of transcendence and inspiration. In doing so, I hope to have demonstrated, not just the plurality, but also the density of the interconnections between Romantic and nationalist thought in early-nineteenth-century Europe. If there is such a thing as Romantic nationalism, we must conceive of it, not as a lump of facts or a cloud of semantics, but as a knot, a tight tangle, a node in the mycelium of intellectual and cultural developments. Romanticism and nationalism, each with their separate, far-flung root-systems and ramifications, engage in a tight mutual entanglement and *Wahlverwandschaft* in early-nineteenth-century Europe; and this entanglement constitutes a specific historical singularity. We can give this singularity a name: Romantic nationalism. And we may understand that to mean something like: the celebration of the nation (defined in its language, history, and cultural character) as an inspiring ideal for artistic expression; and the instrumentalization of that expression in political consciousness-raising.

Notes

1 In what follows, I want to steer clear of the vexed finesses of periodization and typology that affect the discussions both of Romanticism and of nationalism. In selecting examples of Romantic writers, artists, intellectuals or cultural products, I follow the broadly accepted canon, fanning out from literary activities in 1790s Germany and Britain to other media and to European areas over the next decades; in selecting examples of nationalism, I follow the same spatiotemporal frame, as set out in my *National Thought in Europe: A Cultural History* (Amsterdam: Amsterdam University Press, 2008). Two further prolegomena: I cite classic Romantic 'soundbytes' merely as illustrative point of recognition requiring no specific source-reference; and throughout the text I rely, without specific source-referencing in each instance, on cases made in greater detail in a few earlier articles: 'Nationalism and the Cultivation of Culture', *Nations and Nationalism* 12, no. 4 (2006): 559–78; 'From Bökendorf to Berlin: Or, How the Past Changed in Jacob Grimm's lifetime', in *Free Access to the Past: Romanticism, Cultural Heritage and the Nation*, ed. L. Jensen, J. Leerssen and M. Mathijsen (Leiden: Brill, 2008), 55–80; *De Bronnen van het Vaderland: Taal, Literatuur en de Afbakening van Nederland 1806-1890*, 2nd ed. (Nijmegen: Vantilt, 2011); 'Viral Nationalism: Romantic Intellectuals on the Move in Nineteenth-Century Europe', *Nations and Nationalism* 17, no. 2 (2011): 257–71; 'The Rise of Philology: The Comparative Method, the Historicist Turn and the Surreptitious Influence of Giambattista Vico', in *The Making of the Humanities*, ed. R. Bod, J. Maat & T. Weststeijn, vol. 2, *From Early Modern to Modern Disciplines* (Amsterdam: Amsterdam University Press, 2012), 23–35.

2 Hans Kohn, 'Romanticism and the Rise of German Nationalism', *Review of Politics* 12 (1950): 443–70. To be sure, the case of Germany stands out (and will be referred to in this article as well), since the interconnections between the Romantic Movement and the concurrent anti-Napoleonic *Befreiungskriege* were always a matter of record; cf. Andries David Verschoor, 'Die ältere deutsche Romantik und die Nationalidee', doctoral thesis (Amsterdam: H.J. Paris, 1928), Klaus Siblewski, *Ritterlicher Patriotismus und Romantischer Nationalismus in der Deutschen Literatur 1770-1830* (München: Fink, 1981) and Wolfgang Müller-Funk and Franz Schuh, eds., *Nationalismus und Romantik* (Vienna: Turia + Kant, 1999).

3 Thus in surveys such as Gustave Charlier, *Le Mouvement Romantique en Belgique (1815-1850)*, vol. 2, *Vers un romantisme national* (Bruxelles: Palais des Académies, 1959), or Jean Plumyène, *Histoire du Nationalisme*, vol. 1, *Les Nations Romantiques: Le XIXe Siècle* (Paris: Fayard, 1979).

4 Joan S. Skurnowicz, *Romantic Nationalism and Liberalism: Joachim Lelewel and the Polish National Idea* (New York: Columbia University Press, 1981); Andrzej Walicki, *Philosophy and Romantic Nationalism: The Case of Poland* (Oxford University Press, 1982); Serhiy Bilenky, *Romantic Nationalism in Eastern Europe: Russian, Polish, and Ukrainian Political Imaginations* (Stanford: Stanford University Press, 2012); Wilhelm Baum, *Urban Jarnik: Romantik, Nationalismus und Panslawismus in Kärnten* (Klagenfurt-Wien: Kitab, 2009); Balázs Trencsényi & Michal Kopeček (eds.), *Discourses of Collective Identity in Central and Southeast Europe*, vol. 2, *National Romanticism: The Formation of National Movements* (Budapest: CEU Press, 2007). My own *National Thought in Europe* contains some ideas and examples in this direction which will be picked up in the present article.

5 Roger D. Abrahams, 'Phantoms of Romantic Nationalism in Folkloristics', *Journal of American folklore* 106 (1993): 3–37; Oscar Julius Falnes, *National Romanticism in Norway* (New York: Columbia University Press, 1968); Barbara Miller Lane, *National Romanticism and Modern Architecture in*

Germany and the Scandinavian Countries (Cambridge: Cambridge University Press, 2002); Katie Trumpener, *Bardic Nationalism: The Romantic Novel and the British Empire* (Princeton, NJ: Princeton University Press, 1997).

6 In nationalism studies, an inspiring example to that effect is Anne-Marie Thiesse's *La Creation des Identités Nationales* (Paris: Seuil, 1992), which admirably manages to analyse culture both as an agency and as a historical dynamics.

7 Maurizio Viroli, *For Love of Country: An Essay on Patriotism and Nationalism* (Oxford: Clarendon, 1995).

8 Hans Aarsleff, *The Study of Language in England, 1780-1860* (Princeton, NJ: Princeton University Press, 1967); Sylvain Auroux, E. F. K. Koerner, Hans-Josef Niederehe, and Kees Versteegh, eds., *History of the Language Sciences. An International Handbook on the Evolution of the Study of Language from the Beginnings to the Present*, 2 vols. (Berlin: De Gruyter, 2000-2001); Mary Anne Perkins, 'Romantic Theories of National Literature and Language in Germany, England, and France', in *Nonfictional Romantic Prose: Expanding Borders*, ed. S. P. Sondrup and V. Nemoianu (Amsterdam: Benjamins, 2004), 97–106; Pierre Swiggers and Piet Desmet, 'Histoire et Épistémologie du Comparatisme Linguistique', in *Le Comparatisme dans les Sciences de l'Homme*, ed. G. Jucquois and C. Vielle (Paris / Louvain-la-Neuve: De Boeck, 2000), 157–208.

9 Carmen Alén Garabato, *L'Éveil des Nationalités et les Revendications Linguistiques en Europe* (Paris: L'Harmattan, 2000); Petra Broomans et al., eds., *The Beloved Mothertongue: Ethnolinguistic Nationalism in Small Nations; Inventories and Reflections* (Leuven: Peeters, 2008); Otto Dann, 'The Invention of National Languages', *Proceedings of the British Academy* 134 (2006): 121–33.

10 Cf. my *Remembrance and Imagination: Patterns in the Literary and Historical Representation of Ireland in the Nineteenth Century* (Cork: Cork University Press, 1996).

11 Despite Kohn's now-notorious tendency to schematize 'good' western-democratic nationalism versus bad eastern-despotic nationalism, his *Pan-Slavism, its History and Ideology*, 2nd. ed. (New York: Vintage, 1960) is still unsurpassed as a conspectus of the intellectuals, writings and events.

12 Miroslav Hroch, *Die Vorkämpfer der Nationalen Bewegung bei den Kleinen Völkern Europas. Eine Vergleichende Analyse zur Gesellschaftlichen Schichtung der Patriotischen Gruppen* (Praha: Universita Karlova, 1967).

13 In the original: 'Das Unendliche umgibt den Menschen, das Geheimnis der Gottheit und Welt'.

14 'Romanticizing something is to raise its exponent to a higher power. The lower self becomes its higher self, much as we ourselves are such an exponential succession. . . . If I give the banal a higher sense, give the well-known a mysterious aspect, vest the familiar with the dignity of the unfamiliar, then I romanticize it; and conversely so, when I logarithmically bring down the higher, unknown, mystical and infinite into a common expression'. Ernst Behler, *Frühromantik* (Berlin: Walter de Gruyter, 1992), 162.

15 M. H. Abrams, 'The Correspondent Breeze: A Romantic Metaphor', in Id., *The Correspondent Breeze: Essays on English Romanticism* (New York: Norton, 1986).

16 For a high-definition photograph of the work, go to http://en.wikipedia.org/wiki/File:Pils_-_Rouget_de_Lisle_chantant_la_Marseillaise.jpg

17 'Rouget de Lisle, for he it was, burst into the room, wrote it all down, music and words. He returned singing the stanza 'Come, children of the fatherland!' It was like a burst of light from the sky. Everyone was moved, excited, all recognized the song even as they heard for the first time. They all knew it, they all sang it, all of Strasbourg, all of France. The world, for as long as

there will be a world, will forever sing it'. Cf. Michel Vovelle, ' "La Marseillaise" ', in *Les Lieux de Mémoire*, ed. Pierre Nora, vol. 1 (Paris: Gallimard, 1997), 107–52.

18 'Such indeed was the soul of France, moved by imminent combat, violent against its obstacle, yet wholly magnanimous, with a youthful and naive grandeur; even at the height of anger, above anger'.

19 Cf. Ann Rigney, *The Rhetoric of Historical Representation: Three Narrative Histories of the French Revolution* (Cambridge: Cambridge University Press, 1990).

20 Jean Tulard, 'Le Retour des Cendres', in *Les Lieux de Mémoire*, ed. Pierre Nora, 3 vols. (Paris: Gallimard, 1997), 1729–56.

21 'Religion, prayer, love of the ruler, of the fatherland, or virtue: all that is nothing but poetry. There is no enthusiasm without a poetic disposition. If we act only from cold calculation, we become rigid egoists. The security of the throne is founded on poetry.' Quoted in Leerssen, *National Thought in Europe,* 118.

22 'What is the German's fatherland? / At last do tell me where it lies! / As far as the German tongue is heard, / singing the praises of God on high, / That it must be! / That, bold German, you can name yours! // That is the German fatherland: / Where scorn destroys all French foppery / Where every Frenchman is called foe / And every German is called friend, / That it must be! / Germany entire it must be!' For the German original, see Gilbert Krebs and Bernard Poloni, *Volk, Reich und Nation: Texte zur Einheit Deutschlands in Staat, Wirtschaft und Gesellschaft 1806-1918* (Asnières: Presses de la Sorbonne Nouvelle et CID, 1994), 31.

23 Csilla Erdödy-Csorba, ed., *Europäische Romantik und Nationale Identität: Sándor Petőfi im Spiegel der 1848er Epoche* (Baden-Baden: Nomos, 1999).

24 Celia Applegate and Pamela Potter, eds. *Music and German National Identity* (Chicago: University of Chicago Press, 2002); Philip Vilas Bohlmann, *The Music of European Nationalism: Cultural Identity and Modern History* (Santa Barbara, CA: ABC-Clio, 2004); Benedikte Brincker, 'The Role of Classical Music in the Construction of Nationalism: An Analysis of Danish Consensus Nationalism and the Reception of Carl Nielsen', *Nations and Nationalism* 14, no. 4 (2008): 684–99; Benjamin Curtis, *Music Makes the Nation: Nationalist Composers and Nation-Building in Nineteenth-Century Europe* (Amherst, MA: Cambria, 2008); Carl Dahlhaus, 'Die Idee des Nationalismus in der Musik', in Id., *Zwischen Romantik und Moderne. Vier Studien zur Musikgeschichte des späteren 19. Jahrhunderts* (München: Katzbichler, 1974), 74–92.; Olympia Frangou-Psychopedis, *I Ethniki Scholi Mousikis: Provlimata Ideoloyias* (Athens: Idryma Mesogeiakon Meleton, 1990); Marina Frolova-Walker, *Russian Music and Nationalism from Glinka to Stalin* (New Haven, CT: Yale University Press, 2007); Glenda Dawn Goss, *Sibelius: A Composer's Life and the Awakening of Finland* (Chicago: Chicago University Press, 2009); Martina Grempler, *Rossini e la Patria. Studien zu Leben und Werk Gioacchino Rossinis vor dem Hintergrund des Risorgimento* (Kassel: Bosse, 1996); Rutger Helmers, 'Not Russian enough: The Negotiation of Nationalism in Nineteenth-Century Russian Opera', doctoral thesis (Utrecht: Utrecht University, 2012); Václav Holzknecht, *Bedřich Smetana: Život a Dílo* (Praha: Panton, 1979); Krisztina Lajosi, 'National Opera and Nineteenth-Century Nation-Building in East-Central Europe', *Neohelicon: Acta Comparationis Litterarum Universarum* 32, no. 1 (2005): 51–70; Joseph J. Ryan, 'Nationalism and Music in Ireland', doctoral thesis (Maynooth: National University of Ireland, 1991); Jim Samson, 'Nations and Nationalism', in *The Cambridge History of Nineteenth-Century Music* (Cambridge: Cambridge University Press, 2002), 568–600; Michael C. Tusa, 'Cosmopolitanism and National Opera: Weber's Der Freischütz', *Journal of*

Interdisciplinary History 36, no. 3 (2006): 483–506; Harry White and Michael Murphy, eds., *Musical Constructions of Nationalism. Essays on the History and Ideology of European Musical Culture, 1800-1945* (Cork: Cork University Press, 2001).

25 Quoted in Jeffrey Richards, *Imperialism and Music: Britain, 1876-1953* (Manchester: Manchester University Press, 2001), 12.

26 Cf. generally Christoph Mährlein, *Volksgeist und Recht: Hegels Philosophie der Einheit und ihre Bedeutung in der Rchtswissenschaft* (Würzburg: Königshausen & Neumann, 2000). How the semantics of the neologism *Volksgeist* relates to the slightly older *Nationalcharakter* is an intriguing challenge to conceptual historians; in the usage of these decades, the two are by no means interchangeable. It should also be noted that as the term *Volksgeist* emerges, so does the notion of *Volkstum* (coined by Friedrich Ludwig Jahn in his book of that title, 1810), while Arndt in his *Geist der Zeit* pamphlets prepared the coinage of the parallel term *Zeitgeist*.

27 Edmund Burke, *Reflections on the Revolution in France*, ed. L. G. Mitchell (Oxford: Oxford University Press, 1993), 96–7.

28 For what follows, generally my '*Ossian* and the Rise of Literary Historicism', in *The Reception of Ossian in Europe*, ed. H. Gaskill (London: Continuum, 2004), 109–25 and 'Literary Historicism: Romanticism, Philologists, and the Presence of the Past', *Modern Language Quarterly* 65, no. 2 (2004): 221–43.

29 The best recent introduction is the biography by Steffen Martus, *Die Brüder Grimm: Eine Biographie* (Berlin: Rowohlt, 2010).

30 Wilhelm Schoof, ed., *Briefe der Brüder Grimm an Savigny* (Berlin: Erich Schmidt, 1953); for the continuing indebtedness, see Ruth Schmidt-Wiegand, 'Das Sinnliche Element des Rechts. Jacob Grimms Sammlung und Beschreibung Deutscher Rechtsaltertümer', in *Kasseler Vorträge in Erinnerung an den 200. Geburtstag der Brüder Jacob und Wilhelm Grimm*, ed. L. Denecke (Marburg: Elwert, 1987), 1–24. Also, my 'From Bökendorf to Berlin: Private Careers, Public Sphere, and how the Past Changed in Jacob Grimm's lifetime', in L. Jensen et al., eds., *Free Access to the Past: Romanticism, Cultural Heritage and the Nation*, 55–70.

31 Heinz Rölleke, 'Die Beiträge der Brüder Grimm zu "Des Knaben Wunderhorn" ', *Brüder Grimm Gedenken* 2 (1975), 28–42.

32 Maria Herrlich, *Organismuskonzept und Sprachgeschichtsschreibung. Die 'Geschichte der deutschen Sprache' von Jacob Grimm* (Hildesheim: Olms-Weidmann, 1998).

33 The idea that the language is not a general-human capacity but the cultural and intellectual DNA of each separate nation was formulated most forcefully by Wilhelm von Humboldt. Cf. Pierre Caussat, Dariusz Adamski, and Marc Crépon, eds., *La Langue Source de la Nation: Messianismes Séculiers en Europe Centrale et Orientale (du XVIIIe au XXe siècle)* (Sprimont: Mardaga, 1996).

34 From the huge body of literature on the topic I mention only Max Behland, 'Nationale und nationalistische Tendenzen in Vorreden zu wissenschaftlichen Werken', in *Nationalismus in Germanistik und Dichtung*, ed. B. von Wiese and R. Henß (Berlin: Schmidt, 1967), 334–46; Johannes Janota, *Eine Wissenschaft Etabliert sich, 1810-1870* (Tübingen: Niemeyer, 1980); Katinka Netzer, *Wissenschaft aus Nationaler Sehnsucht: Verhandlungen der Germanisten 1846 und 1847* (Heidelberg: Winter, 2006).

35 'Piety towards one's ancestors is the strongest bonding agent of a nation; of those who are mindful of the intellectual and scholarly standing of our country amidst other peoples, of all

those who, across the centuries of its history, cherish that 'sweet France' for which one was already prepared at Roncesvalles to die a good death.'

The original also contained the following passage: 'Nous faisons appel . . . à tous ceux qui aiment la France de tous les temps, à tous ceux qui croient qu'un peuple qui répudie son passé prépare mal son avenir, et à tous ceux qui savent que la conscience nationale n'est pleine et vivante que si elle relie dans un sentiment profond de solidarité les générations présentes à celles qui se sont éteintes.' Quoted in Charles Ridoux, *Évolution des Études médiévales en France de 1860 à 1914* (Paris: Champion, 2001), 410 and 425.

36 Dirk van Hulle and Joep Leerssen. eds., *Editing the Nation's Memory: Textual Scholarship and Nation-Building in 19th-Century Europe* (Amsterdam: Rodopi, 2008).

37 'Of the three poetic genres, none is more difficult to judge than the epic. For lyrical poetry, arising as it does out of the human heart itself, turns directly to our feelings and is understood from all periods in all periods, and dramatic poetry attempts to translate the past into the frame of reference—the language, as it were—of the present, and cannot fail to impress us when it succeeds. But the case is far different with epic poetry. Born in the past, it reaches over to us from this past, without abandoning its proper nature, and if we want to savor it, we must project ourselves into wholly vanished conditions.' Jacob Grimm, 'Über das finnische Epos', in *Kleinere Schriften*, vol. 2 (Berlin: Dümmler, 1865), 75.

38 Generally on this topic, see my 'Oral epic: The Nation Finds a Voice', in *Folklore and Nationalism during the Long Nineteenth Century*, ed. T. Baycroft & D. Hopkin (Leiden: Brill, 2012), 11–26.

39 Jean-Yves Guiomar, 'Le Barzaz-Breiz de Théodore Hersart de la Villemarqué", in *Les Lieux de Mémoire*, ed. Pierre Nora, vol. 3 (Paris: Gallimard, 1997), 3479-514. Gaela Keryell, 'The "Kalevala" and the "Barzaz-Breiz": The Relativity of the Concept of "Forgery" ', in A. Ahlqvuist et al., eds., *Celtica Helsingiensia: Proceedings from a Symposium on Celtic Studies* (Helsinki: Societas Scientiarium Fennica, 1996), 57-104. Edward L. Keenan, *Josef Dobrovský and the Origins of the Igor Tale* (Cambridge, MA: Harvard University Press, 2001). Also: Mary-Ann Constantine, *The Truth against the World: Iolo Morganwg and Romantic Forgery* (Cardiff: University of Wales Press, 2007).

40 Ann Rigney, *Imperfect Histories: The Elusive Past and the Legacy of Romantic Historicism* (Ithaca, NY: Cornell University Press, 2001). Id., *The Afterlives of Walter Scott: Memory on the Move* (Oxford University Press, 2012).

41 Monika Baár, *Historians and the Nation in the Nineteenth Century: The Case of East-Central Europe* (Oxford: Oxford University Press, 2010); Stefan Berger, M. Donovan and K. Passmore, eds., *Writing National Histories. Western Europe since 1800* (London: Routledge, 1999). Stefan Berger and Chris Lorenz, eds., *Nationalizing the Past: Historians as Nation Builders in Modern Europe* (Basingstoke: Palgrave Macmillan, 2008). Dennis Deletant and Harry Hanak, eds., *Historians as Nation-Builders. Central and South-East Europe* (London: Macmillan / School of Slavonic and East European Studies, 1988).

42 Ann Rigney, *The Rhetoric of Historical Representation: Three Narrative Histories of the French Revolution* (Cambridge, MA: Cambridge University Press, 1990). Boris Réizov, *L'historiographie Romantique Française, 1815-1830* (Moscou: Editions en Langues Étrangères, 1962).

43 Françoise Baudson, *Le Style Troubadour* (Bourg-en-Bresse: Brou, 1971). Sam Smiles, *The Image of Antiquity: Ancient Britain and the Romantic Imagination* (New Haven, CT: Yale University Press, 1994).

44 A similar trajectory from classicist to nationalist we can notice in the literary genre that pre-
cedes the historical novels and runs alongside that of the history painting: the historical drama.
While Home's *Douglas* is an early example of a national-historical tragedy, the non-classical trag-
ic heroes that Goethe and Schiller choose for their Weimar period, while they may be nationally
German (Götz von Berlichingen and, at a pinch, Wallenstein and Wilhelm Tell), can as easily
be from other parts of Europe: Jeanne d'Arc, Egmont. However, post-Schiller playwrights like
Adam Oehlenschläger and even the early Ibsen use the theatre to bring, specifically, the nation's
own past 'back to life'.

45 The case of Belgium has been covered by Judith Ogonovsky: 'La Peinture Monumentale,
"Manière Parlante d'Enseigner l'Historie Nationale" ', in *Les Grands Mythes de l'Histoire de Bel-
gique, de Flandre et de Wallonie*, ed. A. Morelli (Bruxelles: Vie ouvrière, 1995), 163–74. Id., *La Peinture
Monumentale d'Histoire dans les Édifices Civils de Belgique (1830–1914)* (Brussel: Académie royale de
Belgique, 1999). The case of Germany emerges from the in-depth study of the Goslar murals
by Monika Arndt, *Die Goslarer Kaiserpfalz als Nationaldenkmal: Eine ikonographische Untersuchung*
(Hildesheim: Lax, 1976). Further: Alice Laura Arnold, 'Poetische Momente der Weltgeschichte:
Die Wandbilder im Schloss Hohenschwangau', doctoral thesis (München: Ludwig-Maximilians-
Universität, 2006); Reinhold Baumstark and Frank Büttner, eds., *Großer Auftritt: Piloty und die
Historienmalerei* (München: Pinakothek-Dumont, n.d.). Julius Fekete, *Carl von Häberlin (1832-1911)
und die Stuttgarter Historienmaler seiner Zeit* (Sigmaringen: Thorbecke, 1986). Gabriella Szvoboda
Dománszky *Régi Dicsőségünk: Magyar Históriai Képek* a XIX. *Században* (Budapest: Corvina, 2001).
Michael Huig, 'Tot eer van Bohemen: De verbeelding van nationale geschiedenis, circa 1789-
1848', doctoral thesis, 2 vols. (Amsterdam: Universiteit van Amsterdam, 2005). David Jackson and
Patty Wageman, eds., *Akseli Gallen-Kallela: The Spirit of Finland* (Rotterdam: NAi Publishers, 2006).
Karl Koetschau, *Alfred Rethels Kunst vor dem Hintergrund der Historienmalerei seiner Zeit* (Düssel-
dorf: Kunstverein für die Rheinlande und Westfalen, 1927). Doris Lehmann, *Historienmalerei in
Wien: Anselm Feuerbach und Hans Makart im Spiegel Zeitgenössischer Kritik* (Köln: Böhlau, 2011). Peter
Murray, ed., *Daniel Maclise (1806-1870): Romancing the Past* (Cork: Crawford Art Gallery and Gan-
don Editions, 2008). Barbara Rommé, *Moritz von Schwind – Fresken und Wandbilder* (Ostfildern-
Ruit: Hatje, 1996). Marie Schäfer, 'Historienmalerei und Nationalbewusstsein in Russland 1860-
1890', doctoral thesis (Köln: U zu Köln, 1985). Franz Zelger, *Heldenstreit und Heldentot: Schwei-
zerische Historienmalerei im 19. Jahrhundert* (Zürich: Atlantis, 1973). Ursula Ziem, 'Die Spanische
Historienmalerei des 19. Jahrhunderts', doctoral thesis (Stuttgart: Stuttgart University, 2007).

46 I mention in passing the vogue of engravings and book illustrations as intermedial visualiza-
tions of the past; cf. Adolf Bär and Paul Quensel's 1890 *Bildersaal Deutscher Geschichte: Zwei
Jahrtausende Deutschen Lebens in Wort und Bild, mit 483 Abbildungen und 48 Kunstbeilagen nach Origi-
nalen Hervorragender Künstler* (reprint Wiesbaden: Marix, 2004), and Tom Verschaffel, *Beeld en
Geschiedenis: Het Belgische en Vlaamse Verleden in de Romantische Boekillustraties* (Turnhout: Brepols,
1987).

47 On the national function of public monuments in these decades, most analyses follow Thomas
Nipperdey's path-breaking article 'Nationalidee und Nationaldenkmal in Deutschland im 19.
Jahrhundert', *Historische Zeitschrift* 206 (1968): 529–85. Also, Maurice Agulhon, 'La "Statuomanie"
et l'Histoire', in Id., *Histoire Vagabonde I: Ethnologie et Politique dans la France Contemporaine* (Paris:
Gallimard, 1988), 137–85.

48 Also – and this is a point hitherto perhaps insufficiently noted in Scott studies – Scott, a law-
 yer himself, is continually at pains to stress the fact that Scotland maintained, even after the
 Unions of the Crowns and of the Parliaments, its own legal system. The constant undercurrent
 of legal references in the Waverley Novels, when read in the light of Savigny-style legalistic or-
 ganicism and historicism, show (I submit) that Scott firmly claimed an autonomous, subsidiary
 but never subaltern, status for Scotland within the British context.

49 John Prebble, *The King's Jaunt: George IV in Scotland, August 1822. 'One and twenty daft days'* (Edin-
 burgh: Birlinn, 1996).

50 Murray Pittock, ed., *The Reception of Sir Walter Scott in Europe* (London: Continuum, 2007).

51 Walter Gobbers, 'Consciences *Leeuw van Vlaenderen* als Historische Roman en Nationaal Epos:
 Een Genrestudie in Europees Perspectief', in A. Deprez and W. Gobbers, eds., *Vlaamse Literatuur
 van de Negentiende Eeuw. Dertien Verkenningen* (Utrecht: HES, 1990), 45-69.

The Concept
of Pop...

THE CONCEPTION OF POPULARITY IN THE ENLIGHTENMENT AND ROMANTICISM

GÜNTER OESTERLE

TRANSLATED BY LAURA ZIESELER

[ABSTRACT]

It can hardly be disputed that the theme of popularity is central to the Enlightenment. Popularity is the sociality equivalent to the individual appeal: 'Dare to know.' Parallel to this runs the following imperative: 'Dare to encourage your neighbour and your fellow man and woman to think on their own – even though they do not belong to the erudite elite.' It is also undeniable that Romantic authors and philosophers polemically attempted to tear down the popularity project of the Enlightenment, their main criticism being its tendency towards mediocrity. It is less well known that Romantic authors and philosophers themselves, around the turn of the nineteenth century, made popularity their central concern. To quote Friedrich Schlegel in the journal *Athenaeum:* 'The time of popularity has come.' This article explores the Romantics' alternative conception of popularity, with especial reference to Johann Gottlieb Fichte and the Grimm brothers. To this end, it is helpful to reconstruct the background of the Romantic attempt to create an independent concept of popularity: the debate between Immanuel Kant and the German popular philosopher Christian Garve on the necessity, possibilities, and limits of popularity.
.

KEYWORDS *Kant, Garve, Fichte, F. Schlegel, Grimm.*

By choosing to view the constellation of the Enlightenment and Romanticism exclusively as a binary opposition, the range of each term is narrowed down considerably, while the complex relationship between continuity and discontinuity is reduced. Conversely, by underexposing the difference between the Enlightenment and Romanticism, one important finding can be easily overlooked: the insight into the selectivity of a paradigm shift around 1800.

However, the following consideration may help to elude this predicament between either narrowing down the focus by overstressing the differences between the Enlightenment and Romanticism or diluting them by underexposure: In conjunction with the call for independent thought and autonomy, Romanticism can be seen as the sometimes problematic attempt at a second, more radical Enlightenment. From such a perspective, Romanticism addresses the immanent contradictions, exclusions and dogmas of the first Enlightenment and tries to

Günter Oesterle, Emeritus Professor of modern German literature, Justus-Liebig University Giessen
Aarhus University Press, *Romantik*, 02, 2013, pages 37-52

deconstruct them or at least to expand and complete them, thereby naturally creating its own new dogmas, contradictions, and exclusions.

Such a view of the constellation of the Enlightenment and Romanticism distances itself from the traditional hermeneutic-harmonic model of a 'dialogue of the ages' which merely deals with questions and responses. Instead, it pays at least equal attention to the destructive, polemic energies of knowledge. Not only did Romantic authors and philosophers address the questions which had been left unanswered by the Enlightenment and suggest their own solutions, they also positively zeroed in on the *aporias*, exclusions, and taboos of the Enlightenment. They were determined to go beyond the boundaries of that era in order to continue the Enlightenment in a highly idiosyncratic manner. Such a perspective on two different forms of Enlightenment with their respective achievements and *aporias* enables the modern reader to create historical distance and precision. The problem of popularity provides a case in point of the Romantic tendency to continue, through deconstruction, the Enlightenment.

It can hardly be disputed that popularity is one of the central themes of the Enlightenment. Popularity is the 'sociality' equivalent to the individual appeal: '*Habe Mut, dich deines eigenen Verstandes zu bedienen*' [dare to know] – and it goes as follows: Dare to encourage your neighbour, colleague and your fellow man and woman to think on their own.[1] Through this collective appeal, the tenet of the Enlightenment – that man has a universal capacity for rational thought – is put to practical use. It is the call for everyone to engage in universal and public reasoning about the affairs of human society. *Everyone*, even if they lack expert knowledge or have not undertaken prolonged studies; *everyone* regardless of social status or class, as long as they are eager to learn, unafraid to think, given to observation and open to new experiences and to sharing them with others.[2] The Enlightenment's conception of popularity is a universal concept with utopian tendencies.

It is equally undisputed that the Romantic authors and philosophers tried polemically to deconstruct this conception of popularity preferably with regard to its specification in popular philosophy. It is those authors and philosophers this article will focus on. They mainly reproach the Enlightenment's conception of popularity with having a tendency to foster mediocrity. To quote Friedrich Schlegel: '*Der Ahriman des Zeitalters ist die Mediokrität; Garve und Nicolai dürften es bis zur Religion dahin gebracht haben. Voß und Wieland für Poesie. Matthison in der Nullität*' [The Ahriman of that age is mediocrity; Garve and Nicolai have arguably made it their religion. Voß and Wieland did the same for poetry. Matthison in nullity].[3]

Among other things, the shrill polemics against the conception of popularity within popular philosophy has led to both non-academics and academics labelling Romanticism as elitist, avant-garde, exotic and sinister rather than as popular. This view is exemplified by the last statement of an article on popular philosophy in the *Lexikon der Aufklärung* [Encyclopaedia of the Enlightenment]. It says: Popular philosophy '*wurde sehr bald von J. G. Fichte, der einen "neuen vornehmen Ton" in die Philosophie einführte und seinen Schülern überholt*' [was soon made

obsolete by J. G. Fichte and his disciples who introduced a 'new refined tone' into philosophy].[4] According to this summary, philosophy *'wurde wieder einmal elitär und antipopulär'* [once again became elitist and anti-popular].[5] In contrast to this prejudice, Friedrich Schlegel formulates the following programmatic thought in the magazine *Athenaeum* published by himself and his brother in 1799: *'die Zeit der Popularität ist gekommen'* [the time of popularity has come].[6] Correspondingly, he states in the 1803 edition of his magazine *Europa* that the philosopher Fichte was *'gegenwärtig am meisten'* [currently most] interested *'für die literarische Form'* [in literary form] and hence in popularity.[7] In *Athenaeum*, F. Schlegel had already presented Fichte as an important role model for popular philosophical writing. Having declared his intention *'die Schriften des berühmten Kant, der so oft über die Unvollkommenheit seiner Darstellung klagt, durch Umschrift verständlich zu machen'* [to rewrite the texts of the famous Kant, who himself often deplores the imperfection of his descriptions, in order to make them more intelligible],[8] he goes on to write in his essay 'Über Philosophie' [On Philosophy]:

Bei Fichte wäre ein solches Verfahren sehr überflüssig. Noch nie sind die Resultate der tiefsten und wie ins Unendliche fortgesetzten Reflexion mit der Popularität und Klarheit ausgedrückt [worden]. . . . Es ist mir interessant, dass ein Denker, dessen einziges großes Ziel die Wissenschaftlichkeit der Philosophie ist, und der das künstliche Denken vielleicht mehr in seiner Gewalt hat, als irgendeiner seiner Vorgänger, doch auch für die allgemeinste Mitteilung so begeistert sein kann. Ich halte diese Popularität für eine Annäherung der Philosophie zur Humanität im wahren und großen Sinne des Worts, wo es erinnert, dass der Mensch nur unter Menschen leben, und so weit sein Geist auch um sich greift, am Ende doch dahin wieder heimkehren soll. Er hat auch hierin seinen Willen mit eiserner Kraft durchgesetzt, und seine neuesten Schriften sind freundschaftliche Gespräche mit dem Leser, in dem treuherzigen, schlichten Style eines Luther'

[Such a procedure would be highly unnecessary with regard to Fichte's work. Never before have the results of the most profound and virtually infinite reflection been expressed with such popularity and clarity. . . . I find it intriguing that a thinker whose sole major purpose is the scientific nature of philosophy and whose mastery of abstract thinking probably surpasses that of all of his predecessors can nevertheless find enthusiasm for the most common of messages. I consider this popularity to be philosophy's approach to humanity in the truest sense of the word – reminding us that man can only live among men and that eventually, he will always return home to their company, regardless of how far his mind may reach. He [Fichte] has been adamant to make his point in this regard as well, and his latest texts are friendly conversations with the reader in the trusting, plain style of Luther.][9]

It seems obvious: During Romanticism, popularity is at least as emotionally charged and imperative as it was during the Enlightenment.[10] Friedrich Schlegel writes: *'[I]st es die Bestimmung des Autors, die Poesie und die Philosophie unter die Menschen zu verbreiten und für's Leben und aus dem Leben zu bilden: so ist Popularität seine erste Pflicht und sein höchstes Ziel'* [If it is the author's vocation to create poetry and philosophy from life and with life in mind and to spread them among his fellow men: then popularity is his first duty and his highest aim].[11]

However, Romanticism only deserves to be called an attempt at a second Enlightenment if it manages the Herculean task of popularising an esoteric, avant-gardiste, non-empirical way of thinking and writing as a more radical, autonomous way of thinking.

Thus, the structure of this article can be outlined as follows:

1. Sketching out the universal concept of popularity as conceived by popular philosophy – predominantly with regard to the explosiveness of the controversial discussion between Garve and Kant about the limits of popularity within philosophy.
2. Reconstructing the relentless, polemical way in which this concept of popularity was analysed by the Romantic authors and philosophers – and to extrapolate their Romantic alternative.

The Universal Concept of Popular Philosophy and its Limits

Even in its specific form within popular philosophy, the concept of popularity during the Enlightenment is a universal one. This means that it has become effective and left its mark *'in jedem auch noch so untergeordneten Kreise des Lebens'* [in every sphere of life, no matter how subordinate],[12] in communication, in the circulation of knowledge, in the habitus, in the style of thinking, writing, and living. The first and accentuating achievement of popular philosophy was to liberate the arts and philosophy from the ghetto of a business run by specialists and experts as it had been established by scholarly philosophy. Consequently, this led to the focus being shifted from logic epistemology and metaphysics to moral philosophy, psychology, anthropology, and new aesthetics, i.e. to empirical sciences and worldly philosophy. Secondly, popular philosophy makes experiences accessible by creating methods for observation. Its lasting socio-political merit is to have cultivated the art of assuming multiple viewpoints and multiple perspectives in conversations, essays, and historiographical writing. Its specific achievement is the invention of the high art of reasoning, i.e. of turning and weighing different arguments this way and that, and of having them scrutinised by many parties. A new habitus, new media (*inter alia* journals), new ways and formats of presentation and new mediators as well as a tone of writing and speaking (the so-called conversational tone) which until then had only been reserved for the elite – they all came to serve as a role model and tended to become part of common knowledge. When a new scholarly discipline, aesthetics, emerged around the middle of the 18th century, scholars started to be criticised as pedantic.[13] They were no longer supposed to educate themselves as specialists, but rather to practise ways of elegant and open communication. Parallel to economic theories, urban ways of life were created in order to link and practise the circulation of knowledge and the know-how of certain ways of speaking and writing. Ramdohr demands: '[D]ie Gelehrten, die schönen Geister und die Künstler müssen Vereinigung-Punkte haben, wo sie . . . besonders mit Welt- und Hofleuten zusammenkommen, und dabei laut sprechen und

glänzen können. Von dort aus geht dann der Stoff an Hof und Stadt, wird durchgeknetet und zur Speise für jedermann zubereitet' [Scholars, poets and artists need to have a common ground where they . . . can convene first and foremost with cosmopolitans and courtiers, and where they can speak freely and scintillate with their wit. From there, the subject matters of their discussions reach the court and the city, where they are kneaded and turned into a palatable meal for everybody].[14] Such social gathering points existed in a plethora of variations. They ranged from municipal reading societies to the reading circles of rural nobility and exchanged their ideas via popular science journals (mostly emerging in the wake of English morality weeklies) which had a similar aim of changing general habits. 'Fictitious' authorship provided creative freedom including 'letters', 'dreams' and 'anecdotes' and thus presented the programme of a happy union of *entertainment and education*.[15] Gottfried August Bürger claims that *'alle Poesie soll volksmäßig sein'*[16] [all kinds of poetic work ought to be popular], that is *'den mehrsten aus allen Klassen anschaulich und behaglich'* [intelligible and pleasing to the majority of every class].[17] This is achieved when *'sogleich alles unverschleiert, blank und bar, ohne Verwirrung, in das Auge der Phantasie springe'* [everything immediately catches the reader's imagination in an unvarnished, bare, simple and unconfused fashion].[18] 'Popular philosophy' during the age of Enlightenment deepens and broadens these ambitions by reflecting on the feasibility of a *'Lebhaftigkeit der Darstellung'* [vividness of depiction], i.e. a pointed way of writing under a salient perspective or a *'Unterscheidung zwischen Dialog und Erzählung'* [distinction between dialogue and narration].[19] In his *Logik*, Immanuel Kant states that *'[e]in populärer Vortrag verlangt über die logisch-begriffliche Deutlichkeit hinaus lebendige Bilder, Beispiele in concreto und also ästhetische Deutlichkeit'* [on top of logical and terminological clarity, a popular disquisition needs vivid images, concrete examples and hence aesthetic clarity].[20] The thesis *'Popularität solle nicht sowohl die Gegenstände bezeichnen, welche man behandelt, als die Art und Weise wie man sie behandelt'* [popularity ought not to refer to the objects treated, but rather to the way in which they are treated] aims at the standard of an educated, common language.[21] In this context, it is hard to overstate the importance of the fact that the German popular philosophers often looked across the borders towards England and France.

During the Enlightenment, popular philosophy gained greater currency thanks to the discussion between Christian Garve and Immanuel Kant about the limits of popularity within philosophy. This discussion turns the Enlightenment into an experimental playground. In July and August 1783, it reaches a high-watermark in two letters exchanged between the rivals. Ten years later – in 1793 – it obtains its final form in Garve's balanced reasoning in his essay *Von der Popularität des Vortrags* [On the popularity of the disquisition]. Garve and Kant's two letters demonstrate what has already been stated earlier in this article (on an intermediate level of abstraction) about the achievement of popular philosophy: First of all, it is noteworthy that the two scholars and authors held each other in high regard (the letter exchange was occasioned by a slating public review of *Kritik der reinen Vernunft* [Critique of Pure Reason] and Kant's call for the

anonymous critic to reveal himself to the public). This makes the importance of transparency and clarity within their argumentation understandable. However, one particularly admirable aspect of those letters is the authors' circumspect approach and their willingness to qualify their own judgements. '*Aber das ist auch jetzt noch meine Meynung vielleicht eine irrige*' [However, this is my opinion and it may be mistaken], Garve writes before going on to formulate his imperative of the universality of popularity.[22] What makes those two letters genuine gems is the formidable sincerity with which the two scholars make references to the state they are in at the time of writing, up to and including the situation in which they are writing (e.g. while on a journey). Garve confesses his reluctance with regard to the cumbersome and unintelligible nature of Kant's text:

Ich will das nicht ganz von mir ableugnen . . . dass [ich] über den Schwierigkeiten . . . unwillig geworden sei. Ich gestehe, ich bin es zuweilen geworden; weil ich glaubte, es müsse möglich sein, Wahrheiten, die wichtige Reformen in der Philosophie hervorbringen sollen, denen welche des Nachdenkens nicht ganz ungewohnt sind, leichter verständlich zu machen

[I cannot completely deny . . . that the difficulties made [me] reluctant. I have to admit that sometimes this was the case; because I believed that it had to be possible for truths aimed at reforming philosophy to be made more intelligible for those not entirely unaccustomed to reflection.][23]

And Kant? He is the paragon of commitment: In his turn, he responds to those 'in ihrem geehrten Schreiben deutliche Beweise einer pünktlichen und gewissenhaften Redlichkeit und einer menschlichen teilnehmenden Denkungsart' [clear proofs of a punctual and conscientious integrity and a human, compassionate way of thinking in your revered letter][24] with a confession providing insight into his life story as a scholar.

Auch gestehe ich frei, dass ich auf eine geschwinde günstige Aufnahme meiner Schrift gleich zu Anfangs nicht gerechnet habe; denn zu diesem Zwecke war der Vortrag der Materien, die ich mehr als zwölf Jahre hintereinander sorgfältig durchgedacht hatte, nicht der allgemeinen Fasslichkeit gezwungen angemessen ausgearbeitet worden, als wozu noch einige Jahre erforderlich gewesen wären, da ich hingegen in etwa vier bis fünf Monate zu Stande brachte, aus Furcht, ein so weitläufiges Geschäft würde mir, bei längerer Zögerung, endlich selber zur Last werden und meine zunehmenden Jahre (da ich jetzt schon im sechzigsten bin) möchten es mir, der ich jetzt noch das ganze System im Kopf habe, zuletzt vielleicht unmöglich machen

[I must also freely confess that I had not expected my text to be quickly and well received initially; since the disquisition of the subject matters which I had given careful thought to for more than twelve years had not been composed so that it could be commonly understood – a task which would have required several additional years; instead I completed it in just four to five months, fearing that such a comprehensive endeavour would eventually become a burden if I hesitated too long, and that my increasing age (seeing as I am already 60 years old) may eventually prevent me from writing down the entire system which as of now is still fresh in my mind].[25]

Embedded in this mutual tone of considerate conversation, there is nevertheless Garve's unequivocal and plain call '*dass das Ganze Ihres Systems, wenn es wirklich brauchbar werden soll, populärer ausgedrückt werden müsse, und es Wahrheit enthält, auch ausgedrückt werden könne; und dass die neue Sprache, welche durchaus in demselben herrscht, so großen Scharfsinn auch der Zusammenhang verrät, in welchen die Ausdrücke derselben gebracht worden, doch oft die in der Wissenschaft selbst vorgenommenen Reform oder die Abweichung von den Gedanken anderer, noch größer erscheinen machen als sie wirklich sind*' [for the entirety of your system to be expressed in a more popular manner, should it really be put to use – which ought to be possible as long as it contains truth; and that the new language of this system, however perspicacious the context in which its terms are used, often makes the scholarly reform or the idiosyncrasy of the expressed ideas appear larger than they actually are].[26]

In his multi-tiered reply, Kant first acknowledges the legitimacy of a call for popularity although he deems it to be absolutely unobtainable when it comes to unfolding the principles of epistemology.[27] Secondly, Kant asks for the creators of an entirely new system (which cannot avoid introducing new terminology) to be given licence to initially present the system '*als Ganzes*' [as a whole] '*in einer gewissen Rohigkeit*' [in a somewhat rough state] '*eine Zeitlang*' [for a certain time]. He hopes that the author himself may afterwards 'explain' and popularise his work piece by piece, in detail and with the help of others (through a '*vereinte Bemühung*' [common effort]) so that the '*erste Betäubung*' [initial stunning effect] '[*die] eine Menge ganz ungewohnter Begriffe und einer noch ungewöhnlicheren Sprache, hervorbringen musste . . . verlieren wird*' [engendered by a plethora of quite unfamiliar terms and an even more unfamiliar language . . . will subside] (an argument Friedrich Schlegel would return to in his essay 'Über Unverständlichkeit' [On unintelligibility]).[28]

Despite his confidence that popularity will gain ground in difficult areas of philosophy, Kant, having weighed all options, still remains sceptical with regard to the attention level of the '*geschmackvolleren Publikums*' [more tasteful audience].[29]

According to him, the '*herrschende Geschmack dieses Zeitalters*' [prevailing taste of the age] does not really support such an endeavour: '[*D]as Schwere in speculativen Dingen als leicht vorzustellen (nicht leicht zu machen)*' [to present the difficult nature of speculative matters in a simple way (not to simplify them)].[30]

In hindsight, it can be said that in his reasoning and considerations regarding both the necessity and the virtually insurmountable difficulty of achieving a truly 'popular' philosophy, Kant does offer many new points of departure. The authors and philosophers of Romanticism endorse Kant's *Zeitgeist* diagnosis that an increasing general power of judgement in the area of empirical knowledge has resulted in the already low number of people interested in speculative thought becoming even lower. In his essay on Forster, Friedrich Schlegel returns to Kant's sceptical statement that '*eigentliche Philosophie*' [philosophy proper] '*nicht für jedermann sei*' [is not for everybody].[31] And yet, in the middle of the contemporary '*Sandwüste*' [sand desert] of speculative thought, the Romantic philosophers set

themselves the Herculean task of presenting the difficult nature of speculative matters in a simple manner (as opposed to simplifying them).[32] For his part, the popular philosopher Garve revisits the difference between the genesis and the ensuing validity of a new system of thought, an aspect of creative theory Kant had addressed in his response letter. In his essay *Von der Popularität des Vortrags* [On the popularity of the disquisition] (1793), Garve reflects on exceptions from popularity and the ensuing efforts of reintegration necessary for his universal call for popularity to be eventually met. His argumentation is as follows: An inventor cannot be popular since he is forced to assume his own, highly individual point of view that goes against the grain of established knowledge. Rather, he needs to position himself outside the box of 'common sense' in order to arrive at '*ungewöhnliche Folgerungen und Ideenverknüpfungen*'[33] [extraordinary conclusions and connections of thought]. Only if this invention has been '*getrennt*' [separated] '*von der bloß subjectiven Form des ersten Erfinders*' [from the merely subjective form it had been given by the original inventor], '*gesäubert*' [cleaned] and '*abgeschliffen*' [polished], i.e. once it has been de-individualised and made '*objektiv*' [objective] afterwards in a common effort, this invention can be presented in a popular way '*zu größerer Brauchbarkeit*' [with more practicality] and more '*Geschmeidigkeit*' [elegance].[34]

Criticism of the Conception of Popularity During the Late Enlightenment and the Presentation of a Romantic Alternative

This separation of genesis and validity, of the 'dark workshop of thinking' and the polished result, of professional work and presentation, provokes the Romantics' critical and polemic energy. To the Romantic authors, such a dissociation of innovation and popularisation ('*Wenn der Geist der Innovation aufhört, kann die Popularisierung beginnen*' [popularisation begins where the spirit of innovation ends]) bears witness to how the high good of popularity is degraded to a mere instrument, a vehicle and a rhetorical veil.[35] For them, '*das allmähliche Verfertigen des Gedankens*' [the gradual development of thought] – i.e. genetic speaking and writing becomes one of the possible roads to popularity. In terms of creative theory, Garve concedes that innovation can only be obtained if we '*unserer Eigenheit mehr nachgebe[n] und daher sich um das Publikum wenig kümmer[n]. Die Denkkraft wird geschwächt, wenn ihr Zwang angetan wird: und unsere Bemühungen unsere Gedanken deutlich zu machen, ist eine Art Zwang*' [give more room to our individuality and in turn care little about the audience. Coercion only weakens the power of thought: and our efforts to clarify our thoughts are a kind of coercion]. It is this concession that the Romantic authors pounce upon in a bid to solve the predicament of innovation and popularity. In his essay on Lessing, Friedrich Schlegel suggests that all '*Interesse der öffentlichen Mitteilung*' [interest in informing the public] should be abandoned (since it in any case merely fuels the vanity of authors) in exclusive favour of the study of the matter itself, irrespective of public interest.[36] In doing

so, i.e. by capturing the matter in a most individual manner, the author may in turn captivate his potential recipient. Certain styles of writing lend themselves particularly well to such reciprocal inspiration– for example the essay: '*Der Essay ist ein wechselseitiger Galvanismus des Autors und des Lesers und auch ein innerer für jeden allein; systematischer Wechsel zwischen Lähmung und Zuckung. – Er soll Motion machen, gegen die geistige Gicht ankämpfen, die Agilität befördern*' [The essay is a reciprocal galvanism between the author and the reader, as well as an inner galvanism for every person on their own; a systematic change between paralysis and twitching. – It is meant to cause motion, to battle ossification of the mind, to encourage agility].[37] As a consequence, Friedrich Schlegel diagnoses a '*Tendenz unseres Zeitalters, alle Wissenschaften zu essayiren*' [tendency of our age to cast all scholarly thought into essays].[38]

In his essay on Forster, Friedrich Schlegel revisits Kant's sceptical observation that the popularisation of speculative systems of thought was difficult at the time, and proceeds to apply it to the fine arts. Simultaneously, Schlegel gives a positive and productive spin to the power of popularity in terms of fine arts and speculative philosophy, which he regards as the result of division of labour. From this position, he presents Georg Forster as an example of what a decidedly 'social' popular author may look like. Schlegel contends that, unlike the micrology of popular philosophy (which Schleiermacher characterises or rather mocks as '*Anmerkungsphilosophie*' [annotative philosophy])[39] Forster's work is marked by the far-sighted and globally-oriented author's ability to find concrete terms for experience and vision, entity and detail, urbanity, and virtue. Thus, Friedrich Schlegel has valid and forward-looking legal reasons[40] to note: '*Die Popularität [ist] ganz eigentlich Prinzip der Autorschaft*' [In essence, popularity is the principle of authorship].[41]

Academics have asserted the importance of Fichte's disquisitions on the *Bestimmung des Gelehrten* [Vocation of the scholar] for Schlegel's concept of a '*gesellschaftlichen Schriftstellers*' [social author].[42] It is hard to overstate the importance of Fichte's contribution to the conceptualisation of Romantic popularity. For Fichte has removed the pitfalls of the asymmetrical communication structure usually inherent in popularity, with its linear top-down transfer from the expert to the layman.[43] He did so by liberating the listeners and readers from their subordinate position and 'constructing' them as future, forward-looking recipients on an equal footing with the author.

Fichte's disquisition 'Über die Bestimmung des Gelehrten' caught the imagination of his contemporary readers and listeners. It was ground-breaking and formative since it transmuted what had hitherto been conceived of as static knowledge into dynamic knowledge transformation capable of producing new, future-oriented ideas.[44] The scholar is presented as a leading role-model in society. His analytical diagnosis of the present enables him to design action-changing options with a view to the future, instead of merely accumulating knowledge or at best re-organising it and putting it into perspective (Fichte speaks of '*Eingreifen gewaltig ins Rad der Zeit*' [changing the course of history]).[45] According to Fichte,

scholars ought to create and 'construct' new and forward-looking thoughts 'genetically' from the inner '*Wurzel seines Lebens*'[46] [root of their lives]. Since these ideas are entirely new and futuristic, they cannot possibly be accounted for by experience and observed accordingly;[47] it takes an equally new, visionary listener and reader which the author Fichte constructs 'a priori' – and a style which (regardless of all effort) essentially cannot be created willingly and intentionally. Fichte provides an elaborate description of how realisation '*in den von ihr ergriffenen und als Eigentum besessenen Menschen . . . hervorbricht*' [wells up in the individuals it captures and possesses].[48] This is the source of the Romantic concept of popularity, the 'point' at which, in Fichte's words, '*der Gelehrte übergeht in den freien Künstler*' [the scholar becomes a liberal artist], '*[der] Punkt der Vollendung des Gelehrten*'[49] [the point of the scholar's completion]. He continues:

Wenn der Philosoph eine Idee in allen ihren einzelnen Bestandteilen Schritt für Schritt zerlegt . . . so geht er den Weg der methodischen Mitteilung. . . . Gelingt es ihm nun etwa noch zum Beschlusse das Ganze in seiner absoluten Einheit in einen einzigen Lichtstrahl zu fassen, der es wie ein Blitz durchleuchte und abgesondert hinstelle, und jeden verständigen Hörer oder Leser ergreife, dass er ausrufen müsse: ja, wahrhaftig, so ist es, jetzt sehe ich es mit einem Male ein: so ist dies die Darstellung der aufgegebenen Idee in ihrer unmittelbaren Anschaulichkeit, oder die Darstellung desselben durch den Witz: und hier zwar durch den direkten, oder positiven Witz [By dissecting an idea step by step, the philosopher follows the path of methodical information. . . . If then, upon concluding his work, he succeeds in capturing that idea in its absolute entity as in a single ray of light, illuminating it like lightning, setting it apart and moving every intelligent listener and reader to cry out: yes indeed, this is it, now it all makes sense: then, this idea has been presented in its immediate clarity, or through wit: that is, through direct or positive wit].[50]

This is not a description of simple intuition. Only at the conclusion of a complex methodical, incremental deduction can the licence and the commandment of an evidential image be formulated. It is the aim of every Romantic call for popularity to create such evidential images – in philosophy, in polemics and in poetry particularly in the genres of the song, the fairy tale and the saga. With its reflections on the '*An- und Umbilden*' [imagination and re-imagination] of existing texts, the conception of a 'New Mythology' seeks to create novel, impressive images from traditional myths and legendary topics.[51] Clemens Brentano's *Loreley* is a successful, popular attempt to relocate the Siren myth from Greek mythology to the Rhine legend. By the same token, the Brothers Grimm's concept of popularity also makes use of evidential images. Obviously, unlike Fichte's, these images do not spring from high pathos, but rather from their closeness to the '*simplicitas majestatis*' usually reserved for biblical texts. From this perspective, the poetic fairy tale is self-evident, necessary, its existence uncontroversial; neither does it need to be defended, nor is it necessary to employ rhetoric in order to convince others of its value. Its existence provides its evidence: *fiat lux*. This conviction is clearly witnessed by a quote from the prologue to the Brothers Grimm's fairy tales: '*Wir wollen in gleichem Sinne diese Märchen nicht rühmen oder gar gegen entgegengesetzte Mei-*

nung verteidigen: ihr bloßes Dasein reicht hier, sie zu schützen. Wer so mannigfach und immer wieder von neuem erfreut, bewegt und belehrt hat, trägt seine Notwendigkeit in sich und ist gewiss aus jener ewigen Quelle gekommen, die alles Leben betaut' [By the same token, we do not intend to glorify these fairy tales, let alone defend them against opposed opinions: by their mere existence they are sufficiently protected. Things which time and again and in so many ways spread joy, move the heart of men and educate their minds have their own inherent necessity and surely spring from the same source that nourishes all life].[52] In the case of the brothers Jacob and Wilhelm Grimm, such a certainty derived from evidential images.[53] This is based on a highly speculative (and as we now have come to learn historically untenable) yet poetically fruitful supposition of *'geheimer, verlorengegangener Berührungen der Märchen mit der eigenen mythischen Herkunft'* [arcane, long-lost points of contact between the fairy tales and one's own mythological origin].[54] The connection between the Brunhilde myth from the song of the Nibelungen and the tale of Sleeping Beauty lacks any historical basis whatsoever; nevertheless, the formidable depiction of the slow awakening of man and nature is derived from natural philosophy. The quest for Romantic evidential images was a highly complex and artificial endeavour. It was marked by an elaborate interplay between writing and the oral tradition, as well as by an exhaustive use of inter-medial means to mobilise the imagination. For example, the final image of the tale *Rumpelstilzchen* [Rumpelstiltskin] is an attempt to channel the affect of utter fury, the rage at the revelation of one's identity into one cipher in a haptic, schematic manner: Besides itself with rage, Rumpelstiltskin stomps a deep hole into the ground, and standing with its legs spread far apart, it then tears itself in half by suddenly pulling up its other leg. This evidential image is not part of the traditional lore, but rather the result of the style employed by the Brothers Grimm.

To summarise: Romantic popularity is constructed from the predominance of scholarly interest over interest in public opinion, from the witty evidence of an intellectual perspective, from a recipient ready to embrace new visions of the future, a recipient who is aware of the dynamics of knowledge and of the historical change in communication horizons. The Romantic conception of popularity refuses any kind of intentional conveyance. Adam Müller states *'und so ist Popularität im echten Sinne nichts anderes als der notwendige, und ohne irgendeinen Vorsatz, aller wissenschaftlichen und künstlerischen Wirksamkeit innewohnende Geist der Bewegung und des Fortschreitens'* [in its truest sense, popularity is therefore nothing else but the necessary, completely intent-free spirit of movement and progress which is inherent to all scholarly and artistic work]. The polemical tone targeting popular philosophers is hard to miss in this observation: *'Bei dem misslingenden, hochmütigen Herablassen der Autoren wird nichts begünstigt als gerade der flache Egoismus der Zeitgenossen, ihr Scheinleben und Scheinwissen. Deshalb habe alles Wissen eine persönliche Gestalt, ein unabhängiges Leben, Fleisch und Mark – es sei nur von Hause aus gemütlich, das heißt, kräftig, das heißt künstlerisch: und es wird von selbst schon wachsen und ergreifen und befruchten'* [With their failing, haughty condescension, the authors benefit

nothing but the shallow egotism of their contemporaries, their pseudo-lives and their pseudo-knowledge. That is why all knowledge ought to have a personal guise, a life of its own, flesh and bone – it only needs to be jovial in its nature, that is, strong, that is artistic: and it will grow and become captivating and fertilising all by itself].[55]

Starting from here, the alternative to the conception of popularity of the Enlightenment becomes all too obvious – with its '*tötenden Verallgemeinerung*'[56] [destructive generalisation], i.e. with its erosion of the individual in the name of objectivity,[57] its methodical tendency '*alle einzelnen Bildungsarten abzuschleifen und auf den mittleren Durchschnitt zu bringen*'[58] [to level out all kinds of education to the medium average] – and by the same token, with its stylistic tendency towards mediocrity, which is – to quote from a 'moral weekly' entitled *Der Patriot*: '*Weder für die Gelehrten zu schlecht und zu niedrig, noch für die Ungelehrten zu hoch und unbegreiflich, sondern jedermann verständlich*' [neither too worthless and low for scholars nor too sophisticated or unfathomable for non-scholars, but intelligible for everyone].[59]

This article could be concluded at this point. In that case, however, we would pass up the opportunity to discuss the controversial and problematic nature of the Romantic concept of popularity as well as its new dogmatism. Hence, a short addendum. The habitual and socio-political centre of both alternative conceptions of popularity can be located by examining their respective stances on tolerance. In his seventh volume of *Dichtung und Wahrheit* [Poetry and truth], Johann Wolfgang von Goethe translated the mediocrity of the popular philosophers, much-maligned by Romantics, to a neutral and non-pejorative perspective: According to him, the achievement of the popular philosophers was to support a '*besondere Mäßigkeit*' [particular moderation] by insisting on the middle course and on tolerance toward all opinions as the right way.[60] As noted by Knigge in the last chapter of his *Über den Umgang mit Menschen* [On human relations], 'Über das Verhältnis zwischen Schriftsteller und Leser' [On the relationship between the author and the reader], this tolerance also included a certain composure and tolerance in terms of writing styles, as long as they did not veer toward the '*Unsittlichen*' [immoral], '*Boshaften*' [malicious], '*Schädlichen*' [harmful] and '*Unsinnigen*' [nonsensical].[61] The mercilessness, relentlessness, and acridity of Romanticism are aimed precisely at this random tolerance of popular philosophy which refuses '*streng zu scheiden*' [to strictly separate] '*Gutes und Schlechtes*' [good from bad] be it in opinion or in style.[62] Two quotes epitomise this attitude: '*Das ist es eben, wovon man nicht wissen will in diesem artigen Zeitalter, wo der Mensch und die Tugend und alles in einen so glatten und geschmeidigen Conversationston gefallen sind, dass die Wahrheit selbst lieber unwahr und unhöflich sein darf* [This is precisely what no-one cares about in this well-behaved age in which man and virtue and everything have been clad in such a smooth and elegant conversational tone that the truth itself may rather be untrue and impolite].[63] This nearly fanatic acridity becomes all too obvious when Schlegel speaks '*von der absoluten Entgegengesetztheit der Wege*' [of the diametric opposition of directions]: '*Es giebt zwei ursprünglich verschiedene Tenden-*

zen im Menschen, die aufs Endliche und Unendliche, also nicht bloß eine Verschiedenheit des Grades, Nuancen von Tugend und Laster, sondern absolute Entgegengesetztheit der Wege, die es jedem Menschen freisteht zu wandeln' [There are two basic, different tendencies in mankind – one towards the finite and the other towards the infinite – that is, not merely different in terms of the degree or the nuances of virtue and sin, but a diametric opposition of the directions everyone is free to take].[64] It is only against this background that we can understand why Schlegel tends to transfer the Zoroastrian battle between *'dem guten und bösen Prinzip'* [the good and the evil principle] as embodied in the figure of 'Ahriman' to the mediocrity of that era.[65] The dogmatic implications of this polemics should be obvious.

Notes

1 Immanuel Kant, 'Was ist Aufklärung', in *Sämmtliche Werke*, vol. 5 (Berlin: L. Heimann, 1872), 111. For the concept of 'sociality', see Kurt Wölfel's epilogue to Christian Garve, *Popularphilosophische Schriften über Literarische, Ästhetische und Gesellschaftliche Gegenstände* [1796], ed. Kurt Wölfel (Stuttgart: Metzler, 1974), 34.

2 Wölfel, ed., *Populärphilosophische Schriften*, 41.

3 Friedrich Schlegel, *Philosophische Lehrjahre, 1796-1806*, in *Kritische Friedrich-Schlegel-Ausgabe*, ed. Ernst Behler, vol. 18 (München: F. Schöningh, 1963), 228. Henceforth abbreviated as *K.A.*

4 Werner Schneiders, 'Popularphilosophie', in *Lexikon der Aufklärung. Deutschland und Europa*, ed. Werner Schneiders (München: C. H. Beck, 1995), 326.

5 Ibid.

6 Friedrich Schlegel, 'Ueber die Philosophie: An Dorothea', in *Athenaeum: Eine Zeitschrift von August Wilhelm und Friedrich Schlegel* (1799), 2. vols. (reprint, Dortmund: Bernhard Sorg, 1989), 411.

7 *Europa: Eine Zeitschrift*, ed. Friedrich Schlegel (1803),. (Darmstadt: Wissenschaftliche Buchgesellschaft, 1973), 54.

8 Schlegel, *Athenaeum*, 406.

9 Ibid., 407.

10 Ibid.

11 Ibid., 411.

12 Adam Müller, 'Popularität und Mystizismus', in Adam Müller, *Kritische, Ästhetische und Philosophische Schriften*, ed. Walter Schroeder and Werner Siebert (Neuwied und Berlin: Luchterland, 1967), 500.

13 Joachim Ritter, 'Aesthetik, Ästhetisch', in *Historisches Wörterbuch der Philosophie*, ed. J. Ritter, vol. 1 (Basel, Stuttgart: Schwabe, 1971), 557.

14 Friedrich Wilhelm von Ramdohr, 'Kunst der Schönen Geselligen Unterhaltung', in Friedrich Wilhelm von Ramdohr, *Studien zur Kenntnis der Schönen Natur, der Schönen Künste, der Sitten und der Staatsverfassung auf einer Reise nach Dänemark* (Hannover, 1792).

15 Wolfgang Martens, *Die Botschaft der Tugend: Die Aufklärung im Spiegel der deutschen moralischen Wochenschriften* (Stuttgart: Metzler, 1968), 147.

16 Gottfried August Bürger, *Sämtliche Werke*, ed. Günter and Hiltrud Häntzschel (München, Wien: C. Hanser, 1987), 730.

17 Ibid., 717.

18 Ibid., 13.

19 Doris Bachmann-Medick, *Die Ästhetische Ordnung des Handelns: Moralphilosophie und Ästhetik in der Popularphilosophie des 18. Jahrhunderts* (Stuttgart: Metzler 1989), 63, 65, and 140. Cf. Christoph Böhr, *Philosophie für die Welt: Die Popularphilosophie der deutschen Spätaufklärung im Zeitalter Kants* (Stuttgart-Bad Cannstatt: Frohmann-Holzboog, 2003).

20 Immanuel Kant, Foreword to *Logik*, in *Gesammelte Schriften*, vol. 9 (Berlin: Der Königlich-Preussischen Akademie der Wissenschaften zu Berlin, 1902), 62.

21 Christian Garve, *Von der Popularität des Vortrages* (1793 and 1796), in Wölfel, ed., *Populärphilosophische Schriften*, 1039.

22 Christian Garve to Immanuel Kant, 13 July 1783, in *Kant's Briefwechsel*, vol. 1, *1747-1788* (Berlin und Leipzig 1922), 331.

23 Ibid.

24 Immanuel Kant to Christian Garve, 7 August 1783, in Wölfel, ed., *Populärphilosophische Schriften*, 336f.

25 Ibid., 338.

26 Ibid., 331f.

27 Ibid., 339 and annotations.

28 Ibid., 338.

29 Ibid., 339.

30 Ibid., 341.

31 *K.A.* 2, 97.

32 Immanuel Kant to Garve, in Wölfel, ed., *Populärphilosophische Schriften*, 341.

33 Ibid., 351 [1059].

34 Ibid., 352 [1060].

35 Johann Christoph Greiling, *Theorie der Popularität* [1805] (reprint, Stuttgart-Bad Cannstatt, 2000), 163.

36 *K.A.* II, 111.

37 *K.A.* 18 (1963), 221, no. 318.

38 *K.A.* 18, 220, no. 318.

39 Friedrich Schleiermacher, 'Garves letzte von ihm selbst herausgegebene Schriften', in *Athenaeum* 3.1 (1800) , 136.

40 Cf. Heinrich Bosse, *Autorschaft ist Werkherrschaft* (Paderborn: Schöningh, 1981), 131f.

41 *K.A.* 18, 215, no. 244.

42 *K.A.* 2, XXVII.

43 Cf. the relevant article by Holger Dainat, ' "Meine Göttin Popularität". Programme Printmedialer Inklusion in Deutschland 1750 – 1850', in Hedwig Pompe and Jens Ruchatz, eds., *Popularisierung und Popularität* (Köln: DuMont Verlag, 2005), 52.

44 Johann Gottlieb Fichte, 'Über die Bestimmung des Gelehrten', in *Fünf Vorlesungen* 1794 (Stuttgart: Verlag Freies Geistesleben, 1959), 42f.

45 Hans Freyer, 'Über Fichtes Machiavelli – Aufsatz', in *Bericht über die Verhandlungen der Sächsischen Akademie der Wissenschaften* (Leipzig: S. Hirzel, 1936).

46 Johann Gottlieb Fichte, 'Über das Wesen des Gelehrten und seine Erscheinung im Gebiete der Freiheit', in *Vorlesungen gehalten zu Erlangen im Sommerhalbjahre 1805* (Leipzig: F. Meiner, 1921), 11.

47 One of the most crucial points of Romanticist criticism regarding Garve's stance on popular philosophy is his affirmation of his own era [cf. *K.A.* 18, 343].

48 Fichte, 'Über die Bestimmung des Gelehrten', 27.

49 Ibid., 31.

50 Johann Gottlieb Fichte, *Grundzüge des Gegenwärtigen Zeitalters in Vorlesungen, Gehalten zu Berlin, im Jahre 1804 – 1805*, in *Ausgewählte Werke in sechs Bänden*, ed. Fritz Medicus, vol. 4 (Stuttgart: Frommann-Holzboog,1962), 469.

51 *K.A.* 2, 318.

52 Brüder Grimm, *Kinder – und Hausmärchen. Ausgabe letzter Hand*, ed. Heinz Rölleke, vol. 1 (Stuttgart: Reclam Bibliothek, 1982), 16.

53 Cf. the most recent methodical considerations regarding the necessity and the limits of evidence in Elke Vöhnicke, *Das Unbewußte im Deutschen Idealismus* (Würzburg: Königshausen & Neumann, 2005).

54 Cf. Jens E. Sennewald, *Das Buch, das Wir Sind: Zur Poetik der 'Kinder- und Hausmärchen, Gesammelt durch die Brüder Grimm'* (Würzburg: Königshausen & Neumann, 2004), 140f.

55 Both quotations from Müller, *Kritische, Ästhetische und Philosopische Shriften*, 500. For a critical commentary see Hermann Bausinger, 'Herablassung', in Eberhard Müller, ed., '. . . *aus der anmuthigen Gelehrsamkeit': Tübinger Studien zum 18. Jahrhundert. Dietrich Geyer zum Geburtstag* (Tübingen: Attempto-Verlag, 1988), 25–39.

56 *K.A.* 2, 286.

57 Garve, *Populärphilosophische Schriften*, 1065.

58 *K.A.* 2, 268, no. 123.

59 Gert Ueding, 'Popularphilosophie', in *Historisches Wörterbuch der Rhetorik*, ed. Gert Ueding, vol. 6 (Tübingen: Max Niemeyer Verlag, 2003), 1553.

60 Johann Wolfgang Goethe, *Dichtung und Wahrheit*, in *Autobiographische Schriften*, vol. 10 (München: C. Bertelsmann Verlag, 1957), 249.

61 Adolph Freiherr von Knigge, Über den Umgang mit Menschen (Bremen: Carl Schünemann Verlag, 1964), 430f.

62 *K.A.* 18, 524.

63 Ibid., 525.

64 Ibid., 524.

65 Schlegel, *Europa*, 54.

Recognition
Dissimul

RECOGNITION AND DISSIMULATION

Nationalism and Genre in James Clarence Mangan's 'The Lovely Land'

CHARLES I. ARMSTRONG

[ABSTRACT]

James Clarence Mangan has been celebrated by James Joyce and W. B. Yeats as one of the preeminent Irish writers of the nineteenth century. This essay interprets his poem 'The Lovely Land', first printed in *The Nation* on 18 July 1846, in terms of genre and nationalism. In an early Irish example of ekphrasis, the poem stages a rhetorical misreading where the speaker mistakes an unnamed Irish landscape of Daniel Maclise's for a painting by Veronese or Poussin. Where – among his English and German Romantic predecessors – might Mangan have found a precedent for the poem's treatment of landscape? And how does the colonial relationship between Ireland and England fit in with the poem's complex manoeuvring of different national iconographies? In seeking to answer these questions, this essay looks to further the 'mapping' of Mangan's position in Romanticism as an international movement.
.

KEYWORDS *James Clarence Mangan, Genre, Nationalism, Ekphrasis, The Nation.*

James Clarence Mangan (1803–49) (ill. 1) published the poem 'The Lovely Land' in the Dublin-based newspaper *The Nation* on 18 July 1846. *The Nation*[1] was far from being an innocuous vehicle for the poem. As a leading Irish nationalist newspaper at the time, fighting for the Repeal of the Union with England, *The Nation* featured key figures of the Young Ireland movement – including its three founders Charles Gavan Duffy, Thomas Davis, and John Dillon, as well as the later key figure John Mitchel – who were friends of Mangan's. Later, in the period between July 1848 and September 1849, *The Nation* would be suppressed by the British government, due to its proclamation of outspokenly nationalist views – often with a revolutionary or violent tenor.[2] This context is relevant to the investigation into how this poem overlays the national with the international. Part of the object of this reading will be to show how the poem articulates a nationalist position, in the context of the Young Ireland movement and other writings of *The Nation*, through engaging with foreign examples and precedents of not only a visual but also a verbal character. An important precedent is provided by Romanticism. There is no overall consensus concerning Mangan's relationship to Romanticism: while some critics acknowledge the value of for instance

Charles I. Armstrong, Professor of British literature, University of Agder
Aarhus University Press, *Romantik*, 02, 2013, pages 55-74

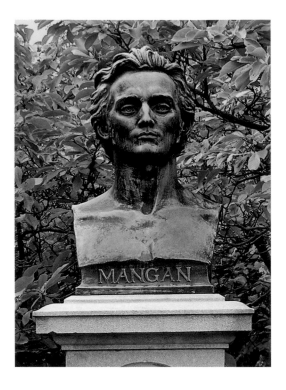

III. 1 [Oliver Sheppard,
Bust of James Clarence Mangan.
Photo: David M. Jensen,
Dublin, Ireland.]

Byron and German Romanticism for his writings, he has also been described as 'in many ways the antithesis of the Romantic poet, at least in its Wordsworthian guise'.[3] Another concern here will be how the ekphrasis of the poem interacts with other genres – such as the pastoral, translation, and the oath – in a complex fashion.

'The Lovely Land' consists of ten quatrains with embracing rhymes, each stanza including three tetrameter lines followed by a trimeter. After two stanzas devoted to an enthusiastically responsive description of a landscape painting, stanzas three through five speculate whether that painting is the work of the Italian Paolo Veronese or the French Claude Poussin. Subsequently, the speaker muses on the supernatural associations evoked by the landscape, and his own desire to attain transcendence through his immersion into it. The final stanzas – stanzas eight through ten – overturn the earlier attribution of the painting to foreign masters: identifying it as an Irish landscape by Mangan's countryman Daniel Maclise (1806–1870), the speaker celebrates his homeland and expresses a strong commitment to his nation's future cause.

The poem's claim to be responding to a landscape by Maclise makes it of particular interest as a forerunner to a rich tradition of ekphrastic poems in Irish literature. A veritable deluge of ekphrastic works in recent Irish poetry caused the critic Edna Longley to title her influential essay on the topic 'No More Poems about Paintings?'[4] The accomplishments of twentieth-century figures such as W. B. Yeats, John Hewitt, and Derek Mahon in this genre are considerable, but there is little evidence of a similar poetic interest in the visual arts, in an Irish

context, if one goes back to the previous century. Partly this may have been the result of the centrality of a rich oral (rather than visual) tradition of bardic verse in Ireland, and partly the longstanding lack of access to major works of art in the country may be to blame. The National Gallery in Dublin first opened its doors in 1864, and other important galleries – including the Municipal Gallery, for which Yeats played an important role – were established much later. This does not mean that the 1840s were devoid of interest in the visual arts. In the pages of *The Nation*, one can for instance read letters written by the painter Henry O'Neill, arguing on behalf of the Royal Irish Art Union that the artistic example provided by Maclise and other Irish artists shows that the time is right to support institutions, galleries, and exhibitions that will foster a native Irish tradition in the arts. There is also a growing interest in the relationship between literature and art, as evidenced for instance by an anonymous two-part article on visual illustration of literary texts printed in *The Nation* on 29 November and 6 December 1845. Entitled 'Maclise's Illustrations of Moore', the article uses the recent publication of a book containing Thomas Moore's *Melodies* accompanied by illustrations by Maclise as the occasion for a principled discussion of a relation between these arts. Through the work of W. J. T. Mitchell and others, we have now grown familiar with the idea that a *paragonal* relationship – a competitive one, where the different forms vie for supremacy and primordial status – has been a staple of much interaction between the arts through the ages.[5] Such a relationship is also in evidence in this article, which proclaims that recent popularity of book illustration is a symptom that the 'pencil, the brush, and the graver, threaten soon to dethrone the pen'.[6] Book illustrations are a mistaken pursuit, readers are told, since such work neglects the fact that literature is fundamentally different – and indeed also placed at a higher level – than the visual arts. The anonymous contributor to *The Nation* hedges his bets, however, by also arguing that all of the main arts have an absolute value as long as they stand on their own. Transgressing the borders between the arts is (apart from a few minor examples) pernicious, as this leads to relations of subservience: '[T]he most exquisite professional illustrator of ancient or modern poetry . . . abandons his charter of equality so long as he assumes the office of mere interpreter and decorator.'[7] After various digressions and swerves of argument, the writer ends by lamenting that Ireland's best artists have emigrated to London: Maclise and Moore may be 'exiled', but they are 'neither forgotten nor forgetful'.[8]

Maclise and the Romantic Precedent

The *Nation* article foreshadows key aspects of Mangan's poem, which would be published in the same weekly a few months later. The complex link between the visual and verbal arts, the relationship between Irish art and its native soil, and the value of a supportive or secondary work of art: all of these are issues that will recur in our reading of 'The Lovely Land'. More covertly, the reclaiming of a lapsed – or potentially lapsing – expatriate may also be at stake. It has proven

Ill. 2 [Daniel Maclise, *The Marriage of Strongbow and Aoife*, 1854.
Oil on canvas, 315 x 513 cm. National Gallery of Ireland. Photo © National Gallery of Ireland.]

impossible for modern scholarship to identify any given landscape by Maclise that fits the description given in Mangan's poem. Maclise's most famous painting with an explicitly Irish theme and setting, *The Marriage of Strongbow and Aoife*, was first exhibited at the Royal Academy in London in 1854 – and hardly fits the bill anyway (ill. 2).

Early drawings made by Maclise during a tour of Ireland in the 1820s – such as 'The Valley of the Seven Churches', based on the Glendalough site – might have been seen by Mangan, but again there is no close correspondence with the poem (ill. 3).

Yet even if one cannot locate any simple pre-textual basis for 'The Lovely Land', there are known factors that explain, at least in part, why Mangan would wish to evoke Maclise at this point in time. Maclise's previously mentioned illustrations to Moore's *Melodies* could well have provided an impetus. In *The Nation*, this 'noble book' was said to include 'the songs of our greatest lyrist, illustrated by our greatest painter',[9] and the publication may indeed also have suggested to Mangan that Maclise deserved the *imprimatur* of being the representative Irish artist of his time. We know that Mangan's appreciation of this artist was no pass-

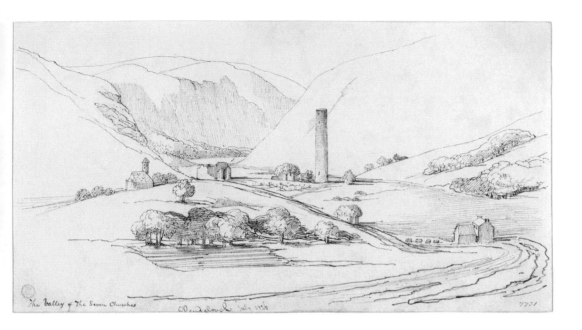

Ill. 3 [Daniel Maclise, *The Valley of the Seven Churches*, 1826.
Pencil and ink on paper, 13 x 24 cm. © The Victoria and Albert Museum, London.]

ing thing: In 1849, which turned out to be the last year of his life, the poet described Maclise as the 'most imaginative painter of the age'.[10] I will return to this issue towards the end of this article, as there are complicating factors that make Mangan's choice of painter somewhat mysterious.

The speaker makes a strong statement in the penultimate stanza of Mangan's poem, claiming that 'through Maclise's eyes / I first see thee, Ireland!' The artwork does not simply replicate or represent the nation, but rather something far more challenging and fundamental: it shows the nation that is Ireland. Literature's part is presumably to comment and elucidate, where art provides the immediate sensory vision of national identity. There is a claim to dynamism and originary power in these lines, which is in agreement with Jean-Luc Nancy's Heidegger-inspired formulation of non-representational being as a 'birth to presence'.[11] Maclise has, as it were, provided an act of midwifery that enables the birth of the idea of the nation. This links up with the beginning of Mangan's poem, which celebrates the landscape as a 'Glorious birth of Mind and colour'. That opening line might be conceived of as hedging its bets: for why are both mind and colour, both a suprasensible and a sensible embodiment, evoked? This formulation is tacitly echoed by Mangan a couple of years later, when he in 'The Tribune's Hymn for Pentecost' describes Ireland as 'The Golden House of Light and Intellect'.[12] The emphasis on mind would seem to contradict the author of 'Maclise's Illustrations of Moore', who had denied the visual arts recourse to the highest levels of thought. Mangan's wording can be explained via Romantic poetics, and its emphasis on the mental faculties of the artist. As with many of the

Romantics, the mind tends to be conceived of by Mangan as a transcendental faculty that goes beyond any parochial or national interest. Thus, his posthumously published 'Consolation and Counsel' takes his countrymen to task for 'the severing bar / That insulates you now from Europe's Mind'.[13] The prose commentary to his oriental translations in the September 1837 issue of the *Dublin University Magazine* expresses this tension in more principled terms:

The mind, to be sure, properly to speak, is without a home on the earth. Ancestral glories, genealogical charts, and the like imprescriptible indescriptibles [*sic*] are favorite subjects with the composite being Man, who also goes now and then the length of dying in idea for his fatherland – but for Mind – it is restless, rebellious – a vagrant whose barren tracts are by no means confined to the space between Dan and Beersheba. It lives rather out of the world.[14]

If one adds to this emphasis on transcendental placelessness Mangan's frequently-expressed lack of interest in natural surroundings, then one gains something of a sense of the anomalous position 'The Lovely Land' has in his oeuvre. For this is not a typical poem by Mangan, of whom Yeats wrote: 'Outer things were only to him mere symbols to express his inmost and desperate heart. Nurtured and schooled in grimy back streets of Dublin, woods and rivers were not for him.'[15] The plot thickens if one takes into account the date of composition: 1846 is not the most propitious time for idyllic eulogies of the Irish landscape. In *Irish Pastoral,* Oona Frawley has claimed that during the first decades of the nineteenth century the 'general Irish population' put up a 'resistance to the romanticization of nature that had taken place in England'.[16] This may or may not be a too simple generalization, but it is not hard to concur when she claims that the famine certainly exacerbated any sense of disharmony there might have been earlier between human lives in Ireland and their surrounding natural landscape. In her biography of the poet, Ellen Shannon-Mangan points to the close connection between 'The Lovely Land' and Mangan's later poem entitled simply 'The Famine'.[17] The later poem starts by evoking a blessed past, 'when thoughts and violets bloomed – / When skies were bright, and air was bland and warm', before concentrating on the subsequent despair attendant to the time when 'a blight fell on the land' and the 'soil, heaven-blasted, yielded food no more'.[18]

By the summer of 1846, the potato blight had already arrived in Ireland, with heart-breaking consequences.[19] Nevertheless, this seems not to be a factor in the poem – at least if one does not read the sixth stanza reference to the landscape being 'Peopled not by men, but fays' as ironic. Passages in 'The Lovely Land' draw clearly on Romantic and pre-Romantic precedents with regard to the celebration of landscape. The beginning of Mangan's poem is for instance evocative of the 'Intimations' ode. In the first stanza the 'radiant face' of the landscape, which also is a 'Glorious birth of Mind and colour', seems reminiscent of line sixteen of Wordsworth's poem: 'The sunshine is a glorious birth'.[20] The second stanza is pitched even closer to the precedent of the Lake Poet, as lines one to four of

Wordsworth's ode famously run: 'There was a time when meadow, grove, and stream, / The earth, and every common sight, / To me did seem / Apparelled in celestial light.' Mangan has a related 'eam'-rhyme in 'beaming'/'dreaming', and follows this up with 'stream' / 'dream' in his fourth stanza. Wordsworth's 'meadow, grove and stream' is strongly echoed by 'mountain, mead and grove', while Mangan's 'divinest light' responds to 'celestial light' in what are closely matched lines. Another influence is evident in the somewhat looser echoes of Friedrich Schiller in the middle part of 'The Lovely Land'. Schiller was one of the poets Mangan most frequently translated, and when the Irishman describes his landscape as an ancient one, associated with supernatural beings and legendary tales, we are not far from the German poet's '*Die Götter Griechenlands*'.[21] Lines 145–8 of Schiller's celebrated poem ('*Kehre wieder / holdes Blüthenalter der Natur! / Ach! Nur in dem Feenland der Lieder / lebt deine goldne Spur*') would, for instance, seem to overlap quite closely with Mangan's sixth stanza: 'This is some rare clime so olden, / Peopled, not by men, but fays; / Some lone land of genii days, / Storyful and golden!' In the prose commentary to his German translations in the October 1835 issue of the *Dublin University Magazine*, Mangan claimed that 'the leading characteristic of German Poetry' was an overly adventurous 'attempt to assimilate the creations of the ideal with the forms of the actual world'.[22] Here, over a decade later, he seems to not only be following – but also outdoing – Schiller in the forging of links between landscape and a supernatural bliss associated with faery beings.

At once one brings a combination of Greek mythology and pastoral nostalgia into the ambit of Mangan's poem, it becomes tempting to relate it to that most influential performance of ekphrasis in British Romantic poetry, John Keats's 'Ode on a Grecian Urn'. Keats's poem has been an inescapable reference point for many subsequent works in this genre, and through his numerous allusions to key figures (including Wordsworth, Shelley, Byron, and indeed also Keats) we know Mangan was quite conscious of his English Romantic forebears. When Mangan's seventh stanza expresses a wish 'to wander / One bright year through such a land' – or even to be content with standing 'one hour' on the hills of the painting – we encounter structures of desire that might seem evocative of Keats's contrast between art and the dissatisfactions of 'All breathing human passion' (l. 28).[23] Apart from this, though, the poems do not seem particularly similar – and certainly 'The Lovely Land' is far removed from both the questioning distance and epigrammatic pithiness characteristic of 'Ode on a Grecian Urn'.

Translation, Landscape, and the Irish Future

The Victorian poet Francis Thompson once pointed out that Mangan 'needed a suggestion or a model to set his genius working',[24] and ekphrasis is a genre – like that of translation – that institutionalizes such a *modus operandi*. The kind of inter-artistic relationships of subservience or dependency decried by the author of 'Maclise's Illustrations of Moore' must at least be negotiated within the genre.

The ekphrastic text necessarily bases itself upon a preceding visual representation, however freely it may relate to that precedent. In the case of 'The Lovely Land', we are unable to gain a clear sense of what sort of liberties Mangan may or may not be taking. If indeed the landscape of Maclise's is a fictional one, invented by Mangan for the purpose of writing his poem, then we are dealing with an example of what James Heffernan has termed 'notional ekphrasis' – an illustrious subgenre that includes Homer's description of the shield of Achilles in *The Illiad*.[25] We are in fact ignorant, though, of whether or not Mangan's poem is actually relating to an existing original. In this respect, 'The Lovely Land' replicates a familiar scenario for Mangan's readers, who must often have been uncertain whether his purported translations were following a German or Oriental original, or whether they were in fact original poems.[26] Mangan did not hide the circumstances that fostered such uncertainty: in a late autobiographical sketch, posthumously published in the *Irishman,* he describes himself as having 'perpetrated a great many singular literary sins, which, taken together, . . . would appear to be "the antithesis of plagiarism"'.[27]

Regardless of whether Mangan had a concrete painting by Maclise in mind or not, his poem would seem to relate closely to the underlying structures of translation – as is made evident by the references to foreign masters of painting in stanzas three and four. The references to Poussin and Veronese are essential to the structure of misrecognition followed by insight constructed within the poem (ill. 4).[28]

One can read this relation in many ways, but in any case it relates closely to translation: where translation rearticulates the foreign text as a native one,[29] 'The Lovely Land' uncovers that the foreign image is in reality a native one. The similarity is even closer for practices of translation that involve dissimulation, as we know to be the fact with Mangan's fictionalised translations. This aspect of dissimulation is acknowledged in David Lloyd's analysis of what he shows to be the underlying, refractory logic of Mangan's translations, whereby 'one tries to put oneself into foreign situations but really only appropriates and reproduces the foreign in one's own sense.'[30]

This does not explain why exactly Veronese and Poussin are singled out in this poem. In his introduction to a recent exhibition devoted to 'Landscape and Irish Identity' at the Crawford Art Gallery in Cork, Peter Murray points out that in the eighteenth century Irish landscapes were typically interpreted through the prism provided by the Italian landscapes of artists such as Claude Lorrain and Salvatore Rosa.[31] Mangan's poem seems to be following this example, but also pointedly updating it through a corrective gesture of Romantic nationalism. Even while defending the Irish landscape against neglect and ignorance, the poem's comparison might also be seen as elevating that very same landscape through association with the classical ideal of Italy. The absence of any reference to English landscape is notable, and might be comprehended in relation to Mangan's adoption of a more aggressively anti-British rhetoric late in his career. Less than a month after the publication of 'The Lovely Land', *The Nation* published Mangan's translation

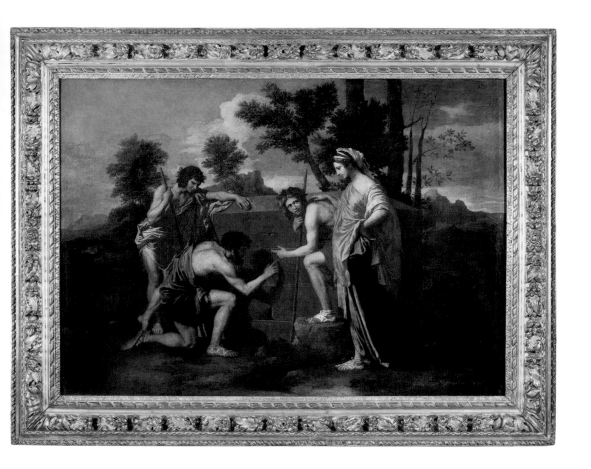

Ill. 4 [Nicolas Poussin, *Les bergers d'Arcadie, dit aussi Et in Arcadia ego,* ca. 1638-40. Oil on canvas, 85 x 121 cm. © Musée du Louvre, Dist. RMN-Grand Palais / Angèle Dequier.]

'Lament over the Ruins of the Abbey of Teach Mologa', which denounced the effects of 'brutal England's power'.[32]

The latter poem is interesting, in this context, for yet another reason: its stanzaic form is closely related to that of 'The Lovely Land'. Although there are differences, we have in both cases an *abba* quatrain, with a shorter final line. This stanzaic pattern is found in two other of Mangan's Irish translations – 'O Hussey's Ode to the Maguire' (also 1846) and 'Owen Reilly: a Keen' (1847) – published during roughly the same time period.[33] All of these three essentially balladic poems are instances of remembered loss, suggesting that Mangan was not oblivious to the emotional potential of the shorter fourth line. Critics have often noted the pathos inherent in the shorter fourth line of the ballad stanza of Keats's 'La Belle Dame sans Merci', and a similar effect is arguably at work in Mangan's Irish stanza. As a result, one can say that the sense of loss that is present in the Wordsworthian and Schillerian intertexts is also tangible at a formal level. The

distance separating the speaker from 'the blest hills yonder' in the seventh stanza of Mangan's poem may appear to be banished at the end of his text, but the form of the poem intimates that full presence is not attained.

To use Schiller's terminology, one could say that 'The Lovely Land' is a sentimental poem that presents itself as 'naïve'. The motivation for such dissimulation is not hard to imagine: the poem is meant to be a nationalist rallying cry in a time of trouble, and as such it necessarily traffics in idealisations of nation and landscape. Arguably the effects of an extra-literary genre are felt at this juncture. The ending of the poem is informed by the mechanics of the public oath, a speech genre very much in the air in Ireland during this decade. In Ireland the 1840s were marked by a strong drive towards teetotalism, and in her biography Ellen Shannon-Mangan shows how much Mangan deliberated over whether he should take Father Theobald Mathew's Total Abstinence Pledge. He also made public oaths of his political commitment, for instance in a letter to John Mitchell that was published in *The United Irishman* on 25 March, 1848. Such commitment may have been troubled by doubts and distractions, but it is in the nature of the oath to set aside any overt show of hesitation in favour of a clear statement of intent. In addition to Mangan's own biography, the use of an oath at this juncture can be understood in the context of Daniel Maclise's work. One of Maclise's most famous early paintings is *The Installation of Captain Rock* (1834), which was inspired by Thomas Moore's *Memoirs of Captain Rock* (1824). Both Maclise's painting and Moore's text are complex affairs, however, and in no way fit comfortably in with the radically nationalist tenor of Mangan's later work. In fact, Tom Dunne reads the former – with its burlesque depiction of a sensual and unruly gang of peasant insurrectionists – as 'mock-heroic, rather than heroic'.[34]

The oath is primarily committed towards the future, and Mangan's poem is indeed tacitly dedicated to an Ireland of the future. The ancient, then, is not only that which confirms the elevated nature of the Irish landscape but also concerns its destination. Antiquity for Mangan is here a dimension that transcends the classical landscapes of Poussin and Veronese, and also enters into Biblical terrain. The title of the poem, which may seem overly saccharine to a current readership, points in this direction. The phrase 'lovely land' crops up earlier in Mangan's oeuvre, in his 1839 poem 'My Home': there the speaker evokes a journey to 'a lovely Orient land, / . . . to this my lovely land, / Where the sun at morning early / Rises, fresh, and young, and glowing'.[35] This poem pretends to be a translation of Karl Friedrich Gottlob Wetzel's 'Kennt ihr das schöne Eiland', but is in fact an original composition of Mangan's. The wording derives the Catholic version of the Bible that Mangan would have used – the Douay-Rheims Bible – where Jeremiah 3:19 reads as follows: 'But I said: How shall I put thee among the children, and give thee a lovely land, the goodly inheritance of the armies of the Gentiles?' The Promised Land is the lovely land. It is only this Bible version that uses this particular phrase, while most others English-language versions – including the King James Version – use 'pleasant land'. So the phrasing might in fact provide something of a shibboleth for Catholic readers of Mangan. Such

an identification of Ireland with the Promised Land of the Jews concurs with other passages in Mangan's writings. Best known is the concluding quatrain of his rendering of the Irish poem 'Kathaleen Ny-Houlahan': 'He, who over sands and waves led Israël along – / He, who fed, with heavenly bread, that chosen tribe and throng – / He, who stood by Moses, when his foes were fierce and strong – / May He show forth His might in saving Kathaleen Ny-Houlahan!'[36]

The Round Tower and the Reclaiming of Exiles

If the Douay-Rheims Bible might provide an understated way of reaching out to a certain audience, the poem is of course also very explicit in how it embraces a sense of Irishness which would have been shared with most of the readers of *The Nation*. The turning point of the poem is marked by an encounter with a specific architectural edifice: 'But what spy I? . . . O, by noonlight! / 'Tis the same! – the pillar-tower / I have oft passed thrice an hour.' The reference to the 'pillar-tower' is notably brief, lacking the elaborateness of Moore's 'Let Erin Remember the Days of Old', which pictures a fisherman on Lough Neagh, catching sight of 'the round towers of other days / In the wave beneath him shining'.[37] A quick reading of 'The Lovely Land' might tempt one to believe that the passing reference to the tower is purely incidental, merely intended to spur a sense of recognition in the speaker. Could any familiar trait of the neighbourhood of the speaker have fulfilled the same function? Perhaps not, since it is vital that the encountered feature in the landscape should spark a sense of specifically national belonging.

Joep Leerssen has shown that pillar towers, or round towers as they are more commonly called today, were a vital and contentious fulcrum of Irish antiquarian interest during the nineteenth century.[38] In 1845, George Petrie – with whom Mangan had collaborated on the Ordnance Survey – finally published his Royal Irish Academy prize-winning essay on the historical origin of the round towers.

Petrie provided a positivist debunking of more fanciful theories, arguing that these were edifices primarily offering Christian monastic communities protection from external enemies. The same year, however, Denis Florence MacCarthy's 'The Pillar Towers of Ireland' was published in *The Nation*. MacCarthy's poem became a much-anthologised, popular favourite, and is far from circumspect in its speculation about the past of these edifices: 'the warm blood of the victim have these gray old temples drunk, / And the death-song of the druid and the matin of the monk'.[39] Petrie's sober antiquarianism was coupled with artistic work such as his watercolour *The Last Circuit of the Pilgrims at Clonmacnoise, Co. Offaly* (1842) (ill. 5), where the round tower plays a central role in establishing the Irish setting. However striking their differences are, Petrie and MacCarthy share a sense of the distinctively Irish nature of round towers.[40] Leerssen notes that the towers 'do not have any analogues in the standard typology of mainstream European architecture and are, therefore, largely *sui generis* and practically exclusively Irish'.[41] Coupled with the backdrop of the lively interest in contemporary antiquarianism, evident for instance in the pages of *The Nation*, this uniqueness makes it

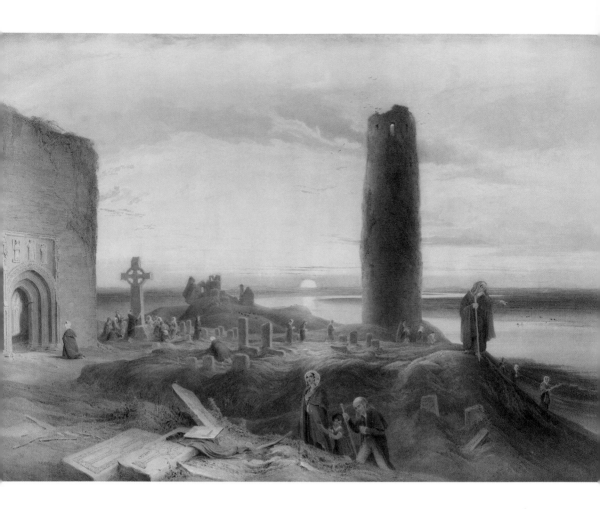

Ill. 5 [George Petrie, *The Last Circuit of the Pilgrims at Clonmacnoise*, Co. Offaly, ca. 1828/1843.
Graphite and watercolour on paper 67.2 x 98 cm. National Gallery of Ireland.
Photo © National Gallery of Ireland.]

possible for Mangan to use a brief mention of the towers as a kind of short-hand
for a rich sense of national identity.

It is not immediately clear what effect the concrete reference to the 'pillar-tow-
er' has on the earlier parts of the poem. Can 'The Lovely Land' be read as ending
in a negation of the pastoral idealization of landscape with which it begins? Are
the earlier, classically-tinged references to an Irish landscape ironically under-
cut by the final recourse to a native building? Interestingly, MacCarthy's poem
features an explicit contrast between the round towers and the more celebrated
buildings of antiquity: 'Beside these gray old pillars, how perishing and weak /
The Roman's arch of triumph, and the temple of the Greek' (ll. 5–6). But 'The
Lovely Land' does not include any comparable architectural opposition. Could
Mangan effectively be saying that it is only by virtue of the human monuments
of Irish artifice, such as architectural structures of this kind, that there is such a

thing as a 'Lovely Land'? Is there a suggestion here, then, that the 'Glorious birth of Mind and colour' celebrated by Mangan's poem is primarily a thing reflecting of mental glories? This would place it in the kind of Romantic territory established by Geoffrey Hartman's celebrated phenomenological reading of the Simplon Pass episode in Wordsworth's *Prelude*.[42] The relative paucity of references to Irish landscape in Mangan's work in general might tempt one to embrace this hypothesis. At the same time, the poem does return – albeit vaguely and briefly – to the 'soil and skies' of Ireland in the penultimate stanza, and there is no evidence that this land is in any way belittled by its lack of distinctiveness compared to the environs immortalized by Veronese and Poussin.

When 'The Lovely Land' was reprinted in *The Nation* after Mangan's death, the editor described it as a 'beautiful descriptive poem' that was 'typical of poor Mangan's loving perception of the many scenic beauties of Ireland'.[43] This rather rose-tinted view not only obscures the complexity of the poem, but also eschews any reference to the puzzling way in which the poem interacts with encroaching contextual features. As mentioned earlier, Mangan's collected oeuvre makes it hard, today, to speak confidently of his 'loving perception' of Irish scenic beauty. This, after all, is a man who – according to his unfinished autobiography – would confess: 'I hate scenery and suns. I see nothing in Creation but what is fallen and ruined.'[44] Further, there is not only no trace of a specific painting by Maclise that might have provided inspiration for 'The Lovely Land', but Irish landscape is indeed not something with which the mature Maclise had much truck. On 2 December, 1843, an article in *The Nation* by Thomas Davis on 'National Art' put its finger on part of the problem:

Ireland has had some great Painters – Barry and Forde for example, and many of inferior but great excellence; and now she boasts high names – Maclise, Hogan, and Mulready. But their works were seldom done for Ireland, and are rarely known in it. Our portrait and landscape Painters paint foreign men and scenes; and, at all events, the Irish people do not see, possess, and receive knowledge from their works.[45]

A stronger statement along these lines would be made by John Sproule, in connection with the Dublin Industrial Exhibition in 1853, when he 'sneered at Irishmen like Daniel Maclise and James Arthur O'Connor for living in England, who "transferring their allegiance to a strange soil . . . soon forget the purer inspiration of their youth at home" '.[46] Such a sceptical holding at an arm's length of Maclise (among others) is perhaps what one would expect, given that *The Nation* was a strongly nationalist newspaper. For Maclise had in fact left Cork for London at the age of 22, and in time his work for the Houses of Parliament would define him as quintessentially an artist of the British Empire. Although one seeks in vain for a consistently negative stance on his art in *The Nation*, the newspaper's letter section of 22 November, 1845, includes an interesting description of Maclise's position as seen from Ireland:

Such pictorial, sculptured and written Illustrations of our history as Mr. Maguire's letter suggests must come sooner or later; but England has robbed us of many, to whom such a task would naturally belong. Maclise, the master of the magic pencil, Franklin, the true successor and rival of Albert Dürer, Shee, the poet-painter, the exquisite Rothwell – why are they not at home to make Irish history and Irish manners immortal upon canvas? . . . There is but one why and because in our misfortunes. If we *had* a living country all these gifted men would be amongst us; and our 'artists in words' too.[47]

Mangan can be seen as pitching in for the national cause, assisting in making Ireland a more 'living country', by writing an ekphrastic poem where he acts as if Maclise had not left Ireland and its landscape behind. If 'England has robbed us', Mangan's act of restitution effectively amounts to robbing back the prestige of Maclise's art to his mother country.

It is a gesture that involves some dissimulation: Mangan pretends that Maclise is a nationalist painter of landscapes, in order to appropriate him firmly to the ideals of cultural nationalism (ill. 6). Insofar as Maclise still, in 1846, might be assumed to long for 'the blest hills yonder' of an independent and prosperous Ireland, the poem imagines the end of his exile. Here the emphatic and unquestioned distinctiveness of the round tower motif, together with its traditional permanence, might also be read as healing or occluding any sense of untrustworthy modernity in the public image of the London-based painter. There may indeed also be a more personal feint involved on Mangan's side: as Ciara Hogan has put it, Mangan's own nationalism was of an 'irresolute', rather than firm, character.[48]

Even more cautiously, Sean Ryder has commented that 'Mangan's political views evolved in response to the circumstances in which he wrote, worked, and published, and it is not always possible to judge the "sincerity" of any of the political sentiments expressed in his poems.'[49] Certainly, this reading has shown that 'The Lovely Land' is a complex affair. A poem of apparent naivety and spontaneity, it is in fact a strongly mediated performance. Its Irish nationalism only comes about through a complex interweaving of the classical and the biblical, even while it feeds on English and German precedent. Leerssen has contrasted 'nineteenth-century particularism', within Irish cultural nationalism, with the opposing idea 'that Ireland, like any nation, is part of the world at large, and that Irish nationality, like any nationality, is to be defined as part of, and not in contradistinction to, the world as a whole.'[50] Mangan's poem presents a scene of nationalist recognition that may seem particularist, but which, at closer inspection, reveals itself to be hard to comprehend without an awareness of a wide context. Similar complexity is at work on a generic level. Far from simply replicating a visual landscape, the genre of ekphrasis is in 'The Lovely Land' informed by a subtle combination of the mechanics of pastoral, translation, elegiac ballad, and oath. Word does not straightforwardly follow image, and is imbricated in not only other images – but also other words, both literary and extra-literary. In his light-hearted collection of epigrams and fragments titled 'A Sixty-Drop Dose of Laudanum', Mangan claimed that 'somehow I find that almost every thing that

Ill. 6 [Edward Matthew Ward, *Portrait of Maclise*, 1846.
Oil on panel 45.7 x 35.2 cm. © National Portrait Gallery, London.]

is natural in me is wrong also.'[51] It would be an overstatement to say that everything that is natural in 'The Lovely Land' is wrong – but it would also be quite a stretch to say that this enthusiastic encomium to Irish landscape is purely and exclusively natural.

Notes

1 All quotations from the poem refer to the following edition: James Clarence Mangan, *Poems: 1845-1847 (Collected Works)*, ed. Jacques Chuto, Rudolf Patrick Holzapfel and Ellen Shannon-Mangan (Dublin: Irish Academic Press, 1997), 201–2. The poem can also be found in James Clarence Mangan, *Selected Writings*, ed. Sean Ryder (Dublin: University College Dublin Press, 2004), 230–1.

2 A key study is Richard P. Davis, *The Young Ireland Movement* (Dublin: Gill and Macmillan, 1987). For a short account of the movement's uneasy relations with Daniel O'Connell and its increasing radicalization, see Gearóid Ó Tuathaig, *Ireland Before the Famine, 1798-1848* (Dublin: Gill and Macmillan, 2007 [1972]), 166–80.

3 Sean Ryder, 'Introduction', in James Clarence Mangan, *Selected Writings*, ed. Sean Ryder (Dublin: University College Dublin Press, 2004), 6. Building on the work of Fiona Stafford, Melissa Fegan has suggested that there is a suggestion of 'immersion in and internalization of English Romantic values and aesthetics', even while he twists this precedent in a subversive direction ('"Every Irishman is an Arab": James Clarence Mangan's Eastern "Translations"', *Translation and Literature,* no. 22 [2013], 210). In an otherwise enlightening article, Patricia Coughlan in 1986 contrasted the political and everyday stakes of Mangan's work with its deployment of 'the grand literary inheritance of high Romanticism, with its imperatives arising from the force of the individual will and sensibility' (Patricia A. Coughlan, '"Fold over Fold, Inveterately Convolv'd": Some Aspects of Mangan's Intertextuality', in *Anglo-Irish and Irish Literature: Aspects of Language and Culture,* ed. Brigit Bramsbäck and Martin Croghan, vol. 2. Acta Universitatis Upsaliensis. Studia Anglistica Usaliensia no. 65. [Uppsala: The University of Uppsala, 1988], 198). More recent scholarship has however shown that these two tendencies are not exclusive of one another – since a notion of the everyday is central, for instance, to the achievement of Wordsworth – and I have therefore chosen not to distinguish between them here.

4 Edna Longley, 'No More Poems about Paintings?', in Edna Longley, *The Living Stream: Literature and Revisionism in Ireland* (Newcastle-Upon-Tyne: Bloodaxe, 1994), 227–51.

5 W. J. T. Mitchell, *Iconology: Image, Text, Ideology* (Chicago, IL: The University of Chicago Press), 1986.

6 'Maclise's Illustrations of Moore', *The Nation*, 29 November, 1845, 12. The article bears some similarity to work by Thomas Davis in *The Nation,* but was published after the latter's death on 16 September, 1845. In the single scholarly discussion of 'The Lovely Land' of any length, David Lloyd frames his reading with a brief explication of Davis's essay on 'National Art' (published in *The Nation* on 2 December, 1843), which calls for an idealization of Irish history and landscape in the nationalist cause. Lloyd's reading centres on what he understands to be Mangan's ambivalence with regard to artistic representation: see David Lloyd, *Nationalism and Minor Literature: James Clarence Mangan and the Emergence of Irish Cultural Nationalism* (Berkeley, CA: University of California Press, 1987), 95–8. I quote from another part of Davis's important article later on in this essay.

7 'Maclise's Illustrations of Moore' (29 November, 1845), 12.

8 'Maclise's Illustrations of Moore' (6 December, 1845), 8.

9 *The Nation,* 22 November, 1845, 6. Interestingly, a little earlier in 1845 – on March 22 – a column in *The Nation* entitled 'Literary Intelligence' mentioned the forthcoming edition of Maclise's

illustrations to Moore's melodies in the company of 'Mr. Petrie's long desired essay on the Round Towers of Dublin' and an edition of Mangan's poems.

10 'Sketches and Reminiscences of Irish Writers. No. IX. William Maginn, LL.D.', in James Clarence Mangan, *Prose: 1840-1882, Correspondence (Collected Works)*, ed. Jacques Chuto et al. (Dublin: Irish Academic Press, 2002), 218.

11 See particularly the introduction to Jean-Luc Nancy, *The Birth to Presence,* trans. Brian Holmes et al. (Stanford: Stanford University Press, 1993).

12 James Clarence Mangan, *Poems: 1848-1912, General Index (Collected Works),* ed. Jacques Chuto, Tadhg Ó Dúshláine and Peter van de Kamp (Dublin: Irish Academic Press, 1999), 56.

13 Mangan, *Poems: 1848-1912,* 230.

14 James Clarence Mangan, *Prose: 1832-1839 (Collected Works),* ed. Jacques Chuto et al. (Dublin: Irish Academic Press, 2002), 129.

15 William Butler Yeats, *Early Articles and Reviews,* ed. John P. Frayne and Madeleine Marchaterre (New York: Scribner, 2004), 99.

16 Oona Frawley, *Irish Pastoral: Nostalgia and Twentieth-Century Irish Literature* (Dublin: Irish Academic Press, 2005), 43.

17 See Ellen Shannon-Mangan, *James Clarence Mangan: A Biography* (Blackrock: Irish Academic Press, 1996), 417.

18 Mangan, *Poems: 1848-1912,* 137-8.

19 Robert Welch writes the following of 'A Vision of Connaught in the Thirteenth Century', a poem published in *The Nation* one week prior to 'The Lovely Land': 'The poem appeared in the *Nation* on 11 July 1846, when during the hot and unnaturally humid summer it was beginning to be apparent that the potato crop that year was to be a total failture' (Robert Welch, *Irish Poetry from Moore to Yeats* [Gerrards Cross: Colin Smythe, 1980], 108).

20 William Wordsworth, *The Poems,* ed. John O. Hayden, vol. 1 (Harmondsworth: Penguin, 1977), 523–9.

21 Mangan did not translate 'Die Götter Griechenlands', but shows familiarity with it in Mangan, *Prose: 1832-1839,* 98 and 268.

22 Mangan, *Prose: 1832-1839,* 81.

23 John Keats, *Poems,* ed. Gerald Bullett (London: Dent, 1974), 191.

24 Thompson quoted in James Kilroy, *James Clarence Mangan* (Lewisburg, PA: Bucknell University Press, 1970), 27.

25 James A. W. Heffernan, *Museum of Words: The Poetics of Ekphrasis from Homer to Ashbery* (Chicago and London: The University of Chicago Press, 1993), 14.

26 The editors of a recent selection of Mangan's verse point towards this problem, when their introductory note states that the poems 'appear as Mangan himself presented them, that is as originals or translations. However, the reader is invited to bear in mind that "translations" may be original poems, and vice versa' (Jacques Chuto et al., 'Editors' Note', xx, in James Clarence Mangan, *Selected Poems,* ed. Jacques Chuto et al. [Dublin: Irish Academic Press, 2003]).

27 Mangan, *Prose: 1840-1882,* 223.

28 The identification of Poussin as a master of sunlight, in stanza four, echoes Mangan's 1937 claim that 'Poussin thought it essential to the effective development of his Arcadia to represent the sunset as illuminating the looks of his shepherds' in *Les Bergers d'Arcadie* (Mangan, *Prose: 1832-1839,* 128).

29 Although such an understanding of translation is common, it is not uncontested: see chapter 6 of Peter Robinson, *Poetry & Translation: The Art of the Impossible* (Liverpool: Liverpool University Press, 2010).

30 David Lloyd, 'James Clarence Mangan's Oriental Translations and the Question of Origins', *Comparative Literature* 38, no. 1 (1986), 26. Jacques Chuto writes that 'we believe that we are reading Wetzel translated by Mangan, whereas we are actually reading Mangan disguised as Wetzel' (Chuto quoted in Welch, *Irish Poetry from Moore to Yeats*, 84).

31 Murray's introduction is on the internet page 'Landscape and Irish Identity', accessed 8 August, 2013, http://www.crawfordartgallery.ie/exhibitions_Landscapes_of_Ireland.html. See also Finola O'Kane, *Ireland and the Picturesque: Design, Landscape Painting, and Tourism, 1700-1840* (London: Yale University Press, 2013).

32 James Clarence Mangan, *Poems: 1845-1847*, 223.

33 For a reading sensitive to the form of the 'Ode to the Maguire', that also places it deftly in the context of the development of an Irish poetical idiom, see Matthew Campbell, 'Lyrical Unions: Mangan, O'Hussey and Ferguson', *Irish Studies Review* 8, no. 3 (2000), 325–38.

34 Tom Dunne, 'The Installation of Captain Rock', in *Daniel Maclise, 1806-1870: Romancing the Past*, ed. Peter Murray (Cork and Kinsale: Crawford Art Gallery and Gandon Editions, 2008), 104.

35 Mangan, *Poems: 1838-1844*, 120.

36 Mangan, *Poems: 1838-1844*, 240

37 Thomas Moore, *Moore's Irish Melodies: The Illustrated 1845 edition*, illustrated by Daniel Maclise (Mineola, NY: Dover, 2000), 38. Maclise's illustration to this song does not include the round tower motif.

38 See Joep Leerssen, *Remembrance and Imagination: Patterns in the Historical and Literary Representation of Ireland in the Nineteenth Century* (Cork: Cork University Press in association with Field Day, 1996), 108–43.

39 Lines 35-6 of 'The Pillar Towers of Ireland', in Denis Florence MacCarthy, *Ballads, Poems, and Lyrics, Original and Translated* (Dublin: James McGlashan, 1850), 142.

40 On the Clonmacnoise image, see Tom Dunne, 'Towards a National Art? George Petrie's Two Versions of *The Last Circuit of Pilgrims of Clonmacnoise*', in *George Petrie (1790-1866): The Rediscovery of Ireland's Past*, ed. Peter Murray (Cork and Kinsale: Gandon Editions, 2004), 126–36. Dunne touches briefly on Petrie's article on 'Remains at Monasterboice, County Louth', *The Irish Penny Journal* 1, no. 7 (August 1840), 49–50. Here Ireland's 'national individuality' is said to be embodied in 'green open landscapes' featuring 'the dark and ruined castle, seated on some rocky height, or the round tower, with its little parent church, in some sequestered valley, . . . of such a scene we should say emphatically, This is Ireland!' Two weeks later, Mangan published his poem 'Woman of Three Cows' in the same journal.

41 Leerssen, *Remembrance and Imagination*, 108.

42 See Geoffrey H. Hartman, *Wordsworth's Poetry, 1787-1814* (New Haven and London: Yale University Press, 1971), 33–69.

43 *The Nation*, 15 September, 1849, 11.

44 Mangan, *Prose: 1840-1882*, 239.

45 *The Nation*, 2 December 1843, 12.

46 Peter Somerville-Large, *1854-2004: The Story of the National Gallery of Ireland* (Dublin: National Gallery of Ireland, 2004), 37.

47 *The Nation,* 22 November 1845, 10.

48 Ciara Hogan, ' "Lost Hero of the Past": Ruin, Wound, and the Failure of Idealism in the Poetry of James Clarence Mangan', *Études Irlandaises,* 35, no. 1 (2010). For an even more ironic reading of Mangan's nationalism, see Lloyd, *Nationalism and Minor Literature.*

49 Ryder, 'Introduction', 8.

50 Leerssen, *Remembrance and Imagination,* 231.

51 Mangan, *Prose: 1832-1839,* 274.

SEEING THE HISTORY OF THE EARTH IN THE CLIFFS AT MØN

The Interaction between Landscape Painting and Geology in Denmark in the First Half of the 19th Century

GRY HEDIN

[ABSTRACT]

During the first part of the nineteenth century, geologists developed a history of the earth so different from that accepted in previous centuries that it encouraged a rethinking of the relationship between man and nature. In this article I will argue that painters followed these changes closely and that some of them let the narratives and images of geology inform the way they depicted nature. In arguing my point, I will focus on images and descriptions of the chalk cliffs on the Danish island of Møn by both geologists and painters. I will follow the scientific advances in geology by referring to the texts and images of Søren Abildgaard, Henrich Steffens, Johan Georg Forchhammer, and Christopher Puggaard, and discuss how their changing theories correspond with paintings of the cliffs by four artists: Christopher Wilhelm Eckersberg, Frederik Sødring, Louis Gurlitt, and Peter Christian Skovgaard.

.

KEYWORDS *Landscape painting, science, geology, the nineteenth century, Christopher Wilhelm Eckersberg, Frederik Sødring, Louis Gurlitt, and Peter Christian Skovgaard.*

The white chalk cliffs on the Danish island of Møn have been termed the most interesting geological site in Denmark.[1] The cliffs were not only seen as a spectacular site untouched by humans, but also as a location where the forces that had created the landscape had left decipherable traces. In their investigations of the cliffs, four geologists, Søren Abildgaard (1718-1791), Henrich Steffens (1773-1845), Johan Georg Forchhammer (1794-1865), and Christopher Puggaard (1823-1864), looked for signs of what had happened, and tested the many varying ideas about the origin of the earth presented in international geology.[2] The cliffs thus became an important site for the development of geology in Denmark during its heroic age – the years between 1790 and 1840 when geology was consolidated as a science internationally.[3] During these years, painters travelled to the island 140 kilometres south of Copenhagen to make the cliffs a motif in their paintings. Though many of these paintings do not exhibit the increasing geological knowledge of the site, some do. In the following, I will analyse paintings by Christopher Wilhelm Eckersberg (1783-1853), Frederik Sødring (1809-1862), Louis Gurlitt (1812-1855), and Peter Christian Skovgaard (1817-1875). I believe these paintings reflect the shifting narratives and images of geology (ill. 1, 3, 6, 9).

Gry Hedin, research fellow in art history at *Statens Museum for Kunst* in Copenhagen
Aarhus University Press, *Romantik*, 02, 2013, pages 77-101

The geological features of these paintings have not received much attention in research. References to geology have been made a couple of times by scholars such as Gertrud Oelsner and Karina Lykke Grand, but geology has not been investigated as an important discourse in itself – only in relation to other discourses. Grand argues that painting the cliffs was part of the development of tourism, while Oelsner argues that it was part of a political project in which painters were encouraged to depict Denmark.[4] Though these fields of research provide important insights into the topic at hand, it is necessary to examine in more detail the ways in which art interacts with geology. The discipline of geology was at this time complex, i.e. recognising many conflicting theories at once. A study of individual works and specific relationships between artists and geologists is needed to unravel the implications of the interaction between landscape painting and geology. Scholars such as Rebecca Bedell, Charlotte Klonk, and Timothy Mitchell have shown that such an approach can yield important insights. They have studied interactions between art and geology in English, American, and German painting in the first half on the nineteenth century.[5] Works by Danish painters have not been discussed in the light of the developments in geology, and this I will do here in order to contribute to this field of research in nineteenth century landscape painting.[6]

Shifting Narratives of the Physical History of the Earth

During the first part of the nineteenth century geology was a science in rapid development, but the narratives that were presented are easily forgotten today, as new narratives have replaced them. Today, it is argued that nature is 'no longer a force separate from and ambivalent to human activity . . . Humanity forms nature. Humanity and nature are one, embedded from within the recent geological record'.[7] To understand this thesis, which is called the anthropocene, the developments in geology in the first half of the nineteenth century must be studied.[8] The narratives developed then constitute a contrast to the present narratives, but they also constitute their starting point. Before our current focus on future developments, the focus was on reconstructing history; and before humanity was given the pivotal role of transforming the face of the earth, the role of humanity was reconsidered as the biblical account was rejected.

It is not surprising that this crucial shift in geology was initiated in the era of Romanticism. This was a time when the relationship between man and nature was reconsidered in regard to the possible presence of God, and it was a time when the past was considered with renewed interest and used to understand the present. Though the developments in geology in general shared these Romantic interests, many geologists came to challenge central Romantic notions, such as natural philosophy and subjectivism, to embrace a more empirically based attitude towards science.

The narratives that geologists presented in the early nineteenth century focused on the physical history of the earth. Geologists rejected earlier notions that considered the planet to be static and fairly young, but this process was not a simple one, and the presented narratives clashed. In 1779, the German mineralogist Abraham Gottlob Werner (1749–1817) proposed the idea of Neptunism. He suggested that the earth's crust had been formed in stages out of a primordial ocean by precipitation from water. In 1812, the French zoologist Georges Cuvier (1769–1832) presented an opposing theory, arguing that catastrophes had formed the landscape and caused extinction. Though Cuvier did not refer to religion, English geologists such as William Buckland (1784–1856) sought to integrate biblical and geological history on this basis. In 1830, Charles Lyell (1797–1875) presented a theory that focused on slow changes happening over a long period. He argued that the face of the earth had evolved slowly over an immense period of time solely under the influence of the forces now present. Lyell's narrative of deep time meant that many scientists abandoned their attempts to reconcile the biblical narrative of creation with the history of the earth. For many, however, this did not mean a rejection of religion but rather a rethinking of the story of creation and the presence of God.[9]

Danish geologists were keen to test these theories and make their own contributions. They tested their ideas on the cliffs at Møn and developed theories that could encompass the geohistory of the site. Painters followed these developments closely and, as we shall see, let the shifting narratives and images of these theories inform their images of the cliffs. Though many of their paintings are accessible today in displays of nineteenth-century art in museums, the theories that informed them have been forgotten.

The First Descriptions of the Cliffs by Eckersberg and Abildgaard

One of the first artists to depict the cliffs was Christopher Wilhelm Eckersberg. His *The Cliffs at Møn. View to Sommerspiret* from 1809 (ill. 1) centres on one of its most distinctive features, the chalk formation called Sommerspiret. When Eckersberg painted the cliffs, the only geological description available was Søren Abildgaard's *Physisk-Mineralogisk Beskrivelse over Møens Klint* [A Physical-Mineralogical Description of the Cliffs at Møn]. Abildgaard was both a draughtsman and a scientist, and he was the father of Eckersberg's teacher at the Royal Danish Academy of Art, Nikolai Abildgaard.

Written in 1781, Abildgaard's book presents a geology about to enter a state of renewed interest and consolidation, and he lets old narratives of the history of the earth mingle with new. He argues that the chalk with its layers of flint consists of sediments of an ancient seabed and incorporates this narrative into the story of the flood in Genesis. He observes that strata are not horizontal, but bend, and argues that these irregularities are the result of a catastrophe that happened in ancient times when the earth's axis moved. This event caused the bibli-

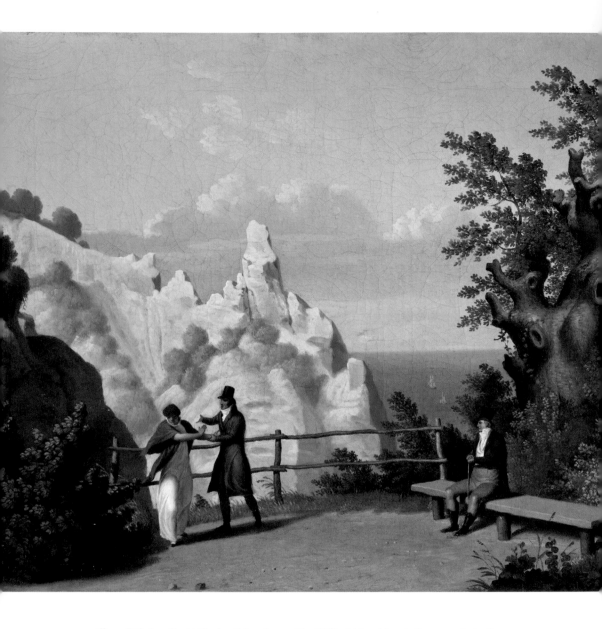

Ill. 1 [Christoffer Wilhelm Eckersberg, *The Cliffs at Møn. View to Sommerspiret*, 1809. Oil on canvas, 38.5 x 45.5 cm. Fuglsang Kunstmuseum. Photo: Ole Akhøj.]

cal flood, and Abildgaard thus expected to find bones of the people who drowned in the flood among the fossils hidden in the cliffs.[10]

Abildgaard produced two illustrations for his book (ill. 2). He writes that he has carefully chosen the spot from which to observe the cliffs.[11] Like the text, however, the image seeks to bridge new observations and existing conventions. He carefully registers how strata bend and closely observes the irregular profile of the cliffs at the formation called Taleren. However, he does not differentiate between the materials making up the cliffs, and the way he renders the vegeta-

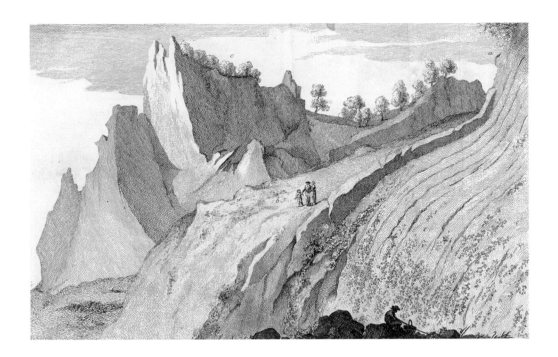

Ill. 2 [Søren Abildgaard, *Physisk-Mineralogisk Beskrivelse over Møens Klint,* 1781, plate 2. Det Kongelige Bibliotek.]

tion is repetitive rather than based on observations of singular plants. He also departs from pure observation in the way the figures are added. A fisherman sits below the cliffs; and, at the top, a man keeps a tight hold on the arm of a child to prevent it from falling. The addition of such figures ties the image to late-eighteenth-century pictorial conventions. This reflects the fact that geology had not yet established its own visual language, and that the transfer of inspiration between geologists and artists could have geologists on the receiving end. Most importantly, Abildgaard's illustration exposes an urge to fit what is observed into existing conventions, which is also reflected in the way he chooses to extend, but also to maintain, the biblical story in the accompanying text.

Like Abildgaard's images of the cliffs, Eckersberg's painting is only to a certain extent based on observation. He has clearly observed the main structure of the landscape, as is evident from a sketch belonging to Statens Museum for Kunst (Inv.no. KKS 396). In the final painting, however, he creates an environment in which the trees and vegetation are examples of their kind rather than specific representations of trees and plants. Here, the light from the setting sun does not appear as the effect of a real light source as much as a way to provide balance in the composition and lead our gaze towards the cliff. The cliff appears as a smooth formation painted in different shades of white from pale pink to subtle yellow-ish tones. The painter registers no lines of strata; neither does he differentiate between the different materials that make up the cliff.

Like Abildgaard, Eckersberg adds a narrative: A man points with his hand towards the cliff and with the other grabs the arm of a woman. He appears to be trying to persuade her to enjoy the view, but she turns away from him and the view as if she is afraid of heights. By adding this narrative, Eckersberg expresses an attitude that focuses on nature as a sounding board for human emotions. This attitude ties the painting to an eighteenth-century pictorial tradition that centres on the way in which visitors can experience both beauty and the sublime, when they look at spectacular sites in nature. In such images, elements like cliffs are not objects of observation in and of themselves, but part of an evocative scene.[12]

In these early images of the cliffs at Møn, observations of the particularities of the site are limited, and existing narratives and conventions are only challenged to a limited extent. Eckersberg may have known Abildgaard's book, but the similarities between Eckersberg's and Abildgaard's images do not betray this. Rather, they share late eighteenth-century pictorial conventions. At this time, geology had not yet developed its own narratives and visual language, but soon it was to develop as a science and to pique the interest of artists – among them Eckersberg. Shortly after Eckersberg finished his painting, he went to Paris and Rome. The reforms he brought about at the academy of art when he returned prepared the ground for connecting art and science. He encouraged his students to paint sketches on the basis of observations of nature and to attend lectures by natural scientists – among others the geologist Georg Forchhammer, and the physicist Hans Christian Ørsted.[13]

Materiality and the Power of Water in Works by Sødring, Steffens, and Forchhammer

One of the first paintings to exhibit explicit knowledge of geology is Frederik Sødring's *Chalk Cliffs on the Island of Møn* from 1831 (ill. 3). Not only the choice of motif but also the detailed observations and the depiction of the drama at sea, reflect with geology. When Sødring worked on his painting in 1830–1, two studies of the cliffs had replaced Abildgaard's: Henrich Steffens' *Geognostisch-geologische Aufsätze* [Geognostical-geological Papers] from 1810 and Forchhammer's *Om de geognostiske Forhold i en Deel af Siælland og Nabøöerne* [On the Geognostical Features in a Part of Zealand and the Neighbouring Islands] from 1825.[14] Steffens was a leading figure in the introduction of German Romanticism in Denmark through a series of lectures in 1802. In his works on geology, he created a synthesis between the geology of Werner and the philosophy of Schelling, incorporating ideas of volcanic activity as well.[15] Whereas Steffens lived and worked in Germany from 1804, Forchhammer was an active participant in the intellectual circles in Copenhagen. Sødring was a student at the academy from 1825 and likely attended Forchhammer's twelve lectures on colour chemistry, given in the winter of 1828 and popular among students at the academy.[16]

Sødring presents a view of the cliffs from the beach towards Sommerspiret. The steep walls of the chalk cliffs tower in the air above a slope of softer materi-

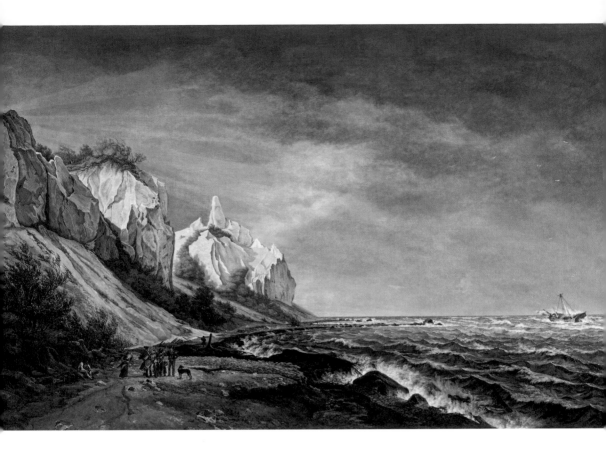

Ill. 3 [Frederik Sødring, *Chalk Cliffs on the Island of Møn*, 1831.
Oil on canvas, 100 x 163 cm. © Lower Saxony State Museum.]

als. Below them, the waves of a turbulent sea break against the granite boulders on the narrow beach; and, farther away, a ship is stranded. Two aspects of the painting are interesting in relation to Forchhammer's and Steffens' accounts of the cliffs: Sødring's interest in the structure and materiality of the cliffs with its strata and his depiction of the power of water.

Sødring exhibits an interest in the different materials of the cliffs that is very similar to Forchhammer's description of them. While Abildgaard focused on the cliffs as a chalk formation, Forchhammer describes in great detail how layers of clay, rubble, and sand interrupt the layers of chalk, and he analyses the distribution of these materials in order to determine the age of the cliffs. Sødring renders the structure and colour of the different materials that make up the cliff landscape. He depicts Sommerspiret as a white formation but differentiates between different shades of ochre, and a darker grey and brown in the cliff walls beneath it and to the left. He is attentive to rough edges and cracks, and uses the light to emphasize the irregularity of the cliff walls. He also observes how a thin layer of soil at the top of the cliffs makes the chalk a fertile ground for vegetation.

Ill. 4 [Frederik Sødring,
Chalk Cliffs on the Island of Møn,
1831, detail.]

Sødring, however, not only observes the cliffs with the same type of scrutinizing gaze as Forchhammer. He also directs his gaze toward the exact aspects of the landscape that Forchhammer pointed out as distinctive characteristics of the cliffs at Møn. First and foremost, Sødring renders slanting strata on several parts of the cliff to the left. He paints them as individual systems of delicate broken lines that are irregular, but parallel to each other (ill. 4). Interestingly, this area is expanded and worked out in much more detail than in the painted sketch now at Fuglsang Kunstmuseum (inv.no. 1996/7). Thus, the complex depiction of strata is not necessarily the result of a scrutinizing gaze, as much as the result of an intention to pass on geological information. By choosing to render strata as lines, rather than portraying them as made up of individual flints, he renders strata in the same way as the geologists of the time. Forchhammer discusses strata and the way they bend at Møn at great length as he was puzzled about what forces had caused them to bend.[17] Second, Sødring renders the interplay between the soft slopes and the steep walls. In his text, Forchhammer discusses the fact that the chalk formation appears to rest on a softer material of sand and clay. He believed this material to belong to the Tertiary Period and, therefore, suggested that the cliffs were much younger than other chalk formations, a hypothesis that met great resistance.[18]

Another aspect of the way the cliff landscape is depicted links it to the geology of the time, namely Sødring's emphasis on the power of water. This is not about observing geological features, but about creating a narrative. The cliffs act as the stage for a shipwreck: A ship is stranded to the right, and people are gathered on the shore. Thus, instead of presenting an evocative view of the cliffs alone, Sødring dramatizes the landscape by making the cliffs part of a drama at sea. The power of water is reinforced in the way waves break against the stones in the foreground, and in the way heavy clouds in the sky suggest imminent rain.

This emphasis on water addresses the natural force that, according to Steffens, had formed the cliff landscape. Steffens considers water to be the most im-

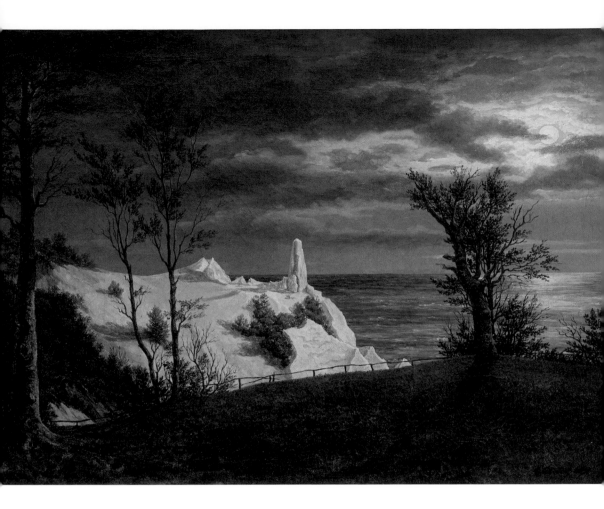

Ill. 5 [Frederik Sødring, *Sommerspiret on the Chalk Cliffs of the Island Møn. Moonlight*, 1831. Oil on canvas, 30 x 41.5 cm. Statens Museum for Kunst. Photo: SMK foto.]

portant creative force behind the landscape formation at Møn. He argues that, with great violence, the Baltic Sea had broken a continuous chain of chalk mountains into the now separate cliffs at Stevns, Møn, and Rügen. In this way, the Baltic Sea had forced its way to the North Sea.[19] In 1822, Forchhammer refers to Steffens' account as incisive and excellent but, in 1825, avoids mentioning him.[20] Forchhammer, by and large, eschewed grand narratives to avoid speculation. Nevertheless, he refers to the consensus of the time that giant floods had created the landscape of northern Europe.[21]

Sødring's painting may be seen in conjunction with issues dealt with in geology at the time. However, another painting of the same year, *Sommerspiret on the Chalk Cliffs of the Island Møn. Moonlight* (ill. 5), is without any trace of a reference to what was going on in geology. It is a reminder of the fact that not all paintings of the cliffs express an interest in geology.

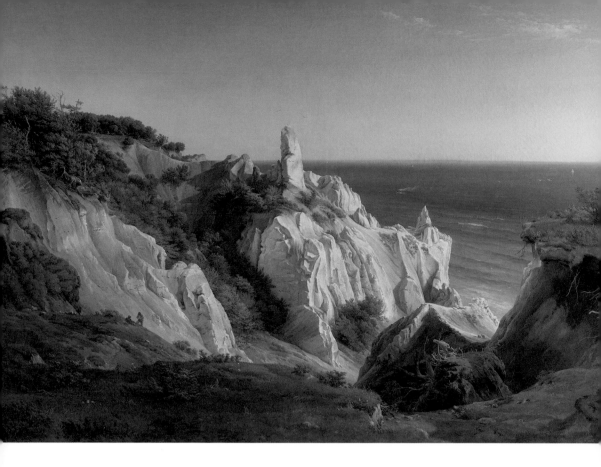

Ill. 6 [Louis Gurlitt, *The Cliffs of the Island of Møn*, 1842.
Oil on canvas, 138 x 197 cm. Statens Museum for Kunst. Photo: SMK foto.]

The Cliffs as National History in Works by Gurlitt and Forchhammer

Another artist to incorporate geological features in a painting of Møn is Louis Gurlitt. In *The Cliffs of the Island of Møn* (ill. 6), a large painting from 1842, he offers a view of Sommerspiret, the same formation that Sødring and Eckersberg depicted.

The most recent investigation of the cliffs available to Gurlitt was a recent book by Forchhammer: *Danmarks geognostiske Forhold* [The Geognostical Features of Denmark] from 1835. Forchhammer's book has a double aim: First, the geology of Denmark as a nation is described in detail; second, the geohistory of Denmark is brought into accord with the newest developments in geology, in which tectonic forces had replaced accounts stressing the power of water. In his introduction, Forchhammer presents geology as an autonomous science that is no longer a footnote to the book of Genesis.[22] On this basis, he then provides a thorough description of the geology of Denmark, not omitting mention of the nation's growing need for resources for its dawning industries. Gurlitt's painting reflects both: the nationalist interests and the detailed and revised geological description.

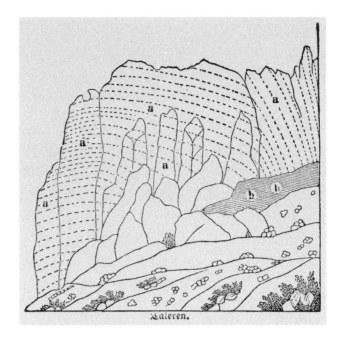

Ill. 7 [Georg Forchhammer, *Danmarks geognostiske Forhold forsaavidt som de ere afhængige af Dannelser, der ere sluttede*, 1835, p. 70. Det Kongelige Bibliotek.]

Forchhammer's book may have caught Gurlitt's attention. Forchhammer's aim of mapping Denmark was congruent with a new trend in the visual arts to portray various parts of the country. In 1840 and 1841, Gurlitt painted various landscapes representing different parts of Denmark. The Danish king, Christian VIII (1786–1848), bought four such monumental paintings from Gurlitt; and, in 1842, he asked Gurlitt to paint Møn.[23] Christian VIII was an important patron of both painters and scientists and an important link between the two. He was the president of *Det Kongelige Danske Videnskabernes Selskab* [Royal Danish Academy of Sciences] from 1838–48 and went on geological expeditions.[24] He may have asked Gurlitt to paint the cliffs, not only because it was a site known for its spectacular beauty, but also because Forchhammer, in his mapping of the nation's geology, had pointed to it as the nation's most interesting geological site.

Gurlitt was born in Altona in Holstein and was a student at the academy of art in Copenhagen from 1832. Though he received attention from the king and the public, he lacked the support of his fellow artists, who judged his style to be too German.[25] Skovgaard, for example, explains that he had a difficult time look-ing at the cliffs after seeing Gurlitts' painting.[26]

Gurlitt presents a detailed depiction of the cliffs with attention to features in the landscape that were significant to geologists at this time. The cliffs are rendered in great detail with attention to their vertical fractures, which were also registered in detail in the illustrations in Forchhammer's book (ill. 7). Further-

more, Gurlitt registers how flint stones create strata. Such strata are seen in detail to the left and from a distance on Sommerspiret itself. A sketch in Kunsthalle zu Kiel (inv.no. 1938-39-SHKV 509) shows how conscientiously he observed the area around the spire. The line of strata, however, is not featured on the sketch, rather it is added to the painting as a deliberate gesture to geology. Whereas attention to the materiality of the cliff and its strata was also visible in Sødring's painting, the landslide in the right foreground is a new feature. The viewer is positioned very close to the landslide beneath the steep edge of the cliff and, because of the large format of the painting, the drama of the landslide is felt strongly. Through the landslide, Gurlitt shows that the cliffs were under constant change, a notion in accordance with recent developments in geology, which Forchhammer dealt with in his book.

Phenomena such as landslides gained geological significance after Lyell presented a new narrative in geology in 1830. He focused on slow evolution and insisted that the landscape was subject to continual change. Forchhammer got to know Lyell well, after the English geologist responded to his aforementioned attempt to date the cliffs at Møn to the Tertiary Period. In 1834, they visited the cliffs together, and Forchhammer then revised his dating.[27] Though he now took tectonic forces into account, he was reluctant to accept the way Lyell relied only on forces no more powerful than today. Instead, he argued for a compromise between Lyell's account of slow change and the catastrophes of Cuvier.[28] In accordance with Lyell, he explains ancient formations by making analogies to phenomena he can still observe in operation,[29] and thus phenomena caused by continual slow changes, such as landslides, gained geological significance. Opposing Lyell, however, he continues to argue that catastrophes had interrupted what he calls the earth's periods of rest. Thus, a giant flood is still part of his account and, to this, he adds a period of underground volcanic activities. These, he believed, caused uplifts that made strata bend.[30]

Features significant to geologists appear in the painting; but at the same time, Gurlitt does his utmost to create a monumental image of a beautiful spot. This creates a tension between art and geology in two respects. First, the way the landscape is painted disturbs the objectivity of the 'geological gaze'. The golden glow of the rising sun and the resulting intensity of the colours make the cliff scenery evocative. Second, a steamship to the right and a pastoral scene of shepherds and their sheep to the left indicate a sense of time different from the strata in the cliff. The shepherds and the steamship not only function as indications of the physical scale of the cliffs, they also act as indicators of different notions of time. Whereas the steamship marks the landscape as belonging to modern times,[31] the pastoral scene acts as a mark of timelessness since it points to a tradition of Arcadian landscapes. Both indicate notions of time different from the strata in the cliff, which instead point to geological time and the many years that passed before humanity began to inhabit the landscape. No harmony exists between these diverse notions; as the steamboat interrupts the peace of the pastoral scene, the strata interrupt the beauty of the cliff almost like dirt or clods in the paint.

Looking Far into the Abyss of Time in Works by Skovgaard and Puggaard

Peter Christian Skovgaard made his first watercolour of the cliffs in 1841. Four years later, an influential art historian at the academy, Niels Lauritz Høyen (1798–1870), encouraged him to revisit the site. He wrote to Skovgaard that '*Der er rigt Stof for en Maler!*' and that '*Klinten fortæller paa flere Steder saa at sige sin egen Historie*' [There is a wealth of material for a painter! . . . In several places, the cliff, so to speak, tells its own story].[32] Thus, Høyen, who at the time was instrumental in bringing artists and scientists together, not only directs Skovgaard toward the cliffs as a motif for his art, he also directs him toward the geohistory of the site. The geohistory of Møn came to interest Skovgaard to an extent that surpasses the interest in geology of Sødring and Gurlitt. Therefore, it is not surprising to find Skovgaard collaborating with a geologist, Christopher Puggaard.[33]

In 1851, Puggaard published the result of an extensive survey of the geology of Møn: *Möens Geologie. Populært fremstillet. Tillige som Veiviser for Besögende af Möens Klint* [The Geology of Møn: A Popular Presentation as well as a Guide for Visitors to the Cliffs at Møn]. When Puggaard planned the illustrations, he asked for the assistance of three artists: Eckersberg, Skovgaard, and Vilhelm Kyhn (1819-1903). Eckersberg delivered a drawing of the cliffs at Stevns from which Skovgaard made a vignette, and Skovgaard also made a vignette with an image based on one of his own watercolours. Kyhn engraved other vignettes and also produced a foldout sheet with a drawing of the cliffs seen from the sea.[34]

In his book, Puggaard presents a theory of the cliffs with a focus on Lyell's theory of deep time. Unlike Forchhammer, Puggaard is not uncomfortable with Lyell's expanded timescale. On the first pages of his book, he gives an account of how planet Earth started as a ball of fluid stone and then developed into a planet with evolving life.[35] In the following three hundred pages, he gives a detailed account of how the site of Møn changed. After being an ocean inhabited with tropical species, the site developed into an arctic ocean where icebergs deposited erratic boulders, and finally the site became a wooded island inhabited by mammoths and Stone Age men. The signs telling this fantastic story are the different materials in the cliffs' sedimentary layers, the nature of the fossils found in the layers, the way these stratified layers bend, and, lastly, the shape and mineralogical character of the erratic boulders.

Skovgaard assisted Puggaard with a vignette for the first chapter of the book: an image of Taleren seen from a distance (ill. 8).[36] Like the other vignettes, this image is without any trace of the geological knowledge of the cliffs that Puggaard presented. Taleren is seen from a distance under passing clouds, and details such as strata and the structure of the cliffs are missing. Rather than offering the reader an application of geological knowledge, Skovgaard stresses the beauty of the landscape and helps Puggaard make the text 'a popular presentation'.

Instead, the alliance between art and geology materialises in another work by Skovgaard: *View of the Sea from Taleren at the Cliffs at Møn* from 1851 (ill. 9). It is no-

Ill. 8 [Christopher Puggaard, *Möens Geologie*, 1851.
Vignette by Peter Christian Skovgaard, p. 1. Det Kongelige Bibliotek.]

table that Skovgaard chooses Taleren as the motif for his large painting. Whereas many artists chose to depict Sommerspiret, geologists rarely mention this formation but instead discuss Taleren at great length. While Sommerspiret caught the attention of artists, Taleren was examined by geologists.

Skovgaard's painting is very similar to the illustration of Taleren in the back of Puggaard's book (ill. 10). The two men observe its irregular profile from more or less the same spot, and they both register how strata of flint create delicate, slanting lines. The strata lines are very similar, but there are slight differences (ill. 11, 12). Skovgaard may have consulted Puggaard's illustration, but he did not base his painting on it. Though he may have simply registered what he saw, he is influenced by what geology made him expect to see. He passes this information on to the viewer as he accentuates strata in a fashion similar to geological illustrations. In the foreground, he provides the viewer with three close-up studies of strata, depicting how individual flints create these lines. Strata are signs to be read by observers informed by geology; and, as Skovgaard presents them in the painting, he offers the informed viewer an image of the grand narrative of the earth. When we read the lines of strata from top to bottom, our gaze travels through long periods of time; and when we follow their bends and curves, we witness the work of the tectonic forces that Puggaard argued had formed the landscape.

Boulders are another sign which Puggaard discusses, and they are evident in Skovgaard's painting. Unlike strata, the boulders occupy a very small space in the painting, and they may seem insignificant. According to Puggaard, rounded

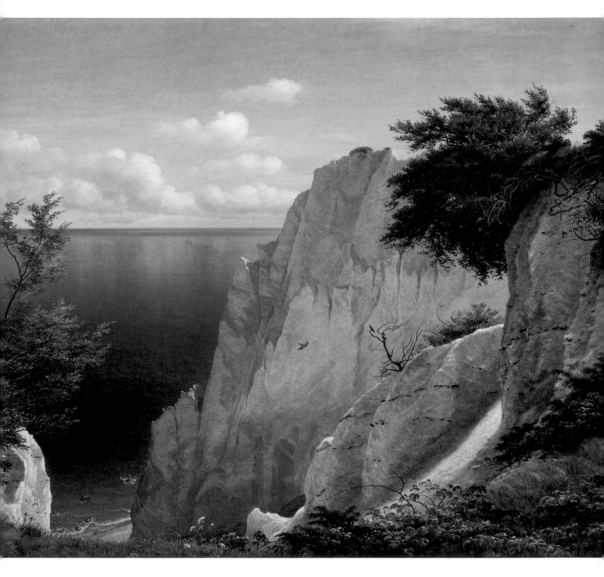

Ill. 9 [Peter Christian Skovgaard, *View of the Sea from Taleren at the Cliffs at Møn*, 1851.
Oil on canvas, 114 x 141 cm. Private collection. Photo: Ole Akhøj.]

boulders make it possible '*at skue tilbage til en uendelig fjern Tid för Menneskeslægtens Skabelse*' [to look into an infinitely distant past before the creation of man] as their shape and mineralogical character convey their origin and journey from the Scandinavian Mountains.[37]

This experience of looking into 'an infinitely distant past' was shared among geologists visiting important geological sites. Puggaard returns to it repeatedly, but it is also found in international geology. Thus, for example, the Scottish geologist John Playfair describes what he felt when he visited an important geological site in Scotland in 1805: 'The mind seemed to grow giddy by looking so far into the abyss of time.'[38] Skovgaard's painting effectively encourages the beholder to

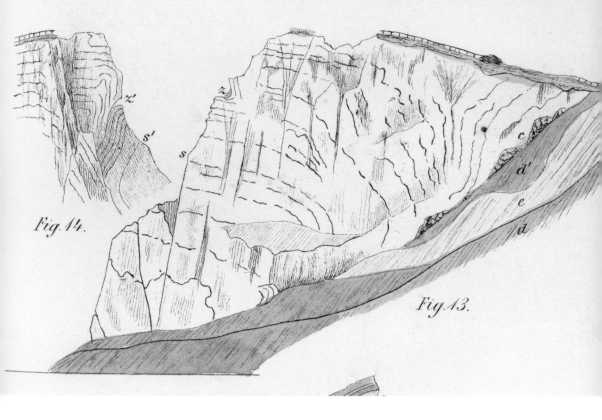

Ill. 10 [Christopher Puggaard, *Möens Geologie*, 1851, plate 13. Det Kongelige Bibliotek.]

Ill. 11 [Christopher Puggaard, *Möens Geologie*, 1851, plate 13, detail.]

Ill. 12 [P.C. Skovgaard, *View of the Sea from Taleren at the Cliffs at Møn*, 1851, detail.]

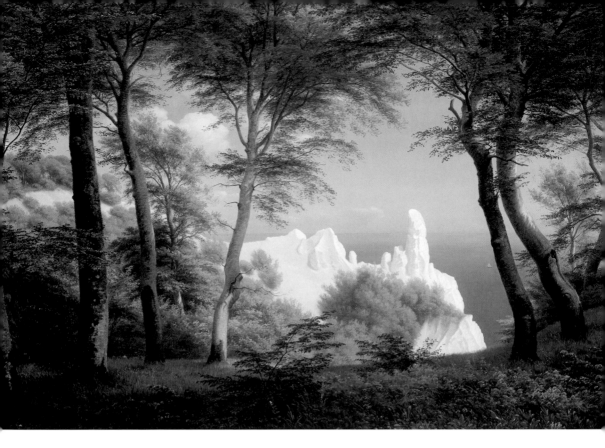

Ill. 13 [Peter Christian Skovgaard, *View of the Sea from the Cliffs at Møn,* 1850. Oil on canvas, 124 x 185 cm. The Skovgaard Museum. Photo: Ole Misfeldt.]

experience this abyss of time. The experience may be achieved through an interpretation of strata and boulders, but Skovgaard also encourages it by the way he constructs the pictorial space. Through the contrast between the boulders at the shore and the small ships, he creates a horizontal space that makes the verticality of the cliffs stand out, and he lets the two birds in the middle of the image direct our attention towards the cliff wall with the strata.

The experience of seeing the history of the cliffs is also reinforced in the way Skovgaard situates himself as observer in time. The narrow foreground reveals the spot from which he observed the cliff; and when he registers the way light affects the colour of the cliff, he situates his image in time. Thus, he presents us with the exact time and place at which he observed the cliff, creating an opportunity for the viewer to experience the history of the cliffs vicariously through the painter. Thus, Skovgaard combines a geological gaze with the gaze of a painter by mixing the methods and narratives of geology and painting.

Outlook and Conclusion

I have focused on a limited number of paintings of the cliffs at Møn by a limited number of artists, selecting images that convey knowledge of geology. Geology and painting, however, do not present an easy fit, and several objections may be raised. In the following, I will anticipate and address the two most important. First, however, I will make a short detour into the aforementioned research on interactions between art and geology in German, English, and American art to indicate how the Danish material fits into a broader context.

In Germany, Caspar David Friedrich (1774–1840) painted several images that connect to geology. As Timothy Mitchell argues, there are references to geology in *Der Watzmann* (ill. 14) from 1825. As is the case in the Danish paintings, an analysis of the relationship must be precise with regard to developments in geology at the time. Mitchell argues convincingly that Friedrich's image relates to the theories of Werner and Goethe. Thus, a Harz mountain outcrop is placed in front of an Alpine massif, the Watzmann, to convey that second-stage mountains rest on a foundation of granite.[39]

In American art, many images include very direct references to geology. For example, Thomas Cole's *The Subsiding of the Waters of the Deluge* from 1829 (ill. 15). Cole's image reveals an interest in linking geology with the biblical account and relates to attempts by, among others, Buckland to use geology as an argument for biblical history.

In England, a long tradition exists of conveying geological knowledge in paintings. One of the clearest examples is William Dyce's *Pegwell Bay, Kent – A Recollection of October* from 1858 (ill. 16). The geological content of the image lies in the detailed description of the materiality of the cliffs with their strata. In the painting, Dyce juxtaposes geology with zoology by having the women collect shells on the beach; and, through the depiction of a comet in the sky, he links geology and zoology with astronomy.[40]

Understood in an international context, it is not surprising to find references to geology in Danish paintings from this era. There are, however, complications. First, it may be asked whether the detailed depictions of the cliff landscape are the result of the painters' scrutinizing gazes rather than a transfer of knowledge between very different fields. Such a gaze is a common denominator between art and science, and it rests on the notion that there is a common ground in the way nature is perceived during a particular period. As far as the painter's interest in the materiality of the cliffs is concerned, this may be the case. However, Sødring and Gurlitt add strata to the final images that are missing in the sketches. It is certainly possible that sketches unknown to us today show these strata, but this at least indicates that the depiction of strata is a deliberate act and that illustrations in books on geology might have been used. It is also worth noting that geologists' attention shifted between different aspects of the landscape as geology developed as a science in its own right. As shown, these shifts also appear in paintings. This is the case with Sødring's depiction of the power of wa-

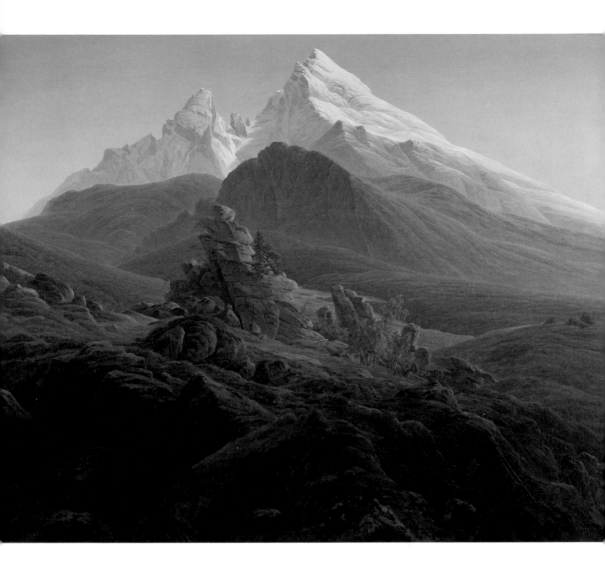

Ill. 14 [Caspar David Friedrich, *Der Watzmann,* 1825.
Oil on canvas, 133 x 170 cm. bpk / Nationalgalerie, SMB,
Leihgabe der DekaBank / Andres Kilger.]

ter, Gurlitt's landslide, and Skovgaard's depiction of the abyss of deep time. The
question of a common scrutinizing gaze versus a transfer of knowledge, however,
is not only a question of the painter's intention. The geological meaning of fea-
tures such as strata, landslides, and boulders did not necessarily have to be picked
up by painters to become part of a transfer of meaning. Their geological meaning
could also be activated by viewers of the paintings with a knowledge of geology.
Many viewers indeed possessed this knowledge. Geology was a popular science at
the time, and its texts were written in a language not reserved for specialists in
the field.

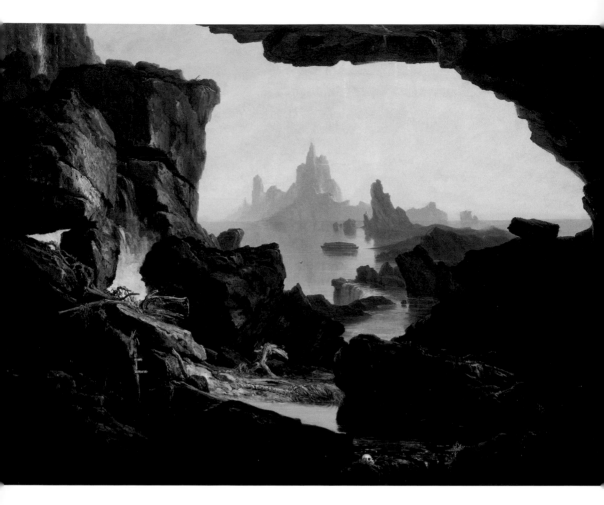

Ill. 15 [Thomas Cole, *The Subsiding of the Waters of the Deluge*, 1829.
Oil on canvas, 90.8 x 121.4 cm. Smithsonian American Art Museum, Gift of Mrs. Katie
Dean in memory of Minnibel S. and James Wallace Dean and museum purchase through
the Smithsonian Institution Collections Acquisition Program.]

Second, if a transfer of knowledge is going on between art and geology, it may
be asked why so few paintings exhibit this knowledge. The answer is not lack of
knowledge since Danish painters, as argued, came into contact with the develop-
ments in geology. The influential art historian Høyen, along possibly with Chris-
tian VIII, directed artists towards the geohistory of the cliffs. Some artists even
attended lectures by scientists, and three artists provided vignettes for the most
extensive survey of the cliffs, Puggaard's *Möens Geologie*. Nevertheless, the paint-
ings analysed above are exceptions both within the oeuvres of the artists and
among the images of the cliffs as a whole. Thus, Eckersberg's painting from 1809
(ill. 1) is one of the first in this tradition; Sødring's *Sommerspiret on the Chalk Cliffs
of the Island Møn. Moonlight* (1831) (ill. 6) is part of this dominating trend; and even
Skovgaard contributed to this tradition with, among others, *View of the Sea from*

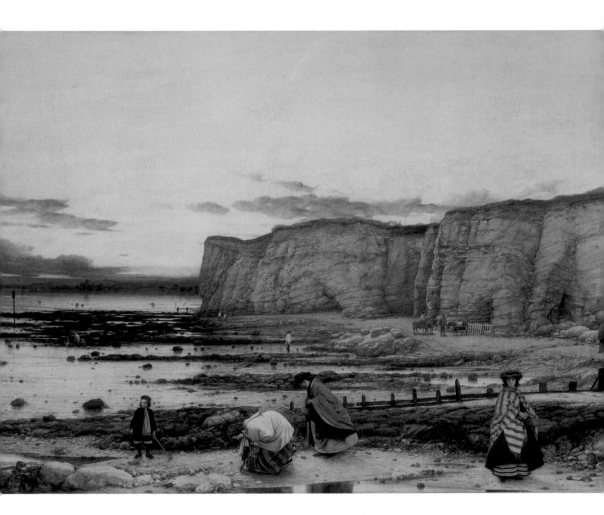

Ill. 16 [William Dyce, *Pegwell Bay, Kent – a Recollection of October 5th 1858,* c. 1858-60. Oil on canvas, 63 x 89 cm. © Tate Britain, London, 2013.]

the Cliffs at Møn (1850) (ill. 13). These paintings may suggest that painters could be reluctant to include references to geology. One reason for such reluctance is formalistic: The visual language of geology, which developed gradually during these years, was far away from the idioms of art and the notions of beauty, the sublime, and the picturesque that dominated art at the time. Another reason to be reluctant, however, was that the narratives of geology raised disturbing questions: How is God present in nature if the biblical account of the creation must be revised? What roles do humans play in the history of the Earth if man only inhabits a small section of time, and is it possible, then, for man to reconstruct the history of the earth? Thus, geology was a science with a potential to unsettle existing conventions, and painters may have felt a reluctance towards geology for this reason.

To conclude, many painters studied the cliffs as a site where the spectator could experience beauty and the sublime – experiences that could be passed on to the viewers of paintings. A few others, however, studied the cliffs as objects of observation in themselves in which the history of the landscape revealed itself to the informed eye. Paintings with geological content reveal the close ties between scientists and artists at this time and reflect the fact that science in these days was available and comprehensible for non-scientists. The lack of geological signs in many paintings does not necessarily indicate a lack of knowledge but that the alliance with geology may have been felt as disturbing to both existing beliefs and pictorial conventions.

Notes

1 Georg Forchhammer, *Danmarks geognostiske Forhold forsaavidt som de ere afhængige af Dannelser, der ere sluttede* (Copenhagen: 1835), 68.

2 A survey of the studies of the cliffs at Møn is provided by Vilhelm Hintze, *Møens Geologi* (Copenhagen: C.A. Reitzels Forlag, 1937).

3 Helge Kragh, *Natur, Nytte og Ånd 1730-1850*. Dansk Naturvidenskabs Historie, vol. 2 (Aarhus: Aarhus University Press, 2005), 360.

4 Karina Lykke Grand, *Dansk Guldalder. Rejsebilleder* (Aarhus: Aarhus University Press, 2012), 55–63; Gertrud Oelsner, 'Udsigt til Guldalderen. Politiske landskaber', in *Udsigt til Guldalderen*, ed. Gertrud Oelsner (Maribo and Viborg: Storstrøms Kunstmuseum and Skovgaard Museet, 2005), 14-15; Gertrud Oelsner, 'Kunstneren som turist', in *Udsigt til Guldalderen*, 97-98; Gertrud Oelsner, 'Skovens demokratiske rum og andre nationale motiver hos P.C. Skovgaard', in *P.C. Skovgaard. Dansk guldalder revurderet*, ed. Gertrud Oelsner and Karina Lykke Grand (Aarhus: Aarhus University Press, 2010), 60, 77; Gertrud Oelsner, 'The Democracy of Nature', *Romantik* 1 (2012): 89-90. In addition to Grand and Oelsner, Bente Scavenius has looked into Møn as a site visited by painters. Her focus, however, is the romantic garden of the country seat of Liselund on the edge of the cliffs, rather than the cliffs as a site of geology (Bente Scavenius, 'Rejsen til de møenske kridtklinter', in *Møen i dansk kunst. Naturromantik i Guldalderen*, ed. Claus M. Smidt (Nivå: Nivaagaards Malerisamling, 1994) and Bente Scavenius, 'De mønske kridtbjerge. Søren Læssøe Lange og C.W. Eckersberg på Møn', in *Udsigt til Guldalderen*).

5 Rebecca Bedell, *The Anatomy of Nature: Geology and American Painting 1825-1875* (Ann Arbor: UMI, 1991); Rebecca Bedell, 'The History of the Earth: Darwin, Geology and Landscape Art', in *Endless Forms: Charles Darwin, Natural Science and the Visual Arts*, ed. Diana Donald and Jane Munro (Cambridge: Fitzwilliam Museum, 2009); Timothy Mitchell, *Art and Science in German Landscape Painting 1770-1840* (Oxford and New York: Clarendon Press, 1993); Charlotte Klonk, *Science and the Perception of Nature, British Landscape Art in the Late Eighteenth and Early Nineteenth Centuries* (London: Yale University Press, 1996).

6 Whereas the relationship with geology has been overlooked, the relationship between art and meteorology is the topic of the anthology: Gertrud Hvidberg-Hansen (ed.), *Himlens spejl. Skyer og vejrlig i dansk maleri 1770-1880* (Odense: Fyns Kunstmuseum, 2002). The relationship between art and the physics of Hans Christian Ørsted has also received much attention in the anthology: Mogens Bencard (ed.), *Krydsfelt. Ånd og natur i Guldalderen* (Copenhagen: Gyldendal, 2000) as well as in: Dan Ch. Christensen, *Naturens tankelæser, en biografi om Hans Christian* Ørsted (Copenhagen: University of Copenhagen, MuseumTusculanum Press, 2009) and in: Helge Kragh, 'Ørsted, natural science and the Danish Golden Age', in *Gold. Treasures from the Danish Golden Age*, ed. Lise Pennington and Karina Lykke Grand (Aarhus: Systime, 2013).

7 Bernd M. Scherer and Katrin Klingan, introduction to *The Anthropocene Project: An Opening January 10-13, 2013* (Berlin: Haus der Kulturen der Welt, 2013), 2.

8 Nobel laureate and atmospheric chemist Paul J. Crutzen formulated the anthropocene thesis. The thesis rests on the claim that the historically-accumulated, planetary environmental effects of an expanding human population, technological innovation, and economic development have become inseparable from the Earth's geo-processes.

9 For a detailed survey of developments in geology during this period, see David Oldroyd, *Thinking about the Earth: A History of Ideas in Geology* (London: The Athlone Press, 1996) and Martin J.S. Rudwick, *Bursting the Limits of Time. The Reconstruction of Geohistory in the Age of Revolution* (Chicago: The University of Chicago Press, 2005).

10 Søren Abildgaard, *Physisk-Mineralogisk Beskrivelse over Møens Klint* (Copenhagen: 1781), 16-7, 58, 66-8.

11 Ibid., preface.

12 Mitchell, *Art and Science,* 13–4.

13 Villads Villadsen (ed.), *C.W. Eckersbergs dagbøger* (Copenhagen: Nyt Nordisk Forlag Arnold Busck, 2009), 1330; Christensen, *Naturens tankelæser,* 1016; Kragh, 'Ørsted', 162.

14 Forchhammer's article was reprinted in 1826 in *Det Kongelige Danske Videnskabernes Selskabs Naturvidenskabelige og Mathematiske Afhandlinger*. I shall refer to this edition. The article was presented in a revised English version in *The Edinburgh Journal of Science* in 1828.

15 Kragh, *Natur, Nytte og Ånd,* 363.

16 For Forchhammer, chemistry and geology were linked, since he used chemistry as an empirical basis for geology. The lectures may have included a discussion of chalk cliffs, since chalk was an important material for painters. The lectures are mentioned in Eckersberg's diary (Villadsen, *Eckersbergs dagbøger,* 330).

17 Georg Forchhammer, 'Om de geognostiske Forhold i en Deel af Siælland og Naboöerne', in *Det Kongelige Danske Videnskabernes Selskabs Naturvidenskabelige og Mathematiske Afhandlinger*, part 2 (1826): 270, 272–4; Georg Forchhammer, 'On the Chalk Formation of Denmark', *The Edinburgh Journal of Science* XVII (1828): 64, 67.

18 Forchhammer, 'Om de geognostiske Forhold i en Deel af Siælland', 271–80; Forchhammer, 'Chalk Formation', 64-6.

19 Henrich Steffens, *Geognostisch-geologische Aufsätze, als Vorbereitung zu einer innern Naturgeschichte der Erde* (Hamburg: Hoffmann, 1810), 210.

20 Georg Forchhammer, 'Om Danmarks geognostiske Forhold', *Tidsskrift for Naturvidenskaberne* 1 (1822): 383. The reason may be that Forchhammer had become uncertain about the scientific quality of Steffens' works. Steffens published his *Anthropogenie* in 1822, a work on geology about which the natural scientist Jacob Hornemann Bredsdorff expressed his concern (Jacob Hornemann Bredsdorff, 'Udsigt over de i Læren om Jordklodens Oprindelse og Uddannelse skete Forandringer fra Aar 1800 af', *Tidsskrift for Naturvidenskaberne* 2 (1823): 79).

21 Forchhammer, 'Om de geognostiske Forhold i en Deel af Siælland', 279–80.

22 Forchhammer, *Danmarks geognostiske Forhold forsaavidt,* 7.

23 Ulrich Schultze-Wülver, 'Louis Gurlitt i Jylland', in *Udsigt til Guldalderen,* 210.

24 Kragh, *Natur, Nytte og Ånd,* 365.

25 Schultze-Wülver, 'Louis Gurlitt', 210.

26 Letter from Peter Christian Skovgaard to Niels Lauritz Høyen 22 August 1846. Cited from J. L. Ussing, *Høyens Levned med Bilag af Breve* (Copenhagen: Samfundet til Den danske Litteraturs Fremme, 1872).

27 Lyell presented his findings from the visit in: Charles Lyell, 'On the Cretaceous and Tertiary Strata of the Danish Island of Seeland and Möen', Geological Society of London, *Geological Transactions* V, second series, part I (1837).

28 Forchhammer, *Danmarks geognostiske Forhold forsaavidt,* 6.

29 Ibid., 37, 40.

30 Ibid., 103-4, 106.

31 Grand, *Dansk Guldalder,* 137.

32 Letter from Niels Lauritz Høyen to Peter Christian Skovgaard 3 August 1845. Cited from Ussing, *Høyens Levned*. The botanist J. F. Schouw, who was a pioneer in plant geography, may have contributed in directing Skovgaard's interest towards the cliffs. Both Schouw and Skovgaard were part of the group around Høyen that met regularly on Fridays (Hans Vammen: ' "Schouw er velsignet..." En professor og hans guldaldernetværk', in *Krydsfelt. Ånd og natur i Guldalderen,* ed. Mogens Bencard (Copenhagen: Gyldendal, 2000), 253. In 1851, Skovgaard married Schouw's daughter, Georgia.

33 Puggaard dedicates his book to his father, the merchant Hans Puggaard. The home of Hans Puggaard was a meeting place for artists such as Bertel Thorvaldsen and Eckersberg.

34 Puggaard thanks Skovgaard for helping him with the vignettes, but no further information has been available as to their collaboration. A number of paintings by Skovgaard from 1846-1851 show his engagement with geology. Skovgaard was aware of what was going on in geology before Puggaard wrote his book and might have learned his first lessons on geology from Forch-hammer. Skovgaard is among the few artists to depict another site of considerable interest to geologists, the cliffs at Stevns. On *Højerup Kirke på Stevns Klint* from 1842, see Oelsner, 'Skovens demokratiske rum', 60.

35 Christopher Puggaard, *Möens Geologie. Populært fremstillet. Tillige som Veiviser for Besögende af Möens Klint* (Copenhagen: C. A. Reitzel, 1851), xxvi-xxvii.

36 Skovgaard based the vignette on one of his drawings now in Statens Museum for Kunst (Inv.no. KKSgb4539). He also created a vignette on the basis of a drawing of the cliff at Stevns by Eckers-berg. Puggaard picked up a couple of small drawings when he visited Eckersberg on Monday, 26 March 1849 according to Eckersberg's diary (Villadsen, *Eckersbergs dagbøger,* 1152).

37 Puggaard, *Möens Geologie,* ii.

38 Cited from Oldroyd, *Thinking about the Earth,* 131. Playfair describes the emotions he felt when he, together with Sir James Hall, looked at rocks at Siccar Point in Scotland.

39 Mitchell, *Art and Science,* 177-9.

40 Bedell, 'The History of the Earth', 62-3.

Too
Frivolo

'TOO FRIVOLOUS TO INTEREST THE PUBLIC'?

Walter Scott, Richard Polwhele, and Archipelagic Correspondence

DAFYDD MOORE

[ABSTRACT]

The Cornish writer Richard Polwhele and Sir Walter Scott corresponded on matters literary and social for a period of 25 years at the start of the nineteenth century without ever meeting. This article examines the published traces of this epistolary acquaintance and establishes what it might tell us about the lines of connection and dissemination it was possible to establish in Romantic Britain between what might otherwise be thought of as outlying areas of the nation. The article contributes to a number of recent archipelagic attempts to better understand the distributed or devolved nature of print culture within the nations and regions of Britain, in this case through a focus on the interconnections between them.

· · · · · · · ·

KEYWORDS *Richard Polwhele, Walter Scott, Poetry, Regionalism, Letter Correspondence.*

In late August 1825, the Cornish clergyman, poet, antiquarian, and controversialist Richard Polwhele wrote to Sir Walter Scott asking for permission to print a selection of the letters he had received from Scott. The two men had never met in person, but had continued correspondence on matters antiquarian, literary and, almost certainly, personal, over a period of nearly 25 years. On 6 October, Scott wrote back granting permission, though he thought 'the greater part of them are too frivolous to interest the public.'[1] A number of letters appeared in volume two of Polwhele's *Traditions and Recollections: Domestic, Clerical, and Literary* of 1826, and a slightly larger selection dedicated to John Gibson Lockhart and glorying under the not insubstantial title of *The Letters of Sir Walter Scott addressed to the Rev R Polwhele; D Gilbert Esq; Francis Douce, Esq, &c., &c. Accompanied by an Autobiographical Memoir of Lieut. General Sir Hussey Vivian* was eventually published in 1832 in London by Polwhele's long-time publisher John Nichols and Son. It is not clear from the published correspondence whether this larger collection was what Polwhele had in mind when he wrote to Scott in the first place. Of the 28 letters published, 20 are to Polwhele, one is to Gilbert concerning Polwhele, two are to Douce on non-Polwhele matters. One suspects that the letters that do not have direct connection to Polwhele owe their presence to the assumption that, in the words of Nichols's advertisement 'nothing that has ever proceeded from the pen of Walter Scott will be unacceptable to the public.'[2] The volume also contains

Dafydd Moore, Professor of eighteenth-century literature, Plymouth University
Aarhus University Press, *Romantik*, 02, 2013, pages 103-124

103

some 200 'introductory lines' by Polwhele, the significant proportion of which are from one of his own letters to Scott. Despite Nichols's confidence, it has to be said that the intervening 181 years have done little to unsettle Scott's initial prediction, and this testament to a quarter of a century's epistolary friendship lies largely forgotten and unread.

This essay aims to redress this neglect (in scholarly terms at least) by arguing that this slim 1832 volume of letters offers an interesting contribution to an increasingly important intersection between two of the recent ways in which critics have questioned the 'Romantic ideology': namely archipelagic understandings of Romantic literary culture, and our increasing sense of the importance of sociability, collaboration and conversation to Romantic culture. As I have argued elsewhere,[3] Polwhele is a figure who should benefit from what Nicholas Roe terms the current 'sharper awareness of the decentred energies of Romantic culture'; the belief that 'regionalism . . . is a key critical dynamic of Romantic studies now' and the conclusion that 'canonical marginality and regional cultures are . . . urgently in need of reassessment within England.'[4] That said, the ways in which such rehabilitation is conducted needs careful attention if it is not to fall victim to the temptations of a naïve assertion in the face of an unfeeling critical establishment. As Murray Pittock puts it, 'the self-congratulation of elements in a local elite are identified as provincial braggadocio by the metropolitan eye, which as a result sees no reason to alter its own perspectives', the upshot of which is 'the prevalence of caricature born either of an exaggerated sense of self-worth or an ignorant desire to dismiss.'[5]

It is in the context of this methodological uncertainty that recent understandings of Romanticism as a phenomenon that 'continued to define itself in terms of conversation' can help to formulate a more sensitive model of attention to regional literatures.[6] An understanding of the neglected regional literary figures of British Romanticism in terms of their interconnections and relationships with others is not without drawbacks. It can lead to a crude reductionism that asserts that the writer discussed is only of value because of a relationship with a previously recognised 'great' (an equation that only reinforces the status quo), and it is vulnerable to the accusation that it is itself a broadly Addisonian (or Johnsonian) version of eighteenth-century culture, and therefore inherently Anglo-cum-metrocentric. Yet, it remains the case that the most satisfying attempts to characterise a version of the past that 'denotes the historiography of no single nation but of a problematic and uncompleted experiment in the creation and interaction of several nations' focus, if only metaphorically, on dialogue and exchange in ways that are more fruitful than shrill assertions of individual worth.[7] In this way, Murray Pittock speaks of the recovery of the 'discarded dialogues of Romanticism in these isles',[8] while Alan Rawes and Gerard Carruthers refer to the 'negotiated dialogues where complicated questions of aesthetics, cultural politics, and nation are asked, and answered in equally complex fashion.'[9] Equally, John Kerrigan characterises archipelagic criticism as a process of 'stripp[ing] away modern Anglo-Centric and Victorian imperial paradigms to recover the long, *braided*

histories played out across the British-Irish archipelago'.[10] The interest in the sociable and archipelagic comes together in John Brewer's claim that provincial intellectuals saw 'themselves not as distant extensions, much less poor imitations, of metropolitan culture, but as integral and important parts of a national, even international, culture',[11] or in Peter Clark's notion of a particularly 'polycentric' British Enlightenment.[12] David Chandler has found evidence for both of these claims in his 'empirical study of the actual mechanisms and patterns of literary production on the ground' in Norwich. In Chandler's work, Norwich emerges as part of the 'increasingly intricate and decentralised national network of literary production' in late eighteenth-century Britain.'[13] That said, relatively little of this work has been explicitly archipelagic in considering the interconnection of these regional nodes of activity, their part of a wider network of non-metropolitan print culture. For example, Chandler focuses on the print culture of Norwich rather than the connections between Norwich and other provincial cities, and Norbert Schürer's account of Jane Cave Winscom's provincial literary career as one conducted entirely separately from the publishing world of London and furthered through engagement with the 'local community wherever she happened to be living' does not consider the links between those communities.[14] In other words the present essay adds to our understanding of the importance of intra-regional provincial print culture through its focus on interconnections between a writer based in Cornwall and Scottish print culture rather than considering Cornish print culture in isolation.

Central to such an effort must be a consideration of why we might find documents such as this of value and interest, of what it may or may not be possible to say about the volume, and for what it might be significant. The subject of the volume of letters is ostensibly Scott – in the literal sense that they are his letters – yet, from a revisionist point of view, it is what they tell us about Polwhele, or at least the relationship between Scott and Polwhele, which is of central concern. Indeed this is barely revisionist given the description in the advertisement of the publication as 'a memorial to the intercourse enjoyed with Sir Walter Scott by the Rev Richard Polwhele', a characterisation that immediately shifts a significant proportion of the emphasis of the volume away from Scott to Polwhele himself. At the same time, however, the point of the exercise is not the hitching of Polwhele's star to Scott's bandwagon in order backhandedly and simplistically to establish the importance of the former. Something like this may have been the equation in Polwhele's mind of course as he wrote to his friend, however paradoxical an effort at self-assertion that might be, given that it comes at the cost of Polwhele rendering himself invisible. But leaving aside the (lack of) credibility of any such a claim, such a simplistic conclusion would run counter to the spirit of a revisionism that seeks a more subtle way of interrogating literary general knowledge than claiming value via a hitherto underemphasised relationship or influence. In other words, the claims that can be responsibly made about this volume, and the relationship to which it testifies, are limited and specific; but it is more, not less, interesting as a consequence.

Before moving on to the letters themselves, it is worth establishing the relative position of the two men at the outset of their correspondence in September 1803. In obvious ways, Scott needs little introduction, though it should be remembered this is not the 'Wizard of the North', but a man at the outset of a literary career, the success of which was far from certain. He had started *The Lay of the Last Minstrel* in 1802, but it would not be published until 1805. He could count himself pleased with the success of his first published effort *The Minstrelsy of the Scottish Border*, the third volume of which had appeared in May 1803, even if Ina Ferris has recently noted that *The Monthly Review* regarded the *Minstrelsy* as a somewhat pretentious effort, the type 'produced by provincial gentlemen as what we would call vanity publishing'.[15] If Scott was at the beginning of his literary career, then Polwhele was approaching the not inconsiderable high-water mark in his reputation as a poet, antiquarian and staunch defender of Church and King. By 1803, he was something of a darling of the literary Right, something that would have only increased his allure for Scott.

Born just outside Truro in 1760, Polwhele died on the same family estate in 1838. In between times, he was a clergyman, poet, polemical journalist and reviewer, translator, satirist, enthusiastic club man, memoirist, antiquarian, and county historian. To the literary historian, Polwhele is known today for one thing, *The Unsex'd Females* (1798), a rabidly anti-Jacobin attack on radical female authorship. That said, his career and interests stretched far beyond this invective. His poetic career began precociously under the encouragement of Cornelius Cardew, the headmaster of Truro Grammar School and John 'Peter Pindar' Wolcot, family friend and mentor to Polwhele. His first volume, *The Fate of Lewellyn* (1778) 'by a young gentleman of Truro School' was published (and critically panned) the year he started at Oxford, though his first poem, in the unlikely shape of a birthday Ode in honour of the republican historian Catherine Macaulay, had been published with five others in 1777. Polwhele left Christ Church Oxford without a degree in 1782 and proceeded to spend much of the 1780s as a curate at Kenton on the Exe estuary, where he socialised amongst the county set and local literati, what General John Graves Simcoe referred to as 'the choice spirits of the West'.[16] Some, such as Richard Hole, author of *Arthur or the North Enchantment* (1789), shared his interest in creating a mythic past for the South West; others, such as his near-neighbour John Swete, shared his passion for antiquarianism; others still, such as the doctor Hugh Downman, shared the interest in didactic poetry that was evidenced in his *The Art of Eloquence* (1785). During this time, Polwhele completed one of his most enduring works – his translation of *The Idylls, Epigrams, and Fragments of Theocritus, Bion, and Moschus, with the Elegies of Tyrtaeus* (1786) – and began collecting materials for his first county history. He also drew together the works of the poets of the region in a two volume *Poems, Chiefly by Gentlemen of Devonshire and Cornwall* (1792). He was, furthermore a founder member of the Exeter Society of Gentlemen, which met from 1792 and produced a volume of Essays in 1796. If there was such a thing as a Devon or Exeter 'Enlightenment', commit-

ted to the ideals of polite and sociable learning, then the activities of Polwhele and his friends were it.

Polwhele's sustained interest in the landscape and history of Devon and Cornwall manifested itself in various ways over a career of nearly 60 years. The heroic romance and tragedy of his youth (much influenced by Macpherson's *Ossian*) continued into his maturity in poems such as *Fair Isabel of Cotehele* (1815), a six-volume heroic romance. But in poetry it also took more internalised forms, in *Pictures from Nature in 19 Sonnets* (1786) and in such poems as *The Influence of Local Attachment* (written 1790, published in 1796), and his 'Ode on the River Colly' (1792). The *Influence of Local Attachment* was perhaps Polwhele's most significant poetic work. It enjoyed a high enough profile for the *Monthly Review* to go to the trouble of accusing it of plagiarising Samuel Rogers' *Pleasures of Memory* (something strenuously denied by Polwhele) and was, as we shall see, central to Scott's admiration for Polwhele. More recently David Hill Radcliffe has cited it as a key part of the Spenserian tradition that evolved through the late eighteenth century.[17] Away from poetry, *The Historical Views of Devonshire* (1793), *History of Devonshire* (1793–1806) and, in particular, his *History of Cornwall* (1803–1807; 7 vols 1816) are all key documents in the historiography of the region. The first two are rather uneven and were considered somewhat disappointing at the time, but posterity has been kinder: the most wide-ranging survey of writing about the area describes his collective efforts 'magnificent studies' that 'scarcely have an equal' for their time.[18]

This survey started by alluding to Polwhele's political writings, and it is important to note that his Tory credentials went beyond *The Unsex'd Females*, particularly in matters of doctrine. He attacked, amongst other things, Methodism (both published sermons and pamphlets), and was a stalwart contributor to the loyalist press, especially the *British Critic* and *Anti-Jacobin Review*.[19] He also had what today might be called 'presence in the field', as his work was widely reviewed and recommended by like-minded individuals. Number 33 of John Watkins' *The Peeper: A Collection of Essays, Moral, Biographical and Literary*, entitled 'On the Social Relation and Domestic Attachment' ends by quoting Polwhele's *Influence of Local Attachment* and its belief in the 'usefulness [of local attachment] to our families, in the exercise of domestic virtues, and, on a wider scale, to our country'.[20] Indeed, it goes so far as to recommend the purchase of a copy by all readers. *Local Attachment* is not an explicitly political poem, though in its promotion of a sentimental attachment to home, family, and native scene it elucidates a conservative patriotic discourse most famously developed by Edmund Burke in his *Reflections on the Revolution in France* with its emphasis on the 'little platoon' as 'the first link in the series by which we proceed towards a love to our country and to mankind'.[21] Similarly Polwhele's friend, the controversialist and antiquarian John Whitaker, devoted a significant number of his reviews for the vehemently anti-Jacobin *British Critic* (for which he was a major contributor) to various of Polwhele's publications, which must have further established them within the conservative literary

establishment.[22] His connection with the Devonian Grandee Sir George Yonge led to the *History of Devonshire* being dedicated to King George III, and subscribers to his *Poems Chiefly by Gentlemen* included Prime Minister William Pitt, Pitt's brother Chatham and Pitt's successor as Prime Minister William Grenville (the latter being an old Christ Church acquaintance of Polwhele). Though it should be noted that, in a rather typically Polwhelean moment, one of the reasons this is known is the letter from Polwhele to John Nichols on 15 December 1794, in which Polwhele complains about the famous subscribers who have yet to pay up.[23]

One further aspect of Polwhele's career is worth touching upon, as it provides the most immediate context for the volume of Scott's letters under discussion here. During the last fifteen years of his life, Polwhele devoted most of his energies to his memoirs, which appeared variously as *Traditions and Recollections: Domestic, Clerical and Literary* (1826), *Biographical Sketches of Cornwall* (1831) and *Reminiscences in Prose and Verse* (1836). While these can be rather repetitive and formless, and are not as well known or as comprehensive as his friend John Nichols's *Literary Anecdotes of the Eighteenth Century* (1812–1815), they do represent an invaluable and much-cited source of information about literary, publishing and political networks and activities during the period. During this phase in his career, Polwhele ostensibly records the correspondence he has enjoyed from a range of famous and not so famous figures in order to offer an insight into these individuals. He is, of course, also demonstrating how well connected a national literary figure he had been in ways that are themselves revealing of the literary, biographical and wider cultural values and assumptions of the day. In these works (as in the Scott volume), what is important about this activity is less the degree to which Polwhele succeeds in establishing his own reputation, and more the manner in which he stages the attempt.

Such questions of staging are important in the Scott volume because it seems likely that Polwhele was selective in choosing the letters of Scott's in his possession that he published (unusually so for a man whose editorial instincts veered to antiquarian comprehensiveness). He does not reproduce more than three letters from any one year, and there is a period of some nine years between letters at one point. This may, of course, merely prove how desultory their correspondence was, but a comparison with the *Millgate Union Catalogue of Walter Scott Correspondence* is instructive. It only lists 19 letters to Polwhele by Scott, even though Polwhele published 20. The discrepancy is probably on account of Scott's first letter going via a third party, but the differences do not end there. Within his 20 Polwhele publishes three letters that are not in the *Catalogue*, while the *Catalogue* indexes three letters by Scott to Polwhele that Polwhele did not chose to reproduce. In some ways the first of these facts is the most intriguing, since it suggests a body of letters available to Polwhele not currently known to scholarship (and which may subsequently have been lost). The catalogue also records 24 letters by Polwhele to Scott, a number of which, when compared with the pattern of known letters from Scott, have no obvious reply. This is particularly notable in the years between 1816 and 1820 when it appears that Polwhele was writing to Scott on

something approaching a regular basis – certainly regularly enough to have suggested he was getting at least some sort of reply.

There is some internal if similarly circumstantial evidence to the existence of these missing letters. On 10 July 1814, for example, Scott refers to a letter he is about to send offering Polwhele advice on a manuscript (probably *Fair Isabel of Cotehele*). This letter is not reproduced (and is not indexed in the *Catalogue*, which contains nothing between 10 July 1814 and a letter of September 1814 also reprinted by Polwhele). Perhaps most strikingly, there are (as we shall see) occasions where Scott demonstrates an awareness of Polwhele's circumstances that hints at a level of intimacy that must have been established and maintained by more than the subject matter represented by the published letters. Of course, the reader only ever witnesses one side of this conversation, and it is impossible to know what exactly Scott is responding to. But the matter-of-factness with which he mentions things in passing (often things unconnected with the immediate context of the letter) does suggest other communication and knowledge, probably of a personal nature. In isolation, each of these circumstances can be explained away in a number of different ways. But taken together, they convey the impression of a more expansive relationship of which the reader is witnessing only some edited highlights. In any case, it is important to be clear about what is at stake and what is not at stake in understanding this body of letters as a sample. The point is not (as it would be if this was a reductive exercise in establishing Polwhele's importance purely on the basis of his relationship with Scott) to explain away an inconveniently slender body of evidence as merely a selection from a more substantial body of work vouching a more substantial relationship. Nor is it primarily about the squirrelling out of undiscovered facts or supposing lost caches of letters (though the idea of a box of letters from Scott sitting in the attic of a rectory in Cornwall, undiscovered to this day, is a rather appealing one). Rather, seeing the volume as a selection allows for consideration of the ways in which Polwhele chooses to stage their correspondence (and the network of literary exchange to which it testifies), how he wishes to represent it and what, of course, might slip through about which Polwhele is himself unconscious. With this in mind, in the rest of this essay I am going to discuss the different types of letters the reader is offered as a means of knowing this friendship and the significance for a more substantial understanding of literary culture across the British archipelago.

At the outset of their friendship their correspondence is scholarly in nature, a part of, in Adam Fox's words, the 'collaborative and communal dimension' of eighteenth-century antiquarianism.[24] In fact, Scott and Polwhele's acquaintance came about by chance, via a third party, and as a result of both men's antiquarian efforts and reputations. In the summer of 1803, Scott met two Cornishmen lodging in the Tweedside village of Clovenford. One of the Cornishmen, Clement Carlyon, by coincidence shared a surname with a Cornish place name in *Sir Tristram*, the text of which metrical romance Scott was at that time preparing for the press, and a manuscript of which, according to Carlyon, Scott was able to

produce from his pocket. Scott wanted to know whether there was still a Cornish port named Carlyon, and, more generally, what Carlyon thought of the text. Carlyon confessed his ignorance on matters Cornish, but suggested that Polwhele might be approached, specifically because Polwhele was at that time engaged on matters Arthurian by way of a supplement to chapter 11 of the second volume of the *History of Cornwall*.[25]

This story fits with what is known about the genesis of *Sir Tristram*. It has been established that Scott started editing and preparing notes for the edition in early 1801, and by October 1802 the edition was set in type, though it would not be available to the public until September 1804. The delay was because, according to John Sutherland, Scott was 'nervous about his scholarship' and eager to 'reassure himself and convert his antiquarian friends to his thesis' about the provenance of the poems (in vain as it turned out).[26] So, it is more than possible that Scott had a fair copy of the text with him in September 1803, and this eagerness to reach out to scholars who may help corroborate his notes is also consistent with Sutherland's view of the process of bringing *Sir Tristram* to print. Furthermore, Scott did write to Polwhele, via Carlyon, on 1 September 1803. Polwhele apparently did not reply until 16 January 1804, and Scott sent his first letter in person less than two weeks later, on 27 January. This is perhaps indicative of who was the more eager of the two at this moment in time. On 27 Scott gives further details of the poem, and answered one particular point in Thomas Malory's version of the Tristram legend that seemed to have outraged Polwhele, namely the alleged cowardice of the Cornish. Scott reassures him that there is not the 'least allusion' to what he terms the 'heresy' of Cornish cowardice in the 'ancient poems'.[27] The *Morte d'Arthur*, says Scott, has 'no authority whatever, being merely the shadow of a shade, an awkward abridgement of prose romances'.[28] Scott moves his letter to a close with the promise to answer any other questions Polwhele may have. He also poses some more of his own as evidence of Cornish traditions and the places associated with Tristram. Finally, Scott compliments Polwhele by suggesting that he is a man 'to whose literary and poetical fame our northern capital is no stranger'.[29] So began the correspondence that would last, on and off, for a quarter of a century. In many ways it conforms to Rosemary Sweet's description of the content and function of exchanges between such correspondents: the 'free exchange of artefacts, manuscripts, and books, the performance of services (such as making transcriptions, identifying references) and the opportunity to exercise patronage by which the recipient was assisted, and the credit and reputation of the patron was enhanced.'[30] But where Polwhele and Scott's relationship complicates this model is in the dynamic nature of the power relations between the two men. In 1803, one could make a relatively strong case for saying Polwhele was performing the role of patron (and indeed being constructed in the role by Scott). It would not remain that way for long. It also differs from Sweet's description in the way in which it broadens itself beyond the strictly antiquarian and into other areas, in particular the workings of the book trade.

In fact, the letters Polwhele chooses to print are almost entirely to do with the business of literature. At the simplest level, the two men swapped books. Polwhele sends Scott of his poetic and historical works, with which Scott (in the letters reproduced by Polwhele) announces himself well pleased. Indeed Scott seemed genuinely to have admired Polwhele's poetry, and he would publically acknowledge the debt owed to Polwhele's verse by one of the most famous passages of his own, the opening of the sixth canto of *The Lay of the Last Minstrel*:

> Breathes there a man, with soul so dead,
> Who never to himself hath said,
> This is my own—my native land?
> Whose heart hath ne'er within him burned
> As home his footsteps he hath turned
> From wandering on a foreign strand[31]

Scott was happy to admit that this was inspired by the opening lines of the first book of *The Influence of Local Attachment*:

> Breathes there a spirit in this ample orb
> That owes affection for no fav'rite clime;
> Such as the sordid passions ne'er absorb,
> Glowing in gen'rous hearts, unchill'd by time
> Is it – ye sophists! – a venial crime
> To damp the love of home with scornful mirth?
> Though, led by scientific views sublime,
> Ye range, with various search, the realms of earth, —
> Seeks no returning sigh the region of your birth?[32]

At the same time, many of Scott's letters to Polwhele are in fact notes accompanying books he is sending his Cornish friend. For example, in July 1811, this was one of 50 privately printed copies of an edition of his *Don Roderick*. On 11 October 1810, Scott writes enclosing a set of his three-volume edition of Anna Seward's poems (Seward, 'the Swan of Lichfield', had died in March 1809). Looked at from the point of view of the negotiation and maintenance of friendship based on mutual respect and admiration, it is worth noting that this edition contained Seward's 'Sonnet to the Rev. Richard Polwhele on his poem *The Influence of Local Attachment*':

> POLWHELE, whose genius, in the colours clear
> Of poesy and philosophic art,
> Traces the sweetest impulse of the heart,
> Scorn, for thy Muse, the envy-sharpen'd spear,
> In darkness thrown, when shielded by desert

She seeks the lyric fane. To virtue dear
Thy verse esteeming, feeling minds impart
Their vital smile, their consecrating tear.
Fancy and judgment view with gracious eyes
Its kindred tints, that paint the silent power
Of local objects, deeds of high emprize
To prompt; while their delightful spells restore
The precious vanish'd days of former joys,
By Love, or Fame, enwreath'd with many a flower.[33]

Sweet has suggested that the gift economy at the heart of relationships such as this offered both parties 'affirmation of [their] own taste', since, 'by flattering the learning and discernment of his correspondent', a writer was 'indirectly laying claim to such approbation for himself'.[34] This is happening to a rather head-spinning (indeed consequentially potentially nauseating) degree here, as Scott gifts Polwhele something he has himself produced, but which includes a poem by a third party in praise of Polwhele.

At a time when books remained, relatively speaking, expensive, the maintenance of acquaintance through the gifting of one's books made other statements about the value one might ascribe to the relationship and indeed one's economic and social status. It seems to have been a feature of other of Polwhele's friendships. William Bligh (of the mutiny fame) was one such acquaintance.[35] They met when Bligh was arrested and hauled before Polwhele (in his capacity as Justice of the Peace) for snooping around Cornish beaches. Bligh was, in fact, surveying on behalf of the Admiralty, probably in 1798. After this conspicuously inauspicious start the men became friends (Bligh was of Cornish extraction and Polwhele's eldest son was in the Navy). It is known that Bligh gifted Polwhele three of his own books, and de Montluzin speculates that this is likely to have been reciprocated.[36] Certainly, Polwhele's correspondence with his friend and bookseller John Nichols provides evidence of the store he set by such things. On 18 April 1792, Polwhele wrote to Nichols with nine copies of the two-volume set of *Poems by Gentlemen of Devonshire and Cornwall*, one for Nichols and eight for a list of friends, including Anna Seward, William Hayley, William Cowper, Erasmus Darwin.[37] Polwhele's *Traditions* also dutifully records the letters of thanks and congratulation he received in response from these individuals. On other occasions, he is asking for copies of works of his that Nichols is selling to be sent to correspondents as far afield as Bishop Auckland and Lincoln.[38]

Of course, this exchange of material had an implicit and at times explicit purpose beyond friendship gift-exchange and what Sweet terms the 'reciprocity of obligation'.[39] The men were swapping books so the other could review them. Thus, in 1808, Polwhele asks Scott to review his 1796 *Influence of Local Attachment* (which would reach its fourth edition by 1810) in the *Quarterly Review*. Polwhele also wanted Scott to put in a good word for him as a potential contributor with the editor William Gifford, both of which Scott says he is happy to attempt (and

he was still asking Gifford about reviewing *Influence* two years later). Equally, we know from Scott's letter of acknowledgement that in 1815 Polwhele sends Scott two copies of *Fair Isabel of Cotehele*, one for Scott himself, and one for Francis Jeffrey. Scott reassures his friend 'that I will not fail to put [it] into [his] hands . . . and request him to read it with attention.'[40] Nor, it should be said, was this all one-way traffic. Scott tells Polwhele he is going to send him something he calls in a letter of 1810 'Northern Antiquities' and suggests that Polwhele reviews it in the *Quarterly*. This book was not his edition of Thomas Percy's 1770 translation of Paul Henri Mallet's *Northern Antiquities*, but something that appeared some four years later than this letter as *Illustrations of Northern Antiquities from the earlier Teutonic and Scandinavian Romances* (1814). Such goings-on were an essential part of the way in which the wheels of the book reviewing business were oiled, given that review copies were not routinely issued by publishers.[41]

In 1810, the book that was eventually published as *Illustrations of Northern Antiquities* was to be the first volume of a projected series. On two occasions, in October and December of that year, Scott writes to ask Polwhele to contribute. As Scott puts it in his second letter, 'if you have any thing lying by you which you would entrust to this motley caravan, we will be much honoured.'[42] Such comments gloss Scott's efforts to get Polwhele's work published in Edinburgh. From the perspective of the twenty-first century, it would be easy to assume that this dimension to their friendship came from (the now obscure) Polwhele's desire to be published. Yet, this would be to overlook the fact that Polwhele had no difficulty in finding booksellers (including major ones) willing to publish his material in London, Bath, Exeter, or in Cornwall itself. Indeed, the *Oxford Dictionary of National Biography* suggests that Polwhele's reputation has suffered as a result of his 'fatal fluency of composition', implying that had Polwhele found it harder to find his way into print his standing as a poet might be higher.[43] That is as may be, but what is clear is that the establishment of an Edinburgh outlet was not merely a question of expediency on Polwhele's part, and, at least, initially was probably as much to do with Scott's needs as those of Polwhele. The letters tell the stories of two particular poems that Polwhele attempted to get published in Edinburgh, with mixed success.

In early 1812, Polwhele sent Scott with the manuscript of his poem *The Deserted Village-School* to see if Scott could find an Edinburgh publisher. This was a long politically-motivated parody in forty-two Spenserian stanzas of Oliver Goldsmith and William Shenstone, taking as its subject a then-current controversy about the most effective form of education in teaching useful skills for the lower classes. The specific details of the controversy (between the supporters of two similar but subtly different methods of education associated with Joseph Lancaster and Andrew Bell) need not detain this essay. Suffice it to say Polwhele takes the characteristically contrary – reactionary – approach of disagreeing with both factions on the grounds that both tend towards the breaking of local and domestic attachment. Scott wrote to Polwhele on 29 February 1812 telling him that even though he 'liked the poetry very much, and much of the sentiment

also', he could not see the bookseller Ballantyne publishing this. According to Scott, all of Edinburgh had taken one side or the other in this debate and 'no one will care to bring forth a poem that laughs at both.'[44] Scott fears that 'suspicion of authorship would probably attach' to himself, and continues that he will 'not urge' Ballantyne to publish. Scott reports that he will be in Edinburgh within the week, will get a definitive answer to convey along with, he assumes, the unwanted manuscript, back to Cornwall. But despite Scott's prediction, and as Polwhele's matter-of-fact note on the letter relates, Ballantyne did in fact publish the *Deserted Village-School* that spring. If this attempt ended in success (albeit against Scott's better judgement), less happy was the fate awaiting Polwhele's completion of Beattie's *The Minstrel; or, The Progress of Genius* (1771/2), in Edinburgh at least. In December 1811, Scott reports that the Ballantynes 'will esteem themselves happy and proud to publish any thing of yours', and that their slight hesitation prompted by the fact that it is a continuation of a well known poem has been overcome by Scott's suggestion of a title page which should not advertise the poem as a continuation, with such declarations being 'reserved for the preface or introduction'.[45]

Whatever might be made of this rather sharp practice, it is certainly evidence of Scott's engagement with, and investment in, the project of publishing Polwhele. Unfortunately for Polwhele, however, the financial hardships in the publishing world (and beyond) of 1812 doomed the poem with Ballantynes, though it was eventually published by the well-known London firm of Rivington in 1814. Moreover it has been identified by David Hill Radcliffe as one of the more significant attempts made to continue the poem around this time.[46] In breaking the news to Polwhele, Scott was adamant that this retrenchment of the business was the sole reason for their last minute refusal since 'independent of the merit of the performance itself, your name alone would have been sufficient to recommend any thing to a publisher in Scotland.'[47] By the same token, the following year, Scott was still encouraging Polwhele that 'assuredly I will have the greatest pleasure in reading anything of yours, and recommending it to the booksellers.'[48]

Scott's would-be patronage of Polwhele went beyond finding a home for his finished manuscripts. In 1814, at the beginning of a period during which, according to Catherine Jones, Scott was planning to write a history of Scotland, they discussed the possibility of Polwhele undertaking some such venture (at Polwhele's suggestion, it appears).[49] Scott is confident that he will be able to provide Polwhele with the necessary contacts and introductions to access the archives he needs in Edinburgh, but the letter (dated 3 April 1814) ends on a bittersweet note:

but I fear that without a residence of many months in this place, very little could be done; and I should rejoice to think this were possible for you, as I should then have the pleasure to improve our epistolary into personal acquaintance. But I doubt whether your other avocations will permit your making so great a sacrifice to your literary pursuits.[50]

Scott's references to the burdens of Polwhele's clerical and domestic duties in West Cornwall make this a poignant moment, all the more so because Polwhele himself very rarely otherwise makes mention of such things anywhere in his work. Yet, he must have discussed them with his Scottish friend. It is perhaps needless to say that there is no evidence that Polwhele did ever go to Edinburgh.

Polwhele's interest in preserving details surrounding mechanisms and networks of patronage, publication and dissemination is notable. It can in part be explained by antiquarian punctiliousness (and an antiquarian overestimation of just how fascinating such minutiae might be), but it is also the case that it seems to have run deep in Polwhele's sense of himself as a literary figure of some importance, a player within a national print culture. It is equally strong in the series of memoirs that provide the most immediate context for the Scott volume. It is possible to read, for example, of Polwhele's early relationship with the agricultural reformer and keen sponsor of young literary talent Edmund Rack (1735?–1787). Rack was an agricultural reformer (the founding secretary of what is now the Bath and West of England Agricultural Society) and man of letters (he was also the founding secretary of the Bath Philosophical Society). Rack was part of the Macaulay circle, of which Polwhele became part in 1777, and a great encourager of literary talent (he even published his *Mentor's Letters to Youth* in 1777). Rack was also a source of contacts and outlets for publications through the late 1770s and early 1780s while Polwhele was at Oxford. Evidence for their relationship is preserved in their published correspondence. On 19 November 1778, Rack writes reporting a fatal duel in Bath that has the town ablaze with gossip:

I therefore wish thee immediately to write an elegy on the transaction and send me by the coach; I will have it printed directly, and doubt not its having a rapid sale. The city is struck with a kind of horror. Call it the Duellists, the Fatal Duel, or any better name.[51]

Other letters show evidence of Rack editing Polwhele's poetry, but also of him passing it on to others, and feeding back their revisions and comments to Polwhele. Similarly, Polwhele reproduces his correspondence from a slightly later date over his *History of Devon* with Sir George Yonge, MP for Honiton in Devon, sometime colonial governor (and secretary of state for war under Pitt until 1794). Yonge provided introductions, manuscripts, warnings, advice and indeed financial assistance. His role encompassed leading the negotiations that secured the *History* a dedication to George III and more mundane tasks such as taking notes in the British Library on Polwhele's behalf and sending them down to Cornwall. Polwhele was so pleased with Yonge's help, since it stood in marked contrast to the obstructiveness of some of the other Devonian gentry during the course of a rather fraught research process, be-devilled by local shenanigans. As a consequence of this, he wrote a sonnet on the subject in 1791. Polwhele rarely sold himself and his activities short, but even by his own high standards, this poem came to a somewhat startlingly Miltonic conclusion:

> Whilst Yonge still prompts me to enlarge my views,
> And bids me sore with no ignoble flight;
>
> . . .
>
> Shall not the *Spirit of Research* proceed,
> And, spurning *Envy*, grasp the historic meed?[52]

This interest in the backstory to publications shades in its tone – if not its intention – into a further preoccupation: gossip of a broadly literary nature (though it should be said that the scandal of Catherine Macaulay's marriage and much Exeter and Truro-related personal gossip do surface in his memoirs). The fact of Scott's gift of a set of his edition of Seward's poems was noted above, but his accompanying letter included the trade gossip that Constable intends publishing her letters in full. Scott goes on to other matters, but it is clear from the note Polwhele attaches to the letter that it is this, and the occasion it affords for an anecdote, that interests him:

I have read Miss Seward's Letters with great satisfaction. With her scenes in general I am but little acquainted: but I am well acquainted with many of her characters.

He goes on to relate a personal anecdote about poets Hannah More and Ann Yearsley, and ends the note with a confession. Seward, while complimentary about the *Devon and Cornwall* volume as a whole, had expressed her disapproval of a travesty of Shenstone it contained, ostensibly the work of one Major Edward Drewe, a cashiered infantry officer, one-time minor *cause celebré* (on account of his court martial) and drinking friend of Polwhele's: 'had I told Miss Seward', confesses the latter, 'that the ridicule which has thus raised her indignation, was started and pursued by the Major and myself, over a bottle of claret, my name would never, perhaps, have occurred in the list of her honoured friends.'[53]

Again Polwhele is here evoking a world of literary friendship and production consistent in method and content with that conjured by his *Traditions and Recollections*, for example in a long letter dating from 1782 relating his doings at Oxford. He recalls bumping into Erasmus Darwin on the stage back from Cornwall and their travelling together as far as Bristol, where their different destinations led to a parting of their ways 'with tears reciprocally shed'.[54] Distraught, Polwhele recalls fleeing to the house of Hannah More, whereupon she cheered him up by reading aloud a poem in manuscript of his friend and mentor John Wolcot's that he happened to have in his pocket. This offers us a remarkably vivid picture of the circulation of literary texts and the prepublication networks of provincial literary culture in the late eighteenth century, even if it is also rather gossipy and involves a quite heroic amount of name-dropping.

These stories tend to date from Polwhele's youth and relative pomp and seem to stress an idea of coterie, albeit one carefully constructed via the imperatives of professional authorship. In contrast a rather sad narrative emerges from the volume of Scott letters, which date from the rather anti-climactic second half of Pol-

whele's career. Throughout Scott is fulsome and remains genuine in his praise of his Cornish correspondent. He is 'a great master of northern lore' on 11 October 1810, and Scott closes that same letter by telling Polwhele that 'if you knew how much I admire your poem on Local Attachment, you would not have threatened me with so terrible a compliment as that of laying down your own harp.'[55] He was delighted with Polwhele's work on Devon and Cornwall, telling him in December 1812 that he had never before seen 'topographical labours conducted at once with the accuracy of the antiquary and the elegance of the man of general literature' and reassuring Polwhele that the work was 'interesting to the general reader and essential to the purpose of the English historian'. 'Your name smoothed all difficulties', he tells Polwhele in 1811 (in connection with Polwhele's attempt at continuing Beattie's *The Minstrel*), while in 1815 Scott remained firm in his view that the *Influence of Local Attachment* is 'one of the poems of modern times which has afforded me the most pleasure'.[56] Yet all that said, the sense of their inverse trajectories is strong. At the outset of their correspondence, the exchange seems two-way, and while Scott's admiration for Polwhele appears to remain staunch, the longer they knew each other, the more one-way become the requests for favours. In 1829, in the last reply to Polwhele published, Scott is explaining his inability, despite enquiries to 'find the means of aiding your very natural wish on behalf of your young relatives', noting that 'I have far less interest in the literary circles of Scotland than you may imagine; but if I can be of service to you it will make me happy.'[57] That same letter makes it clear from the occasion of its writing that Polwhele has written in advance to ask whether Scott would like a copy of his latest works (he would 'be most happy in placing [it] on my shelves, in addition to your other valuable works') rather than feeling able just to send them as in years gone by. Equally Scott's apologetic references to the increasing delays in responding (on 16 November 1812 he refers to a reproach on the point he has received from Polwhele) and their relative, but significantly more brief nature as time goes on indicate the changing dynamics of their relationship. In 1803 it was Polwhele who apparently took six months to reply, and who received an eager, earnest and lengthy response from Scott within ten days. Taken severally but especially collectively, these details tell their own story about a literary friendship of increasing inequality. On their own, they suggest a narrative of considerable and rather touching personal interest, but it is also possible to establish its significance in two further ways.

Firstly, the list of increasingly baroque explanations called forth by Scott to excuse his delays in replying effectively, dramatise the practical difficulties of maintaining a correspondence over such a distance. Indeed, Scott's letters offer a pretty comprehensive list of the challenges to such a relationship in a way that might be obscured through the efforts of a more conscientious – or less busy – correspondent. On 21 July 1808 he is apologising for a delay on the grounds that 'owing to my residence in London for these some months past, I did not receive your letter till my return to Edinburgh.'[58] Again, in August 1813, 'your letter has had a most weary dance after me through the North of England, where I have

been rambling a good while; and, being disappointed in an intended visit to my friend Morris at Rokeby, all my letters miscarried for a season, being sent his charge.'[59] Generally speaking, it is clear that the direction of mail to intermediaries acting on behalf of both men was a significant factor in both maintaining and potentially delaying correspondence. In 1814, Scott had this to offer by way of an explanation of a delay in returning a manuscript to Polwhele, an explanation that reads like something that would not be out of place in the editorial preface to a Waverley novel:

I wrote to you in winter upon the subject of your curious and valuable MS. which I think fully equal to any you have yet written; as that letter did not reach you, I will mention its principal points, in the parcel consisting of the MS itself, which I will return tomorrow. Your poem, with some material papers of my own, has been for some months in a situation rather more secure than accessible; for, in the hurry attending my removal from one house in the country to another, my furniture was deposited in a hay-loft; and at the bottom of a heap of old arms, helmets, and broad-swords, fenced in with a cheveux-de-frise of chairs, tables, and bed posts, stood a small bureau, containing all my own papers and your beautiful poem. I could not trust the key of this treasure-chest to anyone but myself, and I only got my matters a little arranged last week, when I recovered your verses and brought them to town with me. (3 April 1814)[60]

In the same letter, Scott offers an example of a practical difficulty that is nothing to do with the disorganised nature of a correspondent when he says he 'take[s] the liberty to send you a copy of a poem I lately published, but which was originally in rather a cumbrous form to be transmitted so many hundred miles'.[61]

There are other occasions when Scott's embarrassment could summon extravagant flights of fancy, as he sought to acknowledge the potential hurtfulness of so belated a reply through humorous distraction:

I have been a long and distant wanderer from home; and though I reached this cottage six weeks ago, I only got 'Isabel' yesterday. She was in my house at Castle Street, in possession of an old housekeeper; who, knowing perhaps from youthful experience the dangers which attend young ladies on their travels, kept her with some other captives until my wife, going to town to attend a grand musical festival, made a general jail delivery, and sent among many, but none so welcome packets, the fair maiden of Cotehele. (4 November 1815)[62]

The reader is left to conclude that Scott would have been a less interesting, albeit for Polwhele less frustrating, correspondent, had he replied on time.

The second point to be made about the narrative of declining fortunes and reputation the volume offers is that it suggests interesting questions about Polwhele's self-presentation and the way in which he seeks to locate literary reputation and substance. As we have seen, the volume is of a piece with what can only be interpreted as a concerted attempt to establish his credentials as a man of

letters at the outset of the nineteenth century through his memoirs. These trace his life and career by reproducing his voluminous correspondence with figures across the kingdom and indicate the various ways in which he partook in literary culture on the national stage (he was not alone in this, as friends, such as William Hayley, attempt much the same thing). In 1834, Polwhele told his friend (and erstwhile staging post for some of Scott's correspondence to Polwhele) Davies Gilbert that he had collected 56 volumes of correspondence, though it appears that he published only a fraction in the end. In the preface to the *Traditions and Recollections*, Polwhele says that his purpose is to give 'clear and interesting views of characters and transactions' through the publication of their letters, a principle he adopts from William Mason's *Memoirs of the Life and Writings of Mr Gray* (1775), as Polwhele himself makes clear in the advertisement to his *Life of John Whittaker* (1831). Ostensibly, the subject is always the writer of the letter. Yet, the *Transactions and Recollections* is organised in sections according to the phases of Polwhele's own life (school days in Truro, time at Oxford, curacy in Kenton, holding the living at Manaccan and so on), a feature that along with its editorial commentary, underlines a broader point about the importance of the recipient in what we are reading. Polwhele is the significant feature of this book even if he apparently lacks the cultural confidence to offer a more straightforward and unambiguous account of his own literary stature. It is as if Polwhele can only tell the story of his own life through the words of others written to him.

If Polwhele's publication of Scott's correspondence is part of a larger urge to demonstrate his place within the literary world, it shows the fundamental importance of connectedness, an importance so crucial that it trumped the fact that the price to personal dignity of demonstrating this connection was high. As Polwhele himself puts it in the preface to the Scott volume, Polwhele was one who 'never trusted his own strength—never confided in his own judgment; but, in all his literary productions, invariably looked up to others for assistance or support'.[63] It seems that this is the main message to be taken from the volume. In terms of what we might conventionally think of as achievement, the volume is rather a document of Polwhele's decline, if not failure, as he goes from being a source of authority to source of vaguely embarrassing requests for favours for himself and his family. This pattern is repeated in his other memoirs, as he becomes ever more blatant in tapping up old friends and acquaintances – including Grenville – for a good turn, or even just a good word. Indeed, the only thing more poignant than the increasingly modest nature of the requests, as Polwhele scales down his ambition, is the moment when he moves from asking for himself to asking on behalf of his sons. But as documents of connectivity, of Polwhele's continued place within networks of literature and print, of his access to important people in order to ask them for a job, these works are triumphant, even if the evidence provided by those requests bespeaks a more profound failure.

So to conclude, what value does Scott's correspondence with Polwhele have for the more secure understanding of what Kerrigan calls the 'braided' histories of the British Isles? At its most straightforward, it says something about

the interconnections and liaisons it was possible to establish in Romantic-era Britain; collaborations and networks stretching many hundreds of miles. These networks might have been delicate, and they may have relied on intermediaries and been infuriatingly slow-moving and prone to delays, particularly when their target was as peripatetic as Scott appears to have been for considerable periods of time. Communication might have been haphazard and limited by the ability to transport bulky packages, and it occasionally could go entirely astray. Yet for all these vicissitudes, letters (or occasionally their replacements) eventually reached their intended recipients; were eventually responded to; business got done; and communication was maintained. The manuscript becalmed in Scott's hayloft as described on 3 April 1814 was almost certainly *Fair Isabelle of Cotehele*, the receipt of which Scott is belatedly acknowledging on 4 November 1815. Equally, for all the logistical challenges posed by moving books around in the post, what also emerges is the central importance of swapping publications to this relationship. Such movement of printed and manuscript material was not merely social, but part of significant business transactions. Ultimately, the letters are also a testament to the business that could be done, and done with no particular reference to the London book trade. Edinburgh in particular emerges as a place where Polwhele, who had no particular problems getting published throughout his career, sought to get material published. It is a vivid if modest example of the truth of Ian Duncan's recent observation that Edinburgh 'became visible as a world capital of Romanticism in the first third of the nineteenth century'.[64] While Polwhele and Scott's relationship does nothing in itself to prove Duncan's later contention that it was in Edinburgh that 'the genres that would dominate the nineteenth-century literary marketplace acquired their definitive form',[65] nevertheless the fact that a Cornish writer was doing (or attempting to do) the range of business he was, across both poetry and topographical writing and within the world of reviewing, does suggest the ways in which Edinburgh was an important part of a national print culture, a culture that contained an axis of influence and interest that cannot be entirely encapsulated and understood if it is thought about merely in terms of a centralised London book trade. This did not always go according to plan, as the sad episode of Polwhele's continuation of Beattie's *Minstrel* demonstrates. However this does not undermine the central point here to do with the evidence of intra-regional networks of authorship and print offered by Scott and Polwhele's relationship. Indeed the fact that Polwhele went on to publish that work in London demonstrates the genuinely national publishing world in which authors had multiple potential outlets available to them and might publish in London as a compensation for a venture falling through elsewhere. This not only reverses what might be assumed to be the standard polarity of provincial publication standing in for metropolitan failure, but also shows that the situation was more complex and sophisticated than previously assumed. Schürer has recently lamented the 'overwhelming pull of the London metropolis' in narratives of provincial literary endeavour that stress links with London as a way of explaining the sophistication of that endeavour.[66] He seeks to balance the

'skewed conclusions of scholarship' that emphasises 'metropolitan connections' with a vision of self-sustaining provincial literary culture in which writers 'could be successful without the London literary market-place'.[67] Polwhele's career, on the evidence provided by his engagement with Scott, need not be seen in either of these exclusive categories but rather as one built upon publishing, where the market proved most propitious.

Yet, it is also important to reiterate the importance of the study of such correspondence as a counter-weight to the sort of regional revisionism that ends up in the crude assertion of individual importance. An awareness of the existence of his correspondence with Scott does nothing to advance a reductive assertion of Polwhele's status, given that it is more a document of Polwhele's return to obscurity than of his rise to prominence. As such it registers an ambiguous sense of Polwhele as a literary figure.

Furthermore, the way in which Polwhele backs onto the stage via his correspondence with others does not articulate a firm sense of individual worth as we understand it. At best, it demonstrates the essentially connective mindset at work here, a notion of literary and social identity firmly embedded within a broader sociability; at worst, it suggests an element of cultural cringe. Yet what it does do much more unambiguously is offer an advance on Chandler's 'increasingly intricate and decentralised national network of literary production' in the British Isles during the Romantic period because it offers an insight into the networks of dissemination, of opinion and influence forming across geographically distant regions of Britain. As such, it provides us with a way of articulating the importance of understanding the place of regional writers within, and their contribution to, nineteenth-century literary culture that does not rely on wire-drawn, tired, or otherwise wearyingly unconvincing claims to previously unacknowledged individual greatness.

Notes

1 *Letters of Sir Walter Scott addressed to the Rev R Polwhele; D Gilbert Esq; Francis Douce, esq, &c. &c. Accompanied by an Autobiographical Memoir of Lieut. General Sir Hussey Vivian*, ed. Richard Polwhele (London: John Nichols and Son, 1832), 84.

2 Ibid., no pagination.

3 Dafydd Moore, 'Devolving Romanticism: The Case of Devon and Cornwall', *Literature Compass* 5 (2008).

4 Nicholas Roe, introduction to *English Romantic Writers and the West Country* (Basingstoke: Palgrave, 2010), 5.

5 Murray G. H. Pittock, *Scottish Nationality* (Basingstoke: Palgrave, 2001), 147.

6 Jon Mee, *Conversable Worlds: Literature, Contention, and Community 1762 to 1830* (Oxford: Oxford University Press, 2011), 133.

7 J. G. A. Pocock, 'The Limits and Divisions of British History: In Search of the Unknown Subject', *American Historical Review* 87 (1982), 318.

8 Murray G. H. Pittock, *Scottish and Irish Romanticism* (Oxford: Oxford University Press, 2008), 24.

9 Gerard Carruthers and Alan Rawes, 'Introduction', *English Romanticism and the Celtic World* (Cambridge: Cambridge University Press, 2003), 19.

10 John Kerrigan, *Archipelagic English: Literature, History and Politics 1603-1707* (Oxford: Oxford University Press, 2009), 2, emphasis mine.

11 John Brewer, *Pleasures of the Imagination: English Culture in the Eighteenth Century* (London: Harper Collins, 1997), 498.

12 Peter Clark, *British Clubs and Societies 1580-1800: The Growth of the Associational World* (Oxford: Oxford University Press, 2000).

13 David Chandler, '"The Athens of England": Norwich as a Literary Center in the Late Eighteenth Century', *Eighteenth-Century Studies* 43, no. 2 (2010), 173.

14 Norbert Schürer, 'Jane Cave Winscom: Provincial Poetry and the Metropolitan Connection', *Journal for Eighteenth-Century Studies* 36, no. 3 (2013), 415.

15 Ina Ferris, 'Scott's Authorship and Book Culture', in *The Edinburgh Companion to Sir Walter Scott*, ed. Fiona Robertson (Edinburgh: Edinburgh University Press, 2012), 9.

16 Polwhele, *Traditions and Recollections: Domestic, Clerical and Literary*, vol. 2 (London: John Nichols & Son, 1826), 240.

17 David Hill Radcliffe, 'Completing James Beattie's *The Minstrel*', *Studies in Philology* 100, no. 4 (2003), 548–9.

18 Mark Brayshay, 'The Development of Topographical Writing in the South West', in *Topographical Writers in South West England*, ed. M. Brayshay (Exeter: Exeter University Press, 1996), 14.

19 Emily Lorraine de Montluzin, *The Anti-Jacobins 1798-1800: The Early Contributors to the Anti-Jaocbin Review* (London: Macmillan, 1988), 129–32.

20 John Watkins, *The Peeper: A Collection of Essays, Moral, Biographical and Literary*, 2nd edition (London: M. Allen, 1798), 324.

21 Edmund Burke, *Reflections on the Revolution in France*, ed. Conor Cruise O'Brien (London: Penguin, 1986), 135.

22 Emily de Montluzin, 'Attributions of Authorship in *The British Critic* during the Editorial Regime of Robert Nares, 1793-1813', *Studies in Bibliography* 51 (1998), 249–50.

23 Unpublished Correspondence with John Nichols, Bodleian Library MS Eng.lett.c.36.f.78–9.

24 Adam Fox, 'Printed Questionnaires, Research Networks, and the Discovery of the British Isles, 1650-1800'. *The Historical Journal* 53 (2010), 594; DOI: 10.1017/S0018246X1000021X.

25 Clement Carlyon, *Early Years and Late Reflections* ˌ vol. 2 (London: Whittaker & Co, 1856), 62–4.

26 John Sutherland, *The Life of Walter Scott: A Critical Biography* (Oxford: Blackwells, 1995), 92.

27 *Letters of Sir Walter Scott*, 13.

28 Ibid., 14.

29 Ibid., 15.

30 Rosemary Sweet, *Antiquaries: The Discovery of the Past in Eighteenth-Century Britain* (London and New York: Hambledon & London, 2004), 65.

31 Walter Scott, *The Lay of the Last Minstrel* (Edinburgh: J. Ballantyne, 1805), 161.

32 Richard Polwhele, *The Influence of Local Attachment with Respect to Home*, 2nd edition (London: J. Johnson, 1798), 3.

33 *The Poetical Works of Anna Seward*, 3 volumes, ed. Sir Walter Scott, Edinburgh: Ballantyne, 1810, vol.3 p.50

34 Sweet, *Antiquaries*, 65.

35 Emily Lorraine de Montluzin, '"A Close Prisoner": Richard Polwhele's Encounter with Captain Bligh', *ANQ: A Quarterly Journal of Short Articles, Notes and Reviews* 16, no. 3 (2003), 22-26. doi. org/10.1080/08957690309598210.

36 Ibid., 25.

37 MS Eng.lett.c.36.f.74.

38 MS Eng.lett.c.36.f.76-7.

39 Sweet, *Antiquaries*, 65.

40 Polwhele, *Fair Isabel of Cotehele, A Cornish Romance, in Six Cantos* (London: J. Cawthorn, 1815), 66.

41 Antonia Forster, 'Book Reviewing', in *The Cambridge History of the Book in Britain*, ed. Michael F. Suarez, S. J., and Michael L. Turner, vol. 5, *1695-1830* (Cambridge: Cambridge University Press, 2009), 643–4.

42 *Letters of Sir Walter Scott*, 34.

43 W. P. Courtney, 'Polwhele, Richard (1760–1838)', rev. Grant P. Cerny, *Oxford Dictionary of National Biography* (Oxford University Press, 2004); online edition, Jan 2008 [http://www.oxforddnb. com/view/article/22483, accessed 15 July 2013] Richard Polwhele (1760–1838): doi:10.1093/ ref:odnb/22483.

44 *Letters of Sir Walter Scott*, 42.

45 *Letters of Sir Walter Scott*, 38–9.

46 Radcliffe, 'Completing James Beattie's *The Minstrel*', 538.

47 Ibid., 45.

48 Ibid., 50.

49 Catherine Jones, 'History and Historiography', in *The Edinburgh Companion to Sir Walter Scott*, ed. Fiona Robertson (Edinburgh: Edinburgh University Press, 2012), 61.

50 *Letters of Sir Walter Scott*, 53–54.

51 Polwhele, *Traditions*, 120.

52 Polwhele, *Traditions*, 260.

53 *Letters of Sir Walter Scott*, 29.

54 Polwhele, *Traditions*, 87.

55 *Letters of Sir Walter Scott*, 28.

56 Ibid., 66.

57 Ibid., 85.

58 Ibid., 19.

59 Ibid., 50.

60 Ibid., 54–55.

61 Ibid., 54.

62 Ibid., 65–66.

63 Ibid., v.

64 Ian Duncan, 'Urban Space and Enlightened Romanticism', in *The Edinburgh Companion to Scottish Romanticism*, ed. Murray Pittock (Edinburgh: Edinburgh University Press, 2011), 72.

65 Ibid., 72.

66 Schurer, 'Jane Cave Winscom', 215.

67 Ibid., 427 and 428.

Reviews

Hovering Stasis

Arabesque and Allegory in Hans Christian Andersen's Fairy Tales and Stories

[Svævende Stasis: *Arabesk og Allegori i H.C. Andersens Eventyr og Historier*]

By Jacob Bøggild. Hellerup: Forlaget Spring, 2012. 326 pp. DKK 325. Submitted as a doctoral dissertation and defended at Aarhus University in 2012

Jacob Bøggild's monograph on arabesques and allegorical themes in selected fairy tales by Hans Christian Andersen contains fifteen chapters, each focusing on a single or a small cluster of tales. With the exception of the first chapter, which focuses on *Walking Tour from Holmen's Canal to the Eastern Point of Amager*, Bøggild analyses the fairy tales only. His comments on and references to the author's other works are few and brief. The several analyses – they are twenty in number – are thematically organised in a fashion suggested by the title. Bøggild argues that the concept of the arabesque is a general key to appreciating a fairy tale corpus. Utilising an approach informed by deconstruction, the allegorical patterns are read as deconstructed allegories, which links them to the concept of the arabesque with its serpentine design consisting of minute parts. According to the author, both the fairy tales and the authorship as a whole are one comprehensive arabesque. Whilst the

tales are given a thorough analytical treatment, the claims concerning the author's other works are declarative and unsupported by analysis. It should be evident that Bøggild's dissertation uses a deconstructive methodology although he steers clear of subscribing wholesale to the litanies of deconstruction. In its generalities the book is a continuation of Schlegel who in his fragments articulated a Romantic poetics directly connected with modernism.

As an academic monograph, this study is unconventional. It contains no clear break-down of the existing scholarship, no outline or even discussions of theories or of the scholarly work done before Johan de Mylius, Niels Kofoed and a few others. It addresses a modest selection of Andersen's fairy tales without explaining why these and not others have been chosen, and it does not place the analyses in the context of the collected works, even though it states that the analytical positions taken pertain to

the entire oeuvre. These issues are both an advantage and a drawback. It is a work without tedious polemicism and theoretical overkill, but at same time it is a book in which the essential concepts are not accompanied by the amount of theoretical instruction and conceptual analysis that would have prevented them (for instance, arabesque and allegory) from tending towards the loose and vague (arabesque can mean anything from irony, digression, and repetition to movement, opening, freedom, artistic competence, plotting, and so much more). The author's attitude to previous research is arrogant. Largely dismissed, and dismissed without substantial reasoning, the author chalks it up either to aesthetically uninteresting biographism or to wild goose chases in historical conditions with no roots in what in Bøggild's book is so crucial: the self-reflexivity and meta-poetic *Gehalt* of the fairy tales. This means that the author directs his focus to the individual fairy tales and eliminates historical and social contexts. Furthermore, it means that the book at times reads as if it had been written in the heyday of 1990s' dogmatic textual analysis. Not once does Bøggild discuss his own premises, and that is a deficit to which I shall return. The central object of the book is a textual analytical insistence on a modernist-poetic essentially text-based mode of thinking in the fairy tales. In several instances Bøggild presents excellent, often subtle, and in a few cases debatable, analytical insights. But the critique of biographism is an easy one, considering the fact that biographical criticism has been on the wane since

the days of the late Topsøe-Jensen. The subsequent biographies are not contributions to the discipline of comparative literature narrowly construed. The author conducts a somewhat mechanical or superficial critique of previous readings of the tales, whether they are disciplinarily informed by history, the history of ideas, the history of aesthetics, or something else. This, however, poses a problem insofar as his distances seem precarious. Some very central contexts within the history of ideas and aesthetics are denied a careful discussion despite their undeniable significance; they remain unspecified subtexts underneath their own arguments. Bøggild's own text is for this reason totally exposed to deconstructive readings.

By way of introduction, Bøggild analyses *Walking Tour* and proceeds by guiding the reader through a selection of fairy tales from 'The Phoenix Bird' to 'The Garden of Paradise', 'The Little Mermaid', 'The Nightingale', 'The Story of a Mother', 'The Shirt-Collar', 'The Pen and the Inkstand', 'The Money-Box', 'The Shadow', 'The Bell', 'The Snow Queen', 'Poetry's California', 'The Psyche', 'Poultry Meg's Family' before concluding with 'The Gardener and the Lord and the Lady' and 'Auntie Toothache.' Clearly, the selection mixes familiar and widely-read fairy tales with lesser known, largely uninteresting texts. The texts have been selected according to a thematic principle. No sense of progression is developed in Bøggild's textual corpus even though he opens his book with *Walking Tour* and concludes with the very last fairy tale written by

Andersen. The author summarizes his intentions in the dissertation's 'Summary and Conclusion': 'The dissertation provides a perspective . . . [from which] Andersen's work is construed as a continuous interaction between two literary modes: arabesque and allegory, and [it] defends the understanding that this interaction creates a certain dynamic, which is linked to openness and the subtle displacement of meaning that characterizes Andersen's work. . . . I have aimed to capture the essence of this dynamic in the title of the dissertation: *Hovering Stasis*. 'Hovering' here connotes Romantic '*Schweben*', a key word in Friedrich Schlegel's Romantic poetology. 'Stasis', on the one hand, connotes the allegory's apparent lack of movement, . . . and, on the other, the tense equilibrium between opposites associated with the literary arabesque' (273). Rarely does the author aspire to reflections of a more theoretical sort than here although the matter has been laid bare by the preceding analyses.

Most of these fairy tales are given a thorough examination. There are numerous quirky, surprising and interesting observations and arguments in the individual analyses: the discussion of 'The Little Mermaid' with Søren Baggesen, de Mylius, and James Massengale is fine and instructive. However, as previously indicated, in rejecting the psychoanalytic and biographical readings Bøggild is flogging a dead horse. In addition, the work features several worthy observations concerning, for example, the narcissism of the prince and princess as well as the fairy tale's narratological structure. Bøggild argues that 'The Little Mermaid', by virtue, in part, of a number of instances of textual symmetry, forms a constantly restless allegory, which means that the tale lacks stable contents – it is an 'arabesque mobile' – in which the allegorical elements are subordinated to the arabesque construction. Insofar as this observation applies to other texts besides 'The Little Mermaid', it affords a distinct and fertile approach to the Christian constructions in the fairy tales. This clearly pertains to Bøggild's reading of one of the minor works, 'The Garden of Paradise', in which Bøggild shrewdly identifies an instance of genre-mix. The fairy tale oscillates between a fixed allegorical frame of reference (the mythological fall from grace) and that openness and plurality which characterizes the arabesque. For this reason the tale produces, under a seemingly closed surface, an undogmatic dynamism that acknowledges the openness of the other tales. Similarly, interesting things are uncovered with respect to such classics as 'The Story of a Mother', 'The Snow Queen', 'The Nightingale', and 'The Shadow.' The consecutive readings effectively illuminate hitherto underappreciated aspects of Andersen's texts.

In the concluding chapter, Bøggild asserts that 'Andersen's fairy tales and stories are far from being programmatic texts. Rather, as Georg Brandes is stumblingly close to articulating, they comprise a comprehensive but potentially unending arabesque in which each position is provisional and counterbalanced' (279). As will be seen, as a final result of his analyses,

Bøggild posits Andersen's modernist position. By the same token, Andersen's fairy tales enter into a discourse with other contemporary sentiments and responses, whether originating from the disciplines of aesthetics, the history of aesthetics or the history of ideas. Concerned with intertextual aspects, Bøggild lays the groundwork for a discussion of these. Specifically, he juxtaposes 'The Story of a Mother' and Søren Kierkegaard's *Fear and Trembling*. Kierkegaard, remarks Bøggild, appears here in inverted form. It is safe to assume that Andersen kept up with Kierkegaard's writings following the famous attack in *From the Papers of One Still Living*. I would have welcomed, however, a more advanced discussion and investigation of the mutual relation between the two writers – Bøggild has a specialised knowledge of both authorships. Hopefully, that is a task that he will bring to fruition in due course.

Other intertextual references include the Bible, which is skilfully integrated into several analyses, and the central figure in idealist philosophy, Hegel, whose theory of recognition greatly advances the analysis of 'The Gardener and the Lord and the Lady.' Additional references are made to Pontoppidan, Søren Ulrik Thomsen, and Edgar Allan Poe, to name a few. Regrettably absent are any intertextual references to Andersen's own novels and travel writings, although some of these, *expressis verbis*, thematise the concept of the arabesque. Equally puzzling is the author's disinclination to elaborate on Schlegel to a greater extent than the randomly scattered comments, especially since Schlegel's

conception of irony is an important idea to Bøggild.

The most serious problem in the book, according to this reviewer, is the decontextualisation of the fairy tales. It is Bøggild's belief that contextual circumstances detract from the aesthetic quality of the tales, which should rather be approached as 'carefully contrived artworks totally without heeding' the external world (14). This stance generates some problems for the author and vitiates the pertinence of some of the central analyses. The book's fundamental assumption is that the fairy tales belong to a tradition between the German *Frühromantik* on the one hand, and modernist textual strategies on the other, in that the tales to all intents and purposes resist 'Biedermeierization' (one could arguably conduct a more thorough discussion than the one featured here). There is then, despite everything, a historical underpinning to the readings provided in the dissertation. Only, it is never directly thematised, and that is unfortunate. Andersen, according to Bøggild, 'is actually operating reflectively on the front line between Romanticism and modernism, confident in his intuitive expectation that the poetry of modernity will be preconditioned by Romanticism and consequently be unable to institute a radical turning point' (40) – notice the word 'reflectively', a word revealing Bøggild's modernistic interest in the self-reflexivity and meta-poetic interests of the fairy tales. Such estimations are, in their generality, fairly precise. But they also reward further elaboration. As it happens, the Romantic in modernity

and modernism has been a debated issue since Brandes. This relationship between Romanticism and modernism is not scrutinized – at least not at great length – in Bøggild's work, despite his references to Heinrich Detering's articles on some of the fairy tales under investigation. The collapse of aesthetic idealism is, in Detering's work, a central and emphasised point; meanwhile something undefined and new, as yet only a fragile vibration, is anticipated. Thus, to Detering the transition is continuous between Romanticism and modernism. Romanticism is subsumed under modernism, which cannot be conceived in the absence of Romanticism. This issue, which involves both poetological matters and commonality of ideas and experiences, is of crucial significance in Andersen's authorship. In a few places, Bøggild demonstrates that the Romantic text informs and lives on in the new text – as its essence or subtext ('Poetry's California'). Overall, it is only implied, however. In this, Bøggild touches on an issue which in my opinion has constitutional implications for Andersen's fairy tales and the aesthetics they display. The collapse of aesthetic idealism which I am talking about is one of those qualities that makes his fairy tales meaningful and which helps explain why his works, in part helped along by Villy Sørensen's pioneering 1958 study *Digtere og Dæmoner*, continue to fascinate us. The disenchantment, so to speak, of the world represents a very important host of problems in Andersen's works (this concept from Weber is assessed on p. 136). Bøggild boils this disenchantment down to

'the relationship between the material and the spiritual' (134) – a somewhat tepid assessment, it must be admitted, of the emergent encounter with aesthetic idealism that links Andersen's fairy tales with modernity. By the same token, the book offers an extremely bland explanation of the aesthetics linking Andersen's texts with modernity. These shortcomings are most conspicuous in the treatment of 'The Shadow' – the tale correctly canonised by Sørensen. In the best deconstructive tradition, Bøggild focuses on three puns and one instance of literalisation while disregarding the story's narrative (something he dismisses as an illusion [157]). Thus the interpretation is deliberately precluded from going into the downfall of aesthetic idealism as laid out in the story; in turn the story is read as a tale of seduction and ample reserves of linguistic energy. I shall refrain from going into detail here; only let it be said that I would have appreciated a more coherent reading (not necessarily one ignoring linguistic energy and other quirks) of a major text, which to my thinking is quite a bit more than an allegory of the illusions of reading and a *memento mori*. One can be excused for harbouring similar reservations about the readings of 'The Bell', 'The Snow Queen' and 'The Gardener and the Lord and the Lady.' In fact, this problem is evident as early as *Walking Tour*. In my opinion, the Andersen emerging from Bøggild's reading formula is too severely trimmed. And although the autonomising and aesthetic assumption with which the book opens are delineated sufficiently spaciously to recognise Andersen's

linguistic energy and mastery, they are inimical to a multifaceted, and in places troubled, complexity. That is unfortunate.

For better or worse, the author has the capacity to carry out his project. His analyses are often shrewd and almost always instructive. Over the course of his book, illuminating light is shed on aspects of Andersen's tales which the scholarly tradition has slighted. The methodological approach and the analytical idiosyncrasies constantly stimulate the reader.

For the record, it should be noted that I was chairman of the committee, comprising Karin Sanders, Heinrich Detering, and myself, responsible for assessing Jacob Bøggild's dissertation. Additionally, I have a dog in the fight that is H. C. Andersen scholarship in that I have written a book on the author and edited a selection of fairy tales for the Association of Teachers of Danish.

Peer E. Sørensen
Aarhus University

Translated by
Kasper R. Guldberg
Aalborg University

Romans and Romantics

Ed. Timothy Saunders, Charles Martindale,
Ralph Pite, and Mathilde Skoie.
Oxford: Oxford University Press, 2012.
xxii + 431 pp. £ 89.00

The narration of literary history, as we know it, has a number of recurring characteristics, including the ideas of succession and evolutionary lineages. Epochs are supposed to be clearly and mutually delimited and also to simultaneously emerge from, and to negate, each other. The rhetorical power of epochal narration stems from a construction favouring diametrical oppositions. Arranged in this way, the literary heritage becomes manageable, understandable, and teachable. The evolutionary organisation of knowledge is usually traced back to the roots of modern literary historiography in Romanticism; yet, it has become increasingly apparent that models of this sort have repeatedly hindered what may seem more adequate descriptions of Romanticism. A flagrant example of this is a common view of Romantic writers and classical heritage as antithetical. Already the designation of the new literature as 'Romantic' implied the idea that while classicism drew its inspiration from classical literature, Romantic authors turned to medieval literature. The circumstance that several key Romantics were prominent classical scholars, and could even picture the approaching literary era as a rebirth of classical an-tiquity, has in this perspective been a paradoxical fact.

Thus it is highly welcome that in recent years we have seen an increasing number of studies modifying or, more often, completely overturning the idea of anti-classical Romanticism. As the Greek heritage has typically been in focus, though, this idea has sometimes been replaced by the idea of anti-Roman Romanticism. The anthology *Romans and Romantics* thus recompenses for a double neglect. The aim of the anthology is twofold: to highlight the significance of Roman antiquity for Romanticism, and to demonstrate how the idea of ancient Rome is subsequently filtered through the Romantic image of it. The volume forms part of the Oxford-Series Classical Presences, which in no less than 54 volumes so far (2005–June 2013) is devoted to the reception of classical antiquity.

Romans and Romantics is a rich and rewarding book. In particular its first part opens up new perspectives: Jonathan Sachs illuminates the importance of Rome in relation to British Romanticism; Helge Jordheim discusses the 'struggle with time' in Jean Paul's novel *Titan* (1800–1804); Timothy Saunders scrutinizes the

concept of originality in relation to ideas of Rome in, among others, Johann Joachim Winckelmann and the Schlegel brothers; Mathilde Skoie accounts for Romantic readings of the elegies of Roman authoress Sulpicia; and Genevieve Liveley studies Romantic reception of Ovid in her discussion of the concept of 'love'.

In the second part of the volume we find readings of individual Romantic authors: Stuart Gillespie and Bruce Graver devote one essay each to William Wordsworth; Juan Christian Pellicer discusses Charlotte Smith; Catharine Edwards analyses Germaine de Staël's *Corinne* (1807); Timothy Webb elaborates on Lord Byron's, Mary Shelley's, and Percy Bysshe Shelley's reactions to contemporary and ancient Rome; Jostein Børtnes writes about Alexander Pushkin's relationship to Ovidian exile; Jørgen Magnus Sejersted's article concerns Henrik Wergeland's *Skabelsen, Mennesket og Messias* (1830); and Carl J. Richard discusses American Romanticism (Ralph Waldo Emerson and Nathaniel Hawthorne).

Part III of the anthology, finally, deals with the reception of the Romantic notion of Rome: Elizabeth Prettejohn explores the novel *The Amazon* (1880) by Carel Vosmaer; Stefano Evangelista deals with Walter Pater's novel *Marius the Epicurean* (1885), Ralph Pite discusses Thomas Hardy, especially his 'Poems of Pilgrimage' (1902); Erling Sandmo examines Romantic opera; and Piero Garofalo, finally, considers Rome and Romanticism in Italian cinema. The eighteen articles are surrounded by excellent

pro- and epilogues by Ralph Pite and Glenn W. Most, respectively.

The conception of Greece as the great novelty of the time and a favourite object of Romantic desire is hardly challenged by the contributors. Greece undoubtedly exerted a deep attraction over the Romantics, whether they, led by Winckelmann, wished to rediscover Greek art, or, driven by national or religious pathos, supported the Greek struggle for independence. But the fact that Greece was still exotic and difficult to access, while Rome had long belonged to the *grand tour* of educated youth, along with the situation that school teaching was dominated by Latin, while the knowledge of Greek was often poor, makes it evident that the importance of Rome should definitely not be underestimated. As several of the contributors attest, Greece and Rome were not conflicting entities for Romantic authors; on the contrary, the notion of Greece was more often than not filtered through Rome, just as Winckelmann had based much of his seminal ideas of Greek art on Roman copies.

A central suggestion in Sachs's article – elaborated in his book *Romantic Antiquity: Rome in the British Imagination 1789–1832* (2010) – is that republican Rome after 1789 became politically combustible material in British Romanticism. Thus it could also offer models for the perception of modernity: 'Republican Rome, in this reading, becomes increasingly influential in the Romantic period because in a period of political unrest, imperial expansion, and aesthetic reformation, Rome provided competing allegories

for sensitive issues surrounding these aspects of modernity in contemporary Britain' (25). In a general sense Sachs's suggestion is valid for several of the readings in the volume. Jordheim depicts the way the passive and apathetic traveller in Jean Paul's *Titan* through his visit in Rome is transformed into a 'glowing revolutionary' (51), and Erling Sandmo claims that even the relative absence of Roman motives in Romantic opera can be explained by the conception of classical and especially Roman history as revolutionary and thus awkward for the ruling elite (350).

Very illuminating is Timothy Saunders' investigation of the concept of originality, habitually associated so intimately with the Romantic period that it is sometimes regarded as its constituting moment. Saunders, though, goes *ad fontes* and reveals a different picture. The veneration of originality is as we know fully developed in the epoch preceding Romanticism; one need only mention Edward Young's *Conjectures on Original Composition* (1759). The Romantics, however, are rather ambivalent on the issue. Friedrich Schlegel distinguishes between different kinds of imitation: autonomous imitation concerning 'the universal spirit' and slavish, 'simple imitation of the particular' (70). Only the latter, he claims, is reprehensible. The view on the Romantics as promoters of a natural primitivism cannot hold true, either. In the Romantic version of this theme, inherited from the eighteenth century, poetry is instead perceived as an interaction between the 'natural' and the 'artificial' (76).

The declared aim is to offer, 'for the first time, an extensive and wide-ranging discussion of the relationship between Romanticism and Roman antiquity'. Undoubtedly, the totality of the volume is rich and varied, with great diversity in space and time. Perhaps, however, the purpose would have benefited from a concentration around the core issues; the breadth of subjects, not least the volume's extension in historical time, comes at the expense of depth. German Romanticism, despite the fruitful contributions in the first part of the volume, may seem somewhat neglected, while other parts of European Romanticism stay *terra incognita*. For names such as François René de Chateaubriand or Alphonse de Lamartine we look in vain, and investigations into areas such as Romantic drama or Romantic art could certainly have deepened the discussion.

Such objections, however, only point to the richness of the field and should not obscure the fact that *Romans and Romantics* is a highly recommendable and eye-opening book. The last word is hardly said about the relation between Romanticism and Roman antiquity, but this volume makes obvious the potential and productivity of the subject.

Paula Henrikson
Research fellow at the
Swedish Academy,
supported by a grant from
the Knut and Alice Wallenberg
Foundation, appointed at
Uppsala University

Isles of Felicity

Crossings of Poetry, Religion and Eroticism in Danish and Swedish Romanticism

[Lyksalighedens Øer. *Møder mellem poesi, religion og erotik i dansk og svensk romantik*]

By Gunilla Hermansson. Göteborg & Stockholm: Makadam förlag, 2010. 352 pp. SEK ca 280

The dream of faraway islands – exotic worlds beyond the horizon – represents within Romanticism the longing for a higher realm, whether it be religious, poetic or erotic. In her book, Hermansson explores such islands in the works of two Swedish and three Danish Romantics: C. J. L. Almqvist (1793–1866), P. D. A. Atterbom (1790–1855), B. S. Ingemann (1789–1862), J. L. Heiberg (1791–1860), and H. C. Andersen (1805–1875). At the outset, the author declares how the felicity islands function simultaneously as myth, adventure, and cliché. It is a literary motif associated with wish-fulfilment and it also deals with the problem of representation.

Although my initial response – as I skimmed through the different chapters' subheadings – was one of surprise that the word 'island' was not more predominant, it soon becomes apparent that the guiding theme behind the islands of this book is poetry itself. The seven chapters are entitled 'The Dream', 'The Vision', 'The Tragedy', 'The Repetition', 'The Comedy', 'The Fall', and 'The Dreams'

Parade', and it is obvious that Hermansson has put much thought into her outline and selection of authors and texts, the result being that they form a neat archipelago of Romantic texts. This archipelago constitutes a dialogue on Romantic poetry and its hopes, dreams, and achievements as well as its ironies and failures.

The first chapter, after the introduction, takes off in a discussion of Almqvist's theoretical views on the connection between religion and sexual desire. He was influenced by Swedenborg and Moravian thinking, and the connection to the theme of islands becomes clear when Hermansson turns to Almqvist's *Guldfogel i Paradis* (1821, 1849) and *Murnis* (1819, printed 1845, 1850). In *Guldfogel*, a monk is infatuated and captured for a thousand years by the song from a bird of paradise. His story evokes a similar longing in the hearts of two siblings, and they in turn are lured into their own 'islands'. Hermansson's interpretation of *Guldfogel* precedes a discussion of Almqvist's understanding of symbol and allegory; Almqvist

is torn between 1) a stalwart and optimistic view on the ability of literature to bridge the gap between heaven and earth, and 2) a more modern critique of language and representation. In the discussion of *Murnis* – a religious epos on couples who face death and reunite in the spirit world – Hermansson demonstrates how the tension described above takes the form of a metapoetic circle structure in the work. It is a Romantic-ironic structure, in which numinous poetry interferes in the earthly world, and inscribes the reader in its circle. Jakob Staberg's Kittler-inspired reading of Almqvist is rejected here to favour instead Almqvist's own explanations and theories. Hermansson sees Almqvist's vision of poetry as didactic. He is seen to use poetry as a means to unite separate worlds, and to dignify sexuality. But his writing is also ironic, and this leads to a schizophrenic poetics in which a critique of representation exists parallel to an optimistic faith in poetry.

The Atterbom chapter is focused on the 'tragedy of poetry', which refers to his *Lycksalighetens Ö* (1824–1827). Here Hermansson's reading has much to recommend it; I think it definitely adds something important to prior interpretations of Atterbom's work, since she moves away from other critics' way of discussing the work principally from the viewpoint of Astolf, the male protagonist. In that older reading, Astolf is the active subject, the human poet/traveller to the island of felicity, and Felicia, the 'queen of poetry', the desired object of beauty, and symbol of the lure of art. Hermansson's reading instead highlights

the uncertainty between the two, thereby recognising the hermeneutic love circle and dialectic movement their union represents, and in which it is uncertain who is active and who is passive, who is a living subject and who is an object of beautiful art. Her interpretation thus focuses on the exchange between worlds, which is commendable. It turns Atterbom's fairy play into more of a story of an eternal becoming rather than a mere tragic longing for the unattainable. To me, this also opens up ways of reading Atterbom that emphasise his more modern side. Among the existing critical interpretations of Atterbom's island, Hermansson mainly engages in dialogue with Otto Fischer's discussion of symbol and allergory in *Lycksalighetens Ö* (1998). She contends that Atterbom invokes the problem of irony in *Lycksalighetens Ö*, and obstinately tries to solve it.

The Ingemann chapter nicely builds on and develops the Atterbom discussion, and it is now obvious that much is gained by comparing these different Romantic works that all in their different ways circle back and forth to the 'magic island' of poetry. Ingemann's 'repetitive journey' takes both a positive and a negative turn. In his *Sphinxen*, the play between allegory and symbol becomes a play between belief and lunacy. What happens when the poet is made God of the world of art he has created? And who can say that this God-like poet is nothing but a puppet hanging in the strings of another poet? Questions such as these are evoked by Hermansson's reading of Ingemann, which brought Romantic masculinity

to mind. Though a gender perspective could perhaps have been introduced and discussed here, I still find Hermansson's metapoetic reading highly rewarding. *Sphinxen* shows how writing, just like love, is the ability to be in, and tolerate, the paradox of uncertainty. *Huldre-Gaverne*, which is discussed next, is the Romantic-ironic story of Ole Navnløs who inherits his mother's clear sight/lunacy. With this split vision he searches for his identity as a poet. Here Hermansson relates to the Fichtean Subject, and shows how the demonic is inscribed in Inge-mann's literary universe in order to be conquered. Ingemann's inscription of himself as the fictitious publisher of *Huldre-Gaverne* becomes a paradoxical way to show that he is the master of his work, even though the work itself questions if one can ever trust or master the visions one is given. *Holger Danske* (1837), finally, is a story where the circle movement appears, at first glance, to be more harmonic. But, as hero and story, Holger has a double-status, and Hermansson shows how this double-status forces the narrative to repeat itself over and over in order to believe in itself.

Next up is Heiberg, the Hegelian, whose 'comedy of poetry' forms an opposite to Atterbom's tragedy. His *Fata Morgana* (1838) is a philosophical drama in a speculative-dialectic and Calderón-inspired style. The fairy Morgana here represents the destructive power to fool the sight, while the hero Clotaldo fights all the false appearances. In Clotaldo's singing, poetry and love mirror and acknowledge each other. With the beloved comes poetry (speech and song) and with

poetry comes love – not as an illusion, but as a spiritual power for self-realisation. Hermansson shows how Heiberg uses true and false circles to illustrate the double, precarious nature of the poetic image. Does it, like Morgana, merely reflect the earthly, or is it, like Clotaldo's singing, an act of love bringing the ideal back to itself? Love is made the first condition here; the poet must love nature to free it from longing, and thus Heiberg's comedy has a 'happy ending'.

Hans Christian Andersen, finally, is somewhat more torn in his view on art. In her reading of Andersen, Hermansson discusses 'The Garden of Paradise', 'Auntie Toothache', 'The Phoenix Bird', *The Improvisatore*, and 'Poetry's California'. The recurring theme here is the double-bind of poetry. In other words, can poetry establish a bridge to the divine, or will it collapse in subjective self-immersion? The analysis of 'The Garden of Paradise' focuses on the double desire after knowledge and erotic pleasure, and here Hermansson turns to Friedrich Kittler's theory about the importance of the mother's voice for the development of a poet. Andersen is at once ironic and sincere here: instead of turning the desire after the mother's voice into sublimation, the desire in earthly poetry makes sublimation impossible. A fall is unavoidable and catastrophic, and poetry's ability to soar to heaven remains a mere possibility.

What is it that captures us, when the poet sings? And how can one speak about the unspeakable? The idea of a happy island – whether as a paradise of ideal turned real here

and now, or as a mere guidepost to the true heaven – is a central and capable motif for all the five Romantic authors in Hermansson's book. They all place their islands within a circular structure that captures the Christian ideal, but also enables a more modern, fragmented view. Poetry is the main force behind this circle, and it can be compared to erotic fulfilment, religious mystery, and philosophical insight in the context of these authors. Still, the islands of poetic bliss are always somewhat hazy – are they real or just a mirage on the horizon? For Hermansson, the central question of these islands is if they express a Romantic yearning to escape reality, or if they should rather be seen as a 'more real' reality, one with the power to change life and the world as we know it? This is the question that connects these authors. And they all, in different ways, answer this question with an ambivalent 'yes-and-no', according to Hermansson. She sees the islands as places for self-critical showdowns with idealism, but also as attempts to solve the problem of poetry. There are several parodic, satiric islands, which shows how deeply seated the motif was in Romantic thinking, and also how closely intertwined pathos and parody were in the period.

All these islands are metapoetic stories that stress their own limitations as stories; they can only speak about eternity from an ironic standpoint, through the circularity of their own narrative. In her final chapter, 'The Dreams' Parade', Hermansson summarises and compares her five authors. The comparisons highlight and develop the discussion. For instance, Hermansson elaborates on how Almqvist and Atterbom differed in terms of their irony, and on how Almqvist and Ingemann are related in their religious, uncompromising mode; the latter similarity is a product of their shared insistence that a real transcendence between the numinous and the human can take place. This is the case also for Heiberg, although his mode is more comic. Atterbom and Andersen then stand as the two more discouraged Romantics, since theirs are stories of antiheros failing to create a poetic-erotic heaven of synthesis. Finally, Almqvist and Andersen are the two most obviously modern Romantics.

Even though all these authors are holding on to the dream about poetry as a bridge to the ideal, they still in various ways react to the different tendencies and trends of their time. With the societal changes in the 1830s and '40s, new requirements of a more political, realistic literature were raised. From this perspective the Romantic islands are self-critical re-evaluations of the relation between the ideal and the real. Hermansson argues that the Romantic islands from the mid- to later phases of Romanticism are more than just 'reverberation'-literature. Rather, they are examples of a literature that repeats the Romantic dream over and over in relation to the changes in society around them. Some of these islands therefore are also utterances in the political debate between conservative Romanticism and liberalism.

By exploring the line of 'felicity islands' in the first half of the nineteenth century, Hermansson thus

traces a Romanticism that has a longer, more sustained history than the traditional understanding of the period. Hers is a more self-critical Romanticism and one that questions its own ideals. The connection is here made to earlier attempts (both Danish and Swedish) to rewrite the period of Romanticism. Asbjørn Aarseth's and Horace Engdahl's enlarged and renewed notions of Romanticism from the 1980s are mentioned, as well as Wallheim's view from 2007 that the important break of the period is the political one between conservatism and liberalism. My impression is that Hermansson synthesises a newer, more text-focused way of reading Romantic literature, with the Romantic self-understanding built into the texts. By choosing to study a Romantic literary motif – the island – as both a textual structure and a romantic idea, Hermansson bridges the gap between the focus on Romanticism as text dominant in the 1980s, and the Romantic authors' own self-critical attempts to define the limitations of their poetry.

While her readings, as I have tried to summarise above, are concerned with the ability of poetry to bridge the gap between the real and ideal, Hermansson takes her point of departure in the historical prerequisites for a Romantic movement in Sweden and Denmark, and ends with a contemporary discussion of Romanticism as a concept of literary history. Thus she creates her own circle from the real, historical conditions for these authors, to their ideal, poetical worlds and back to our contemporary reality of writing literary history about

them. Except for the brief dialogue with the media theorist Friedrich Kittler, Hermansson's tendency is generally to turn to the thinking and world-views of the authors themselves when she discusses their literary texts. This keeps the works she analyses within a paradigm of Romantic self-understanding. Her examinations are accomplished and persuasive, but they also show how these Romantic texts point beyond their own time and towards later notions of literary subjectivity. The lack of a discussion of this I find somewhat regrettable. When Hermansson writes, in her English summary, '[t]he "isles of felicity" are not mere echoes of something past, they insist, each in their own manner on the continual relevance of a Romantic notion of poetry's sacred realm and high potential'. I can't help wishing she would have elaborated more on this 'continual relevance'. The parallels between Romantic and postmodern understandings of literature and subjectivity are well-known, and I would have liked the inclusion of a dialogue with the critical tradition that links Romanticism with contemporary (language-oriented) psychoanalytical and gender theory. But Hermansson's work is impressive, despite what can be said against it, in its scope and ability to oscillate between driven, in-depth analyses and a general view where central tendencies are outlined.

To sum up, this is definitely a great comparative study of a motif that is at the heart of Romanticism. Hermansson has put together literary texts that really start resonating in each other (and in you, as reader) as

the analyses unfold. She has an eye for details in the various works, and taken together these details evoke a clear image of the ironic and self-critical feature of Scandinavian Romanticism. Her archipelago of analyses will certainly serve as an important source of knowledge and inspiration for current and future scholars and students of Romanticism. I also find Hermansson's way of engaging in dialogue with earlier criticism responsible and proficient. She manages to balance a desirable respect for former research with a driven discernment that keeps the focus on her problem.

Much is also gained from Hermansson's choice to write literary history that moves between and beyond our national islands and language borders. Although Atterbom is often unfairly treated in Swedish literary history, Hermansson's study shows how *Lycksalighetens Ö* still towers over other works as the most 'important and influential monument of poetry about poetry in Nordic romanticism'.

Katarina Båth
Uppsala University

The Book and the People
The Politics of Romantic Literature

[Bogen og Folket. *Den Romantiske Litteraturs Politik*]

By Jakob Ladegaard.
Aarhus: Aarhus University Press, 2013.
224 pp. DKK 249.95

'The French Revolution, Fichte's Theory of Knowledge, and Goethe's Wilhelm Meister are the three *greatest tendencies of the age.*' That phrase opens *Athenaeum* fragment 216, and it was not only Friedrich Schlegel and the circle around his *frühromantische* journal that associated the political revolution in France with German Romanticism and idealism. Even Fichte, as it were, regarded his own philosophical system as congenial to the revolutionary ideas, and many Romantic authors welcomed the French Revolution as a crucial turning point in history. But even if it is established that the Revolution was a decisive impulse for the Romantic movement, much remains unclear about the closer relationship between literary Romanticism and the French Revolution as well as the contemporary political thinking in general.

In *Bogen og Folket: Den Romantiske Litteraturs Politik*, Jacob Ladegaard, a literary historian at Aarhus University, contributes substantially to our understanding of the politics of Romantic literature. Ladegaard rejects the standard image of Romanticism as an entirely apolitical movement.

Although such a feature can be posited with regard to certain parts of the movement, namely those in which society and politics were rejected in favour of unworldly aesthetics of genius and private emotions, several Romantic literary works are more or less explicitly political.

The general political discussion during the Romantic period revolved largely around the classical ideologies, i.e. conservatism, liberalism, and socialism. All three were developed as answers to the political and social questions posed by the French Revolution. Among the Romantic authors, socialist ideas were unusual, and most of them associated the liberal ideology with utilitarian values and a materialistic world view. Partly for this reason, the Romantics have often been associated with the conservative ideology, with its belief that society must be developed carefully, slowly, and organically. The Romantics' enthusiasm for the French Revolution, however, does not fit well with Edmund Burke's *Reflections on the Revolution in France* and other conservative counter-attacks on the Revolution. Although many Romantic authors

gradually turned conservative, in Romanticism as such, and particularly in the *Frühromantik*, a more radical political strain was dominant, even if it is hard to identify and determine it with concepts from the classical ideologies.

In contemporary political theory it is a commonplace to distinguish between politics and the political. Theorists such as Chantal Mouffe, Pierre Rosanvallon, and Jacques Rancière handle the distinction in somewhat different ways, but they all regard the political as something more basic and fundamental than politics. If politics deals with conventional institutions, everyday practices and routine affairs, then the political is about the way in which society is constituted and raises questions about power and right, people and citizenship, equality and justice. These are the types of issues that interest the Romantic authors. To use Mouffe's Heideggerian terminology, their views on and ideas about society are relevant at the ontological level of the political rather than the ontic level of politics.

Ladegaard does not work systematically with such a distinction between the political and politics. Nonetheless, his major theoretical inspiration is Rancière, whose political and aesthetic theories turn out to be an excellent tool for approaching the questions of how Romantic authors deal with the relationship between the private and the public and between the intellectual elite and the people. Ladegaard investigates how these issues in addition to the concepts of people, freedom, equality, and democracy are addressed in Romantic literature.

In combining the political perspective with an aesthetic analysis, Ladegaard follows Rancière and his interpretation of how Kant with his three critiques, especially *Kritik der Urteilskraft* (1790), laid the foundation for the so-called aesthetic regime of the arts. Until the late eighteenth century, two other regimes had been dominating in Western aesthetics, namely, on the one hand, the representative or mimetic-poetic regime founded by Aristotle, and, on the other, the ethical regime for which Plato was a precursor. When Kant established the aesthetic regime, he gave not only art and aesthetics a new kind of autonomy, he also formulated some fundamental paradoxes that many later authors and thinkers tried to sort out. In *The Politics of Aesthetics: The Distribution of the Sensible*, Rancière writes, 'The aesthetic regime of the arts is the regime that strictly identifies species in the singular and frees it from any specific rule, from any hierarchy of the arts, subject matter, and genres. . . . The aesthetic regime asserts the absolute singularity of the art and, at the same time, destroys any pragmatic criterion for isolating this singularity.' The Romantic literature explores these fundamental paradoxes of the aesthetic regime of the arts.

Ladegaard brings together the problem of the politics and the paradoxes of the aesthetic regime in an in-depth analysis of three central Romantic literary works: Friedrich Hölderlin's epistolary novel *Hyperion* (1797/1799), William Wordsworth's autobiographical poem *The Prelude* (1805; first published posthumously 1850) and Victor Hugo's histori-

cal novel *Notre-Dame de Paris* (1832). Written in different languages and in different genres, these texts do not seem to have much in common except that they are usually regarded as the epitome of the Romantic. But Ladegaard shows that they are all concerned with the paradoxes of the aesthetic regime and that they in one way or another raise political questions about freedom, democracy, and the people. According to Ladegaard these literary works represent three main political tracks in Romanticism and together they offer a complex image of the breadth and the diversity of the politics of Romantic literature.

Although the study contains many elucidatory contextual sections, its greatest strength lies in the three close readings focusing on motive patterns, rhetorical figures, and intertextual relations. The arguments are particularly successful when Ladegaard elucidates the authors' – or rather their texts' – complex and ambivalent attitudes to different political issues. The most convincing case study is the one that deals with *Hyperion*. Following in Friedrich Schiller's footsteps, Hölderlin tries to find an alternative route to the disastrous development that saw Revolutionary France slide into the so-called Reign of Terror. In this alternative path the political struggle is subordinated to the individual's self-formation and aesthetic beauty. Whether this should be understood as a political solution, which Ladegaard argues, is, however, debatable. It seems that Laadegard sometimes over-emphasizes the political radical elements in the Romantic literature.

There is a similar tendency of over-interpretation in the analysis of *The Prelude*. The usual understanding of the poem, in the 1850 version, is that Wordsworth is expressing a resigned, conservative position after the almost Jacobin revolutionary Romanticism of his youth. Ladegaard chooses instead to highlight what he considers the poem's republican ideals of liberty, but that interpretation seems rather dubious. Although the speaker in *The Prelude* exclaims 'Now I am free,' the true freedom turns out to be possible only amidst rural countryside far from urban life. If there is something that is idealised in *The Prelude*, it is the simple lifestyle of the people, not tropes of political action or deliberative communication between enlightened citizens that otherwise play such an important role in the republican tradition. Although some republican strains can certainly be discerned in Wordsworth's poem, they are hardly as prominent as the traditional conservative elements.

The political radicalism of Romanticism should not be exaggerated. It is, for instance, striking that none of the analysed literary works pay any tribute to democratic governance. Even Hugo, who politically was a liberal with some socialist sympathies, expresses a fear for the masses as well as for democracy. The people were not yet ready for the kind of political participation and responsibilty that democracy involves, and this was a view also shared by Hölderlin and Wordsworth.

Nonetheless, it stands to reason that *Bogen og Folket* deepens our un-

derstanding of *Hyperion*, *The Prelude* and *Notre-Dame de Paris* while shedding new light on the problem of the political in the Romantic movement. Although not all Romantic literature deserves to be called political, there are indeed, as Ladegaard shows, some prominent works that portray the internal political tensions and conflicts in this Age of Revolution.

Anders Burman
Södertörn University

ABOUT THE AUTHORS

Charles I. Armstrong is Professor of British literature and Head of the Department of Foreign Languages and Translation at the University of Agder, in Norway. He is the author of *Romantic Organicism: From Idealist Origins to Ambivalent Afterlife* (Palgrave Macmillan, 2003), *Figures of Memory: Poetry, Space and the Past* (Palgrave Macmillan, 2009) and *Reframing Yeats: Genre, Allusion and History* (Bloomsbury, 2013). He is also the co-editor of two essay collections, a Visiting Fellow at Wolfson College in Cambridge, and the current chair of the Nordic Irish Studies Network.

Gry Hedin is an art historian who holds a position as research fellow at *Statens Museum for Kunst* in Copenhagen. She received her PhD in 2012 from the University of Copenhagen with a dissertation on the relationship between Charles Darwin and art and literature in Scandinavia. In her current research project she explores the interaction between visual art and science in the Danish Golden Age. She is formerly a curator at *Ordrupgaard* where she curated exhibitions on Edvard Munch, Gustave Caillebotte, and Piet Mondrian. She has published articles on, amongst others, Jens Ferdinand Willumsen, Edvard Munch, Knut Hamsun, and Jens Peter Jacobsen.

Joep Leerssen studied Comparative Literature in Aachen and Anglo-Irish Studies in Dublin. He holds the Chair of Modern European Literature and a Royal Netherlands Academy research professorship at the University of Amsterdam. Starting with his histories of competing national self-articulations in Ireland (*Mere Irish and Fíor-Ghael*, 1986; *Remembrance and Imagination*, 1996) he has worked on the comparative intellectual history of European nationalism and on the discursive and literary formation of national self-images; in these fields he has published various monographs and collections, such as *National Thought in Europe* (2006) and *Imagology* (edited, with Manfred Beller, 2007), as well as articles in journals such as *Nations and Nationalism*. For his research he was awarded the Spinoza Prize (Holland's premier academic award) in 2008, which he uses to fund the *Study Platform on Interlocking Nationalisms* (SPIN, www.spinnet.eu).

Dafydd Moore is Professor of eighteenth-century literature at Plymouth University. His current research engages with archipelagic understandings of eighteenth-century literary culture with a particular interest in non-metropolitan (or not exclusively metropolitan) literary networks and associated questions of cultural and political identity. He has also worked on the eighteenth-century Scottish writer James Macpherson, and has published widely on the work of

Macpherson and associated figures in a number of disciplines, including a full length study of Macpherson's *Ossian* and a 4-volume set of *Ossian*-related materials.

Günter Oesterle is emeritus Professor of modern German literature at the Justus-Liebig University Giessen where for several years he was the head of the doctoral programme 'Classicism and Romanticism' and of the research collaboration 'Erinnerungskulturen' (memory culture). He has held Senior Fellowships at the University of Freiburg, at the Johannes-Gutenberg-University Mainz, and at the University of Vienna, and he has taught as Guest Professor at Columbia University, New York, and in Beijing. He has published extensively on the 'No longer fine arts' (the arabesque, the grotesque, caricature, capriccio, the comical, and the hideous), on intermediality, on German-French relations, on the poetics of the garden, and on cultural memory. Among his most recent book publications are: *Schläft ein Lied in allen Dingen? Romantische Dingpoetik* (edited, with Christiane Hom, 2011), *Gedächtnis und Katastrophe* (edited, with Thomas Klinkert, 2013), and *Altersstile im 19. Jahrhundert* (edited, with Gerhard Neumann, 2013).

Romantik: Journal for the Study of Romanticisms
Issue 02, 2013
© The authors and Aarhus University Press
Cover/bookdesign and typesetting by Jørgen Sparre
Cover illustration: P.C. Skovgaard,
View of the Sea from Taleren at the Cliffs at Møn, 1851
Oil on canvas, 114 x 141 cm
Private collection
Photo: Ole Akhøj

Printed by Narayana Press, Denmark
Printed in Denmark 2013
ISBN 978 87 7124 228 7
ISSN 2245-599x

Aarhus University Press
Langelandsgade 177
DK – 8200 Aarhus N

INTERNATIONAL DISTRIBUTORS
Gazelle Book Services Ltd.
White Cross Mills
Hightown, Lancaster, LA1 4XS
United Kingdom
www.gazellebookservices.co.uk

ISD
70 Enterprise Drive
Bristol, CT 06010
USA
www.isdistribution.com

The publication is supported by the Nordic Board for Periodicals
in the Humanities and Social Sciences NOP-HS and by AU Ideas.